The Genius of Photography

The Genius of Photography

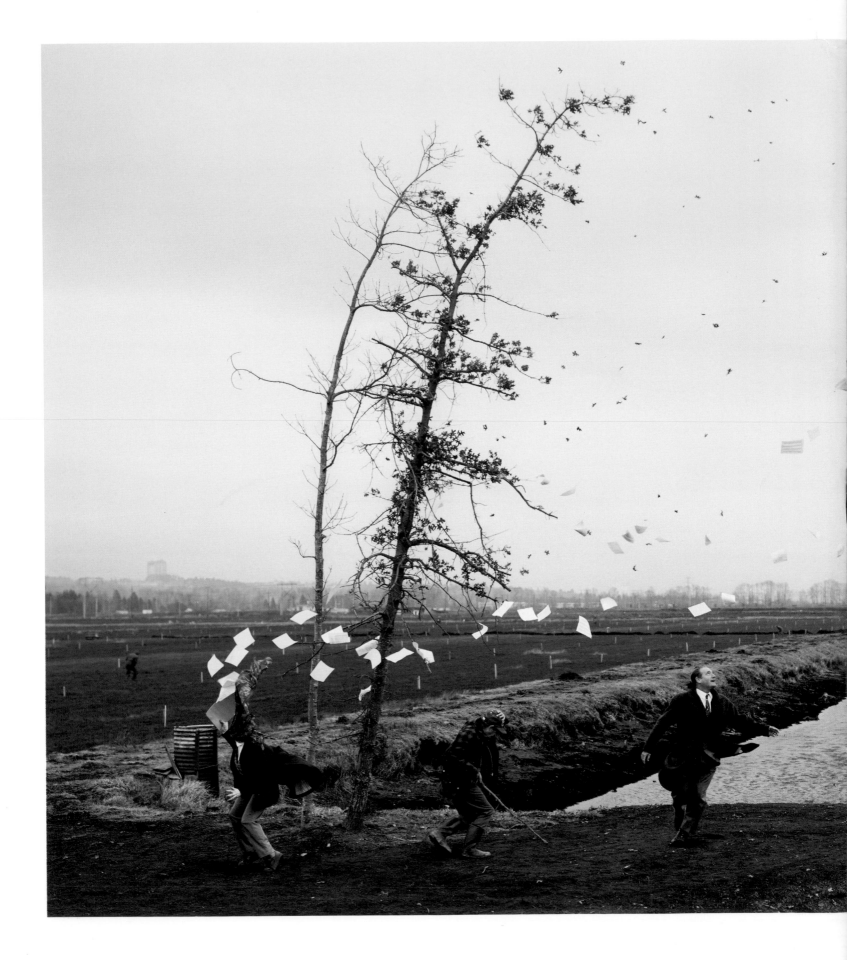

How photography has changed our lives

Gerry Badger

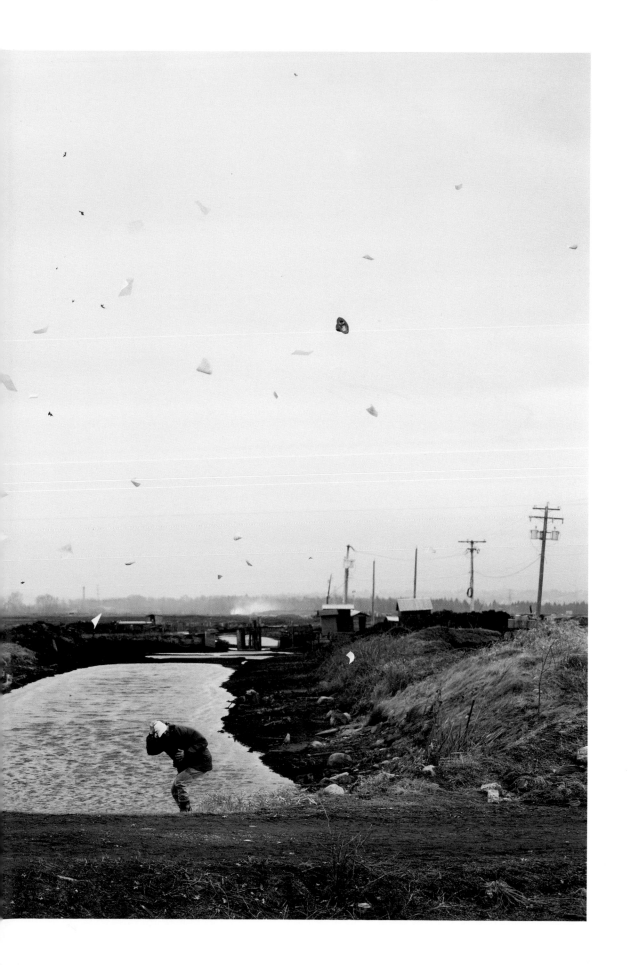

Quadrille

First published in 2007 by Quadrille Publishing Limited
Alhambra House
27–31 Charing Cross Road
London w c 2h 0 ɪ

Reprinted in 2007 (twice), 2008
10 9 8 7 6 5 4

wall to wall
www.walltowall.co.uk

For the book
Editorial director: Jane O'Shea
Design: John Morgan studio
Editor: Mary Davies
Picture researchers: Joanne King,
Frédérique Dolivet and Claudia Condry
Production: Vincent Smith and Ruth Deary

For the television series
Series producer: Tim Kirby
Executive producers: Michael Jackson and Alex Graham

Cataloguing-in-Publication Data: a catalogue record
for this book is available from the British Library.

ISBN 978 184400 363 1

Printed in Singapore

Note to the reader
Figures in the margin of the main text draw the reader's
attention to other pages where the chapter text or
picture essays have particular relevance. The glossary
and timeline at the end of the book offer additional
information, especially on technical matters, and,
of course, the index is another navigational aid.

Contents

The first 'photograph'. Using a pewter plate coated with light-sensitive salts inside a little box with a lens attached, Niépce made the first photograph, from an upstairs window at his country estate near Chalon-sur-Saône. The exposure was eight hours.

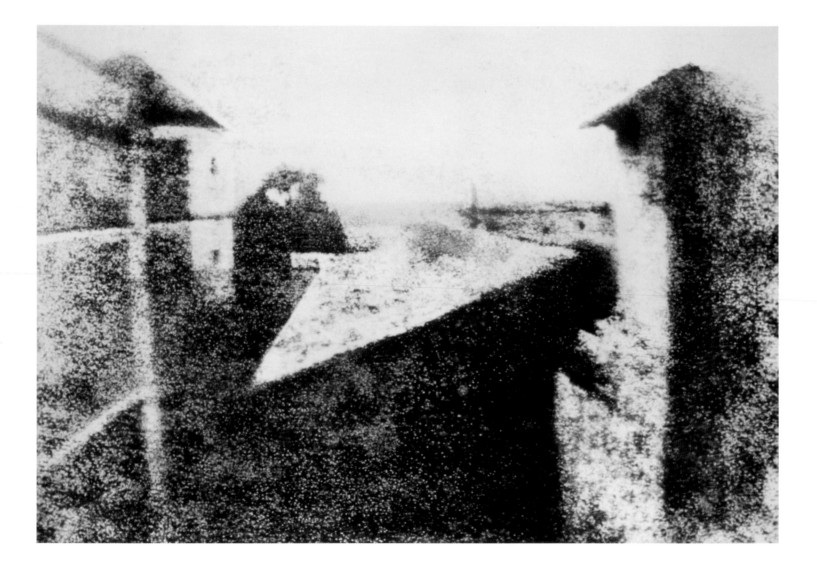

Introduction

'Your photography is a record of your living, for anyone who really sees.' Paul Strand

Joseph Nicéphore Niépce
(French, 1765–1833)
View from the Window at Gras c. 1826
Heliograph

The camera is one of the most ubiquitous of modern tools, ranking with the computer and mobile phone. Some cameras, indeed, are also both computers and mobile phones. Nearly everyone, at least in the world's urban centres, takes photographs, and there can hardly be a person who has not had his or her image captured in a photograph. As we walk down a city street or shop or drive our cars, we are being photographed by batteries of cameras that are not even operated directly by human beings.

There are many reasons to take photographs. More crucially, there are innumerable uses – some benign, some not so benign – to which photographs are put. Photographers take photographs to remember a holiday, to record the growth of their children, to express themselves creatively, to record their view of the world or to change our perception of the world. Photographs can function as repositories for personal memories, as historic documents, as political propaganda, as surveillance tools, as pornography, as works of art. We think of photographs as fact, but they can also be fiction, metaphor or poetry. They are of the here and now, but they are also immensely potent time capsules. They can be downright utilitarian or they can be the stuff of dreams.

The photographic medium has such a diversity of aims and ambitions that to talk about a single, unified story of photography is a nonsense. There are a number of stories of photography, and it is those with which this book will deal. From the very beginning, different histories of photography were in the making. The inventors and early pioneers of photography were unsure whether it was an art or a science, and those who termed it 'half art, half science' probably got it right. Even today, uncertainties about photography's exact status result in fierce debate amongst critics and photo-academics, a debate that in general terms revolves around whether photography is a fully fledged artform or a mass medium. In certain critical quarters photography is now termed 'the new painting', but that does not mean the age-old question 'Is photography an art?' has been resolved. Not by any means.

Of course, anyone picking up this book might reasonably expect that I shall be concentrating primarily upon the art of photography. They will not be disappointed. I firmly believe that photography is not only potentially an artform, it is one of the most important artforms of our times. The question I shall be asking is what kind of artform – or artforms – is it? And the answer will not always be that it is a kind of surrogate painting, something to be stuck in frames, hung on gallery walls and considered in a largely aesthetic sense. Rather, I shall be proposing various ways in which photography can be considered a social art, although that will not necessarily rule out photographic aesthetics, for aesthetics, like anything else, has a social function.

The photograph is such a familiar form of representation that we can often fail to realize what a complex and tricky object it is. We do not look at a photograph so much as 'read' it. We regard the world contained within it, but at the same time interpret it in much, but not completely, the same way we interpret the world itself. The photograph creates a discourse between us and the world, but a discourse that is never neutral, not even in – especially not in – a photograph taken by a satellite or surveillance camera. And even if the camera, even if the photographer, were neutral, the viewer is not.

In an exhibition he curated in 1976, John Szarkowski, then the distinguished director of photography at New York's Museum of Modern Art, designated photographs as 'mirrors' or 'windows'. The 'window' photograph was one in which the subject-matter is of primary importance, a scientific record, for example, and the view of the photographer secondary. The 'mirror' was the opposite, the photograph existing mainly to reflect the photographer's viewpoint, a self-conscious 'art' photograph, for instance. The distinction is useful, but only to a point, because most photographs are both mirrors and windows. And often distorting mirrors and clouded windows at that. But however distorting and clouded they may be, we shall try to look at the meaning of photographs throughout the medium's history, not just their meaning when they were made, but their meaning to us now, for the two can be very different.

Anyone can take a photograph. Not everyone can make great bodies of photographic art, but anyone can take a great photograph. To say that is not to denigrate the work of the great photographers but it is the reason why photography is termed 'the democratic art'. The story of photography for me revolves around what unites all photographers and all photographs. To discuss that is to discuss the essential nature – the genius – of photography.

The author and artist John Stathatos, in an article on the tricky relationship between photography and art, asked whether the photographic image, subsumed these days into '*the insatiable maw of contemporary art, retains an independent identity beyond its purely functional roles – does it, as it were, still preserve any specific and particular qualities?*' His answer was that it does, thanks to the medium's '*unique relationship with reality, a relationship which has little to do with "truth", visual or otherwise, but everything to do with the emotional charge generated by the photograph's operation as a memory trace*'.

A '*memory trace*'. It is a shrewd expression, for it locates the photograph firmly within the realm of human experience. A memory, of course, can be as fleeting and as insubstantial as a shadow, but there are other kinds of memory, some of which, unlike shadows, are persistent, obdurate and enduring. There are fond memories, not-so-fond memories, repressed memories, false memories, shared memories, race memories, cultural memories. Photography serves all of these – we photograph to support our own view of the world – but, as soon as the shutter is tripped, the resultant image reveals only that which is already past. The picture instantly becomes the subject of memory. Yet the photograph is not memory. It is only a trace of memory. And the photographic trace provokes the certainty that something existed, yet it is only a representation of reality and not reality itself.

Photographs are deemed to tell the truth, and we are always disappointed when the camera is 'found out' telling a lie, when it is revealed that a picture was 'set up', or an image manipulated in the computer. In these days of Photoshop software, the old adage that 'the camera never lies' seems to have been replaced by a new one, that 'the camera always lies'. But a photographic image is true and false in equal measure. All photographic evidence, all photographic reality, requires interpretation. The fact that the photograph appears to be a window on the world is one of the medium's greatest problems, and yet is at the root of its potency and its fascination. It is also the potentially tricky but potentially fruitful area – between fiction and truth – where the best photographs, and the best photographers, work.

Whether or not you regard the photograph as absolute truth or absolute fiction, its basic faculty remains. A photograph takes you there. If it does nothing else in terms of artistry, or any other characteristic by which we might judge it, that is, when you think about it, amazing. As the French cultural commentator Roland Barthes wrote, '*This is a strictly scandalous effect. Always, the photograph astonishes me, with an astonishment which endures and renews itself inexhaustibly.*'

Photography takes you there, not just in a geographical but also in a temporal sense. It is a time machine, especially where people are concerned. A photograph is capable of projecting us into visual contact with the physiognomy of someone at the furthest end of the earth, or a human being who no longer exists. Photography has taken us to the moon, and to the depths of the ocean. That is powerful stuff indeed. No matter how technically inept, how lacking in considered formal qualities, a photograph must always stop us short. For it brings us into direct contact with time past, and it transcends geographical and physical boundaries. It puts us into immediate touch with the long ago and far away, with the quick and the dead.

That is at the very root of the story I will be telling. Photography has been used to make significant works of art. The medium has been one of the primary forces in shaping the myths, manners and morals of our contemporary civilization. But in essence it boils down to pointing a camera at the world and clicking the shutter. As Walker Evans, one of the greatest of photographers said, most photography is driven by '*a simple desire to recognise and to boast*'.

Evans, who was almost as great a writer on photography as he was a practitioner, also summed up the medium in words that will be a guiding principle throughout this book:

Leaving aside the mysteries and inequities of human talent, brains, taste and reputations, the matter of art in photography may come down to this; it is the defining of observation full and felt.

thing, but to my mind if photographers want to help serendipity along, that's their business. Real fakery is usually fairly evident, and one must always remember that a photograph, even a photograph to be used for evidence, is only a representation.

Photo-historian Hans-Michael Koetzle is certain that the foreground figure is a 'plant', and that he was the German artist Willi Baumeister, possibly on a visit with Kertész to the Meudon studio of a mutual friend, the sculptor Hans Arp. The evidence is purely circumstantial, yet compelling. We know that a day or two before making this picture Kertész made a 'dry run' or two. One of these shows an empty scene, and in another there is the passing train. So the picture is perhaps not as spontaneously conceived as Kertész has contended.

But what does Kertész' photograph mean? Apart, that is, from the fact that photographers can do this kind of thing – freeze a complex group of buildings and moving people in a busy street scene. It's not easy to play visual gymnastics with the camera, to incorporate a disparate group of elements into the rectangle that is the picture-frame, and contain them in a perfect instant. And the result? They remain frozen for all time, locked into what is essentially an artificial relationship, one that exists only within the picture, in which, as critic Graham Clarke has noted, '*history is sealed, so to speak, in a continuous present*'. Photographers love making this kind of picture, and they are extremely popular with viewers too. Indeed, candid street images almost define photography in many minds.

The standard answer to the question of meaning in a photograph like *Meudon* revolves around the so-called 'social document'. Kertész' picture is a 'slice of life', an image in realist mode that, in conjunction with others in the same vein, explains ourselves to ourselves. In short, it is a picture about modern life, and is perfectly in accord with themes of modernity that occupied painters and writers at that time – speed and transportation, the lonely man in the crowd, and so on. Indeed, a year after Kertész' picture was taken, the *Film and Photo* exhibition in Stuttgart would bring modernist photographs together from far and wide to make a grand statement about the state of the medium as a cultural force.

A more sophisticated answer to the question could be that the image functions as a kind of surrealist dreamscape, apparently lucid and 'real', but in fact a product of a delirious mind, mysterious and unknowable. Kertész made a living from commercial photographic assignments, feeding the illustrated magazines that were such a feature of the period with portraits and reportage photography. But, locating him further in the cultural climate of the time, he was not only developing the small-camera aesthetic, part of the 'New Vision' modernism then sweeping European photography, he was also close to avant-garde circles in Paris, including the surrealists.

What seems clear is that, apart from a description of the scene, the social facts the image gives us are few, and not likely to be particularly useful to the social historian. They are too random. Indeed, while I am not suggesting that the image was put together in a random manner, Kertész' famous image illustrates a problem many people (including many photographers) have when considering photography as an art – one which was discussed from the very beginnings of the medium.

Life is random and messy, and the primary task the photographer faces is ordering it, giving it meaningful form within the image.

Even for a master photographer like André Kertész, there are things outwith the photographer's control, things that can 'drop' into the frame unbidden and affect a picture's meaning.

Consider *Meudon* again. What is the subject? Its *subject*, not its *subject-matter*. What is the picture 'about'? Is it the mysterious man with the parcel, the lonely man in the crowd? Is it the town, the viaduct or the train? And if so, why include the man?

Perhaps the answer is that the photograph is about all of these things, and that the image – where no one part seems to have been given prominence over another, either in formal or subject terms – reflects the chaos and alienation of modern life. One might also suggest that this, exemplified by Kertész' restless picture, is what photography does best. Photography is the medium most capable of setting down a myriad contingent sense impressions, the medium most suited, in the words of John Szarkowski, to exploring '*freely, without formulation, the kaleidoscopic truths of meaningful aspect*'.

The Empire of Photography

1

One day in 1838 or 1839, a citizen of Paris paused in the Boulevard du Temple to have his shoes shined, and he and the man who cleaned them became the first people ever to be photographed.

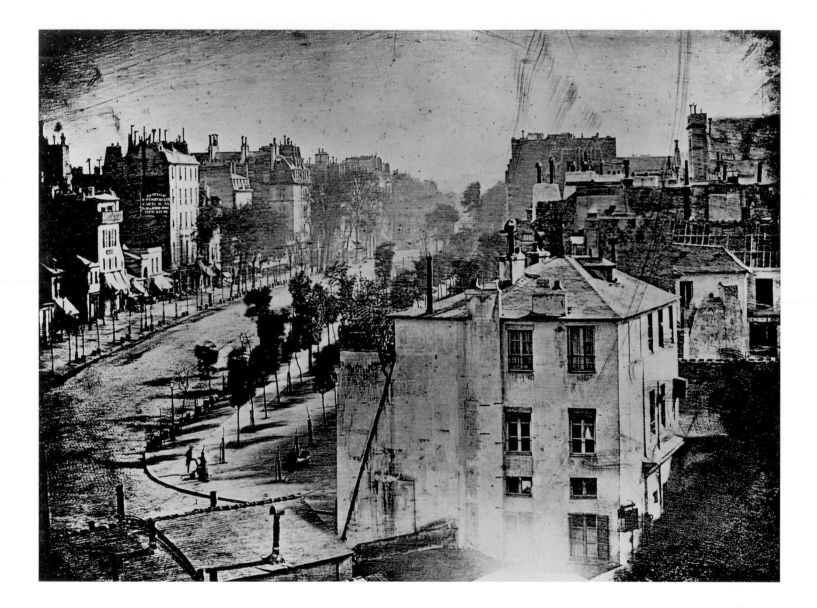

It is likely that neither of them had any idea they were being photographed. Indeed, they would not have known what a photograph was. They were caught up in the process, unknowing and unknown, as a new medium was being invented.

Art or science?

Almost from the day in 1839 that the invention of the medium was announced, the contingent, unformed aspect of photography was perceived as a problem. Photography's ability faithfully to record the world was trumpeted as its unique glory, but some were ambivalent about the camera from the outset, and in certain quarters the mechanistic, mimetic and somewhat indiscriminate nature of the medium hindered its acceptance as a fine art.

The 'Is photography an art?' debate has tended to revolve around this issue ever since. At the very beginning, photography was often described as 'half art, half science', and early commentators on the medium argued about which it was, or whether it was both. Even the two main photographic methods, invented almost simultaneously – one in France and one in England – seemed to take sides and reflect the dichotomy.

The photographic process introduced by Louis-Jacques-Mandé Daguerre in France – the daguerreotype – employed a polished, silver-coated copper plate exposed in the dark to iodine to create a coating of light-sensitive silver iodide. When the plate had been exposed to light in a camera, the latent image was 'developed' by mercury vapour and 'fixed' by a warm solution of common salt. The result was a jewel of an image, highly detailed and faithful to nature. Indeed, the term 'mirror of nature', often applied to the daguerreotype (as Daguerre modestly called it), was entirely appropriate, for the picture was laterally reversed, as one sees oneself in a mirror.

The main rival to the daguerreotype was William Henry Fox Talbot's calotype. Light-sensitized paper was exposed in a camera, which, when developed and fixed, produced an image with nature's tonal values reversed – the 'negative'. A 'print' was made by exposing another sensitized sheet placed in contact with the tonally reversed negative. When printed, the paper fibres tended to diffuse the image and obscure fine details, so calotypes lacked the hard-edged precision of the daguerreotypes. Their effect was broader, substantially closer to the suggestive, romantic naturalism favoured by progressive artists of the day, and the process had evolved from his 'photogenic drawing' experiments.

Louis-Jacques-Mandé Daguerre
(French, 1787–1851)
View of the Boulevard du Temple, Paris c. 1838–39
Daguerreotype

This famous photograph demonstrates both the limitations and virtues of the new medium. Firstly, Daguerre's view of the Boulevard du Temple in Paris takes you there. It is one of the earliest examples of a time and place frozen for eternity. And it also establishes immediately one of photography's great themes – the urban experience.

But when it was made, exposures were far too slow to freeze any semblance of movement. People and carriages moving through the picture during exposure did not register on the plate, so a presumably busy Paris boulevard is populated by ghosts. Except for the citizen who stopped to have his boots polished – long enough to be recorded in Daguerre's photograph. Both men are slightly blurred, but go down in history.

The photograph also demonstrates the drawbacks of photography's fidelity to nature. The composition is a little awkward, proportions are not quite right. Despite the appeal of its immediacy, everything looks slightly scruffy, unfinished, disappointing even. But that is reality, to the chagrin of those who thought that art should deal only with the elevated and the ideal. Some photographers, too, would be dissatisfied with this stark actuality, and would attempt to set a more idealistic mission for photography. But on the Boulevard du Temple, the real was quite enough for Daguerre, and absolutely astonishing for the rest of the world.

Mirror of nature versus photogenic drawing. Already the doubts, confusions and arguments about photography's role were in evidence. Yet even with Talbot's rudimentary, fuzzy early calotypes, the ability faithfully to copy the world was the thing that was prized. As Talbot himself wrote:

One advantage of the discovery of the Photographic Art will be that it will enable us to introduce a multitude of minute details which add to the truth and reality of the representation, but which no artist would take the trouble to copy faithfully from nature.

Although it had early imperfections and problems, and could not compete with the daguerreotype's lucidity, the calotype – named after the Greek word *kalos* (beautiful) – would eventually supersede the French system because of one overwhelming factor. Talbot's process provided a negative, from which any number of positive prints could be made. The paper negative, blessed with the priceless capacity to generate endless reproductions, was to form the basis of all modern photography until the advent of the digital camera.

And if one could make any number of prints from a negative, one could paste them into a book. On 29 June 1844, the first part of *The Pencil of Nature* was published as a part-work by Talbot's Manufacturing Establishment in Reading. Five original calotypes, bound in paper wrappers and printed with accompanying letterpress texts, were priced at 12 shillings, and found 274 customers. By the time the sixth and final instalment came out in 1846, the number of subscribers had dwindled to 73. A giant leap for mankind perhaps, but a financially backward step for its creators. Nevertheless, an important arena – some believe the most important arena for photography – the printed page, had been established.

The Pencil of Nature was not just a selection of photographs. It was a polemic for the new medium. As the eminent photo-historian Beaumont Newhall has remarked, the book was several things in one. It was an advertisement, a calling card, an experiment, a history, an aesthetic achievement and a manifesto:

It was a show book, an account of the history of the invention, and a demonstration of its accomplishments in the form of twenty-four actual photographs.

Talbot discusses the applications of photography, putting forward the case for the medium as an art, but a documentary art – a useful rather than a fine art, a system for garnering facts. And he sets out the principal objection of the art establishment to photography:

The instrument chronicles whatever it sees and certainly would delineate a chimney-pot or a chimney sweeper with the same impartiality as it would the Apollo of Belvedere.

In one brilliant sentence, he had summed up the debate. Photography was too indiscriminate, too democratic. It cut across hierarchies of accepted subject-matter. And in so doing, photography potentially subverted the rigid class structures of 19th-century Europe. The professional portrait studios that sprang up almost overnight in Europe and the United States enabled the proletariat to have likenesses made of themselves. It gave the lower orders – the rising middle classes, at least – some control of the means of representation, of knowledge, and therefore potential power. In New York in the 1840s, one could be 'daguerreotyped' for a dollar. Any young man off the streets, without refinement or art education, could set himself up in business as a camera 'operator'.

Baron Jean-Baptiste Louis Gros
(French, 1810–78)
The Great Exhibition at the Crystal Palace 1851
Hand-coloured daguerreotype

The world's first open photographic exhibition was held at Britain's Great Exhibition of 1851. Seven hundred entries from six nations demonstrated every facet of the new art–science, but the British, co-inventors of the medium, were in for a shock. The French and the Americans scooped all the prizes. The French took most of the medals for paper-negative photography, the Americans for daguerreotypes. Even the great Scottish duo, David Octavius Hill and Robert Adamson, received only an honourable mention.

This magnificent daguerreotype by Baron Jean-Baptiste Louis Gros may well have won a medal, but its purpose was to document the exhibition. Of course, the greatest wonder was the exhibition hall itself – Joseph Paxton's Crystal Palace – in which every achievement of Victorian England and her empire was displayed. Paxton's great steel and glass edifice is the first modern building, the forerunner of so many 19th-century engineering achievements – succeeding exhibition halls, shopping galleries, railway stations, skyscrapers, the Forth Bridge and the Eiffel Tower. So the image is a case of one modern invention recording another.

Gros's daguerreotype shows why the method was initially preferred to the paper negative. Its resolution of detail is astonishing, showing with extraordinary clarity the scene before the photographer. It reveals that, although Paxton's structure was daringly modern and clean lined, enclosing apparently infinite space in a radical way with newly developed technologies, it was filled to overflowing with kitsch, with plaster casts of Greek statues and Victorian bric-a-brac. And did the French photographer notice that in the picture's foreground was a model of Nelson's ship *Victory*? No doubt prominently placed to remind foreign visitors, especially the French, of the natural order of things.

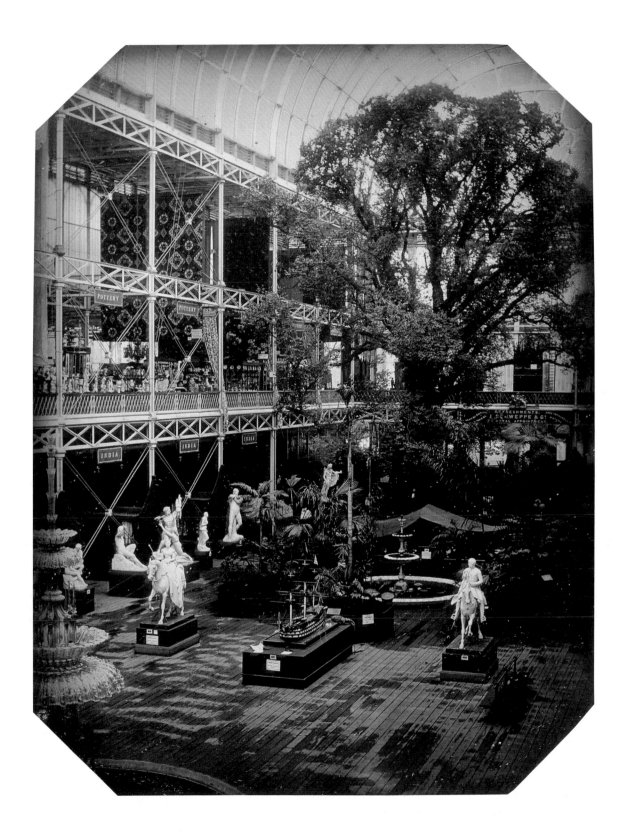

Early photocritics praised the daguerreotype for its amazing resolution and disparaged the calotype for its fuzziness, but that was an oversimplification. One of William Henry Fox Talbot's finest calotypes reveals a wealth of fascinating social detail. We can even date it accurately from close study of the posters in the foreground.

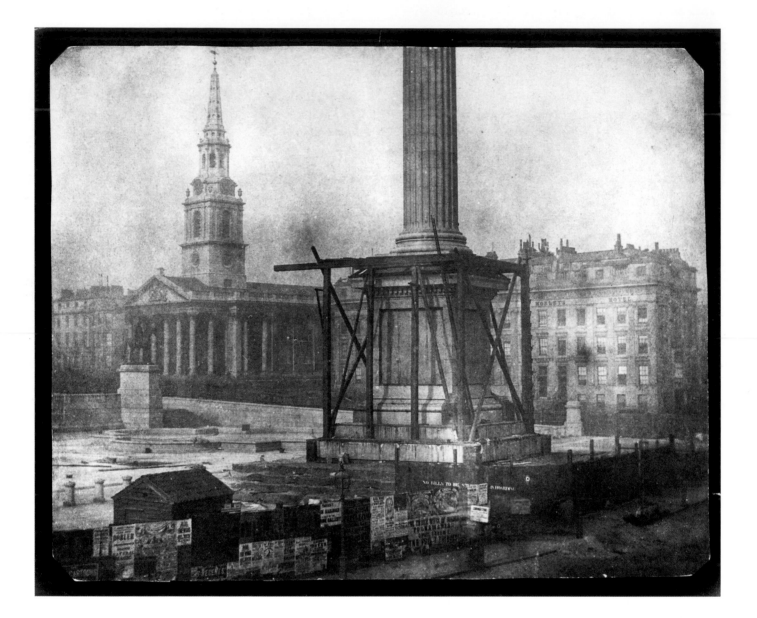

William Henry Fox Talbot (English, 1800–77)
The Nelson Column, Trafalgar Square, London, under Construction 1844
Salted-paper print from calotype negative

The theme is a familiar one from early photography – a building site, the Victorian age under construction. The object being built, however, is not a building or an engineering marvel, but Nelson's Column, erected to commemorate Britain's greatest naval victory over the dastardly French. It is a moment of some historical import, the erection of what is now one of London's most distinctive landmarks. For us, Talbot's photograph is both a work of art and a historical document, but to its audience then it was a marvellous record of the here and now.

Yet both audiences must be struck not just by the general scene, but by the profusion of detail in the picture, especially the bills posted on the hoardings. We can, with the aid of a magnifying glass, read the lettering on each sign, and from the theatre bills photo-historian Larry J. Schaaf has been able to determine that the picture was taken in the first week of April 1844. That is telling – everyday details like these instantly bridge time and make the image particularly immediate and vivid. Especially when we examine a section of hoarding just under the steps of the column and catch a partially masked line of letters reading '*No bills to be stuck on this hoarding*.' Clearly an exhortation ignored in the 19th century, just as it is today.

When the artist Holman Hunt declared in 1854 that the models and subjects of some artists were '*as ugly as a daguerreotype*', there seems rather more than a hint of class prejudice implicit in the observation.

In France and Britain – especially class-conscious England – the confusion about the status of photography was also expressed in comparisons between the amateur and the professional, between noble art and grasping commerce. In reaction to the democratizing tendencies of the daguerreotype, amateurs tended to work with paper processes, firstly the calotype, and then its refinement, the waxed-paper process invented by Gustave Le Gray in 1850. Soaking the paper negative in beeswax before it was sensitized made it more translucent and more capable of resolving fine detail, overcoming some of the objections to the system.

Both daguerreotype and paper negative, however, were destined to be eclipsed by a new photographic method that combined the lucidity of one with the reproductive qualities of the other. In 1851, Frederick Scott Archer introduced the glass negative process, using a glass plate treated with collodion and then sensitized with a dip in silver salts. At first this was a tricky method, as everything had to be done on the spot – the plate coated in the dark, exposed when slightly damp, and then developed immediately. The results, though, were so superior that the wet-collodion or wet-plate process (as it was known) became the standard for much of the rest of the century.

One far-reaching result of the wet plate was to make photographs cheaper, thus extending the empire of photography even further. In 1854, the French photographer André Disdéri patented a way of taking a number of small photographs – usually eight – on one large photographic plate, greatly reducing the cost of each image. Different methods were devised to make these smaller pictures. Some cameras had multiple lenses, to be exposed singly or as desired. Others had a rotating back to move each section of the plate into the correct position.

The result was the *carte de visite* portrait, measuring around 11.4 × 6.3cm (see below). It could actually be used as a calling card, or, if it was a celebrity portrait, sold by the thousand and collected by the public. Portraits of royalty or a celebrity like Sarah Bernhardt could sell over a hundred thousand, particularly during the 1860s, when the fashion for the *carte de visite* photograph was at its height. As Julia Bonaparte wrote in her diary in 1856:

> *It is the fashion to have your portrait made small in a hundred copies: it only costs fifty francs and it is very handy to give to your friends and to have their images constantly at hand.*

The *carte de visite* was so cheap that the lower middle classes could begin to have their portraits taken too, sticking them into special albums, the forerunner of the later snapshot albums. In time, a de luxe version of the *carte de visite* became popular, the cabinet photograph. At 11.4 × 17cm, this was forerunner of the postcard.

Another cheap and popular photographic craze was the stereograph. When looked at in a special viewer, two almost identical small photographs combined to form a single three-dimensional image. There had been stereo daguerreotypes, but the development of multiple-image, wet-plate cameras made this novelty much cheaper, and there was a long-lasting craze for the stereograph, beginning in the mid-1850s.

All these popular uses of photography were, of course, far removed from art photography or even documentary with large-format cameras. But the arguments about the precise place of photography within the cultural hierarchy raged on.

Before photography, only people of consequence could afford to commission a portrait. To have one's portrait painted was to proclaim one's identity, one's position in the world. It was a mark of success. With the invention of the daguerreotype, almost anyone could have an exact likeness made. Everyone, thanks to photography, was given an identity – the daguerreotype portrait was a magical proof of existence. These three girls, photographed by Gustav Oehme, remain caught on the threshold of adolescence.

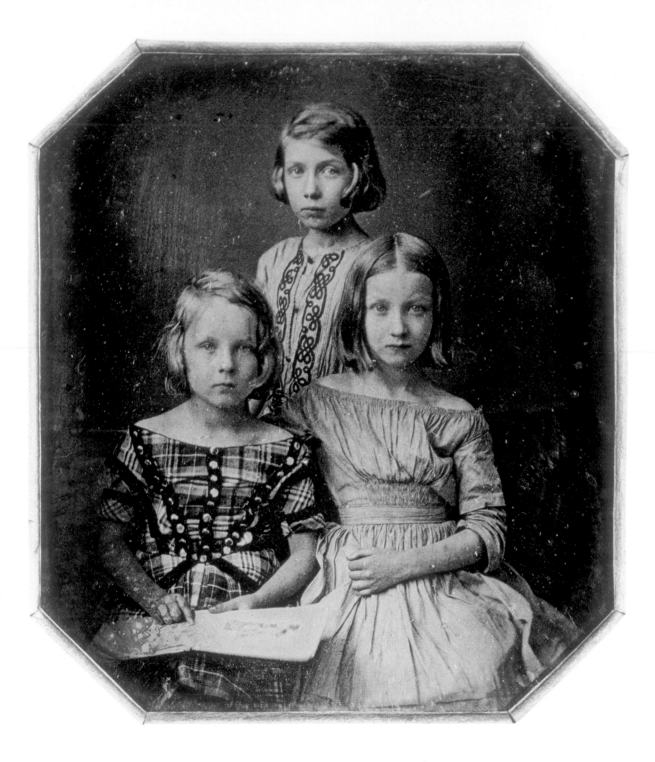

Rineke Dijkstra uses a roughly similar large camera, mounted on a tripod, to that used by Gustav Oehme, making portraits that exhibit the same kind of concentrated stillness as 19th-century photographs. But Dijkstra has the benefit of full colour and, although her subjects frequently look anxious or awkward, it is the result of a totally different conceptual approach to that of the early daguerreotypists.

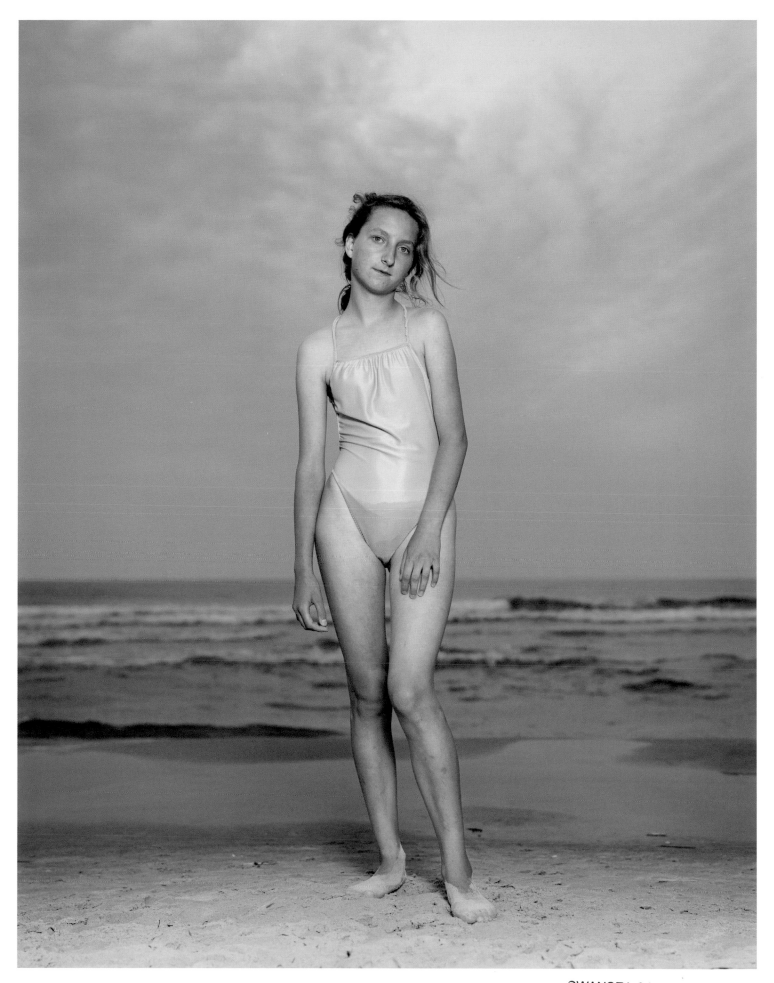

Gustav Oehme (German, active 1840s)
Three Girls, Berlin 1843
Daguerreotype

Such was the talismanic power of daguerreotype likenesses that daguerreotype portrait studios colonized the world in the 1840s and early 1850s. In New York City in 1846, there were sixteen. By 1851, there were seventy-one, and a likeness could be purchased for less than a dollar. Only a few years after photography's introduction, daguerreotype operators opened in places as far away as Samoa.

It would be foolish to pretend that many of these daguerreotype portraits had much in the way of artistic merit. Any young man with an eye to the main chance could learn how to become an operator, although the trade attracted many with some prior knowledge of optics or art, such as engravers, draughtsmen, watchmakers and opticians. Nevertheless, most daguerreotypes are stiff, formal and lifeless, the result of the long exposures, or because they were turned out by rote and by the dozen. But as an unknown writer remarked in 1855: '*There is something interesting in the very worst of these daguerreotypes because there must be something of nature in all of them*.'

This is a beautiful group – and their parents were surely pleased with the result – but for these three girls in their best clothes the strain of trying to keep still is etched on their faces. Gustav Oehme was apparently an optician by trade.

Rineke Dijkstra (Dutch, b. 1959)
Kolobrzeg, Poland, July 26, 1992
Chromogenic (Type C) colour print

Dijkstra's 'signature image' comes from her series of fascinating portraits of adolescents on beaches, in which she isolates her sitters from their immediate social context to make a portrait that is a telling mixture of forensic scrutiny and psychological nuance. She has said that her aim is to capture '*an authentic moment of intensity*', one that reveals a '*concentration of vulnerability and power*' in her subjects.

Another of her strategies for gaining a glimmer of psychological insight is to photograph subjects in transitional, often stressful moments. She has photographed matadors just after they made a kill in the bullring, or women just after they have given birth. With these adolescents, the transition is not so much a moment as a transitional period in their lives, the important rite of passage from childhood into adulthood.

By isolating these children on the beach and stripping them of possessions and clothing, Dijkstra heightens the formality of the portrait-making situation, and that emphasizes the awkwardness they may feel about their bodies at a time when their hormones are running wild. And yet she is not a cold photographer. Her pictures have a disturbing side to them, and she keeps an emotional distance from her subjects, but it is a warm distance, and we feel their vulnerability and self-consciousness with them, just as we feel the heartbreaking melancholy in a daguerreotype. Dijkstra's powerful images will undoubtedly acquire this aspect in decades to come.

One of the most popular outdoor locations for North American daguerreotypists was Niagara Falls. It was more exciting to have one's likeness made with the foaming cataract as a background, rather than a tame studio backdrop. This picture by William England shows the American Falls at Niagara in the distance, and is notable for combining most of the principal subjects of 19th-century photography into a single image.

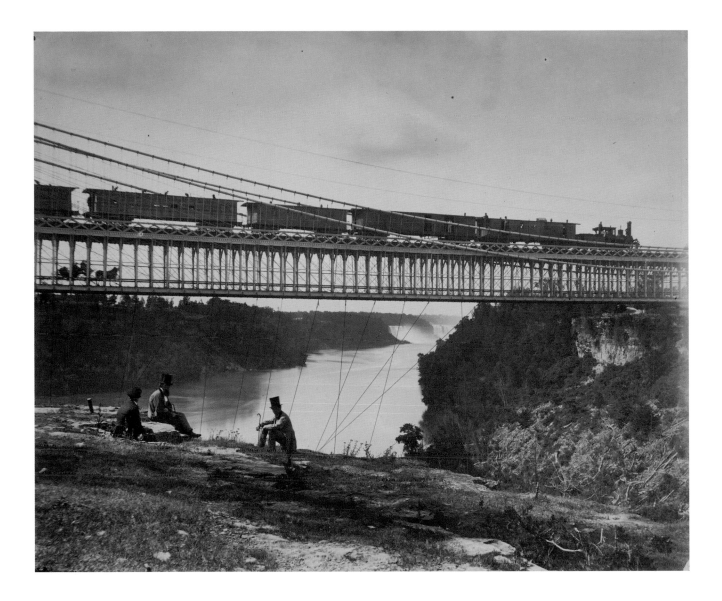

William England (English, 1816–96)
Niagara Suspension Bridge 1859
Albumen silver print from wet-collodion negative

This picture was taken with the photographic system that finally secured the daguerreotype's demise. In 1851, Frederick Scott Archer managed to coat a glass plate with light-sensitive silver salts, producing a photographic negative that combined the infinite reproducibility of the paper negative with the infinite detail of the daguerreotype. The wet-plate system (so called because the negative was exposed when slightly damp) became the standard for most of the 19th century, and its invention ushered a new era of professionalism into photography.

The glass negative could deliver the world, accurately and in great detail. People in Europe who had never seen Niagara Falls, and might not be willing to accept a painter's interpretation, however accurate, could view this natural wonder for 'real' in a photograph.

But England's photograph is of a man-made wonder. If photography could transport the Victorians symbolically, the 'iron horse' – the railways – could transport them in actuality. Both photography and the railways ushered in the modern world, creating a new sense of time and space. Also glimpsed in the picture, below the rail track, is a horse and buggy, eventually to become as redundant as the daguerreotype. And the principal subjects of 19th-century photography? A scenic wonder, a group portrait, an engineering feat and a modern mode of transport. Only an ancient monument is missing. Otherwise England would have had a nap hand.

Witness to the world

In retrospect, it is clear that the debate about photography's significance, while widespread, had less practical effect upon the course of 19th-century photography than its function as part of the information-gathering industry, its use, in short, as a witness. Many of the greatest photographs of the 19th century were made in order to collect, record, store, catalogue, survey and categorize the material things of the world. The camera helped to create a body of knowledge, knowledge which both aided and justified the 19th-century capitalist enterprise. It could be said that the camera was as useful and as ubiquitous a tool of colonialization as the gun. As Susan Sontag has written:

> To photograph is to appropriate the thing photographed. It means putting oneself into a certain relation to the world that feels like knowledge – and, therefore, like power.

Within its first two decades, photography spread everywhere. Britain and France had colonized three-quarters of the globe between them, and photographers from both countries not only photographed that, but the remaining quarter as well. Photography was used to collect facts, information on all kinds of things. It was at the service of the scientists, geographers, geologists, ethnographers, archaeologists, zoologists, botanists and physiologists. It was used by the engineers, architects, contractors, soldiers and administrators who ran the empires of the British and the French.

Photographic documentation of war also provided a persuasive aid in writing the histories inevitably compiled by the winners. Most of the surviving American Civil War photography, for 132 example, was carried out by the eventual winners, the North, and images of the appalling conditions in Confederate prison camps were used as anti-South propaganda. Following that war, many of the selfsame photographers continued to make photographic surveys of the western territories that were being colonized and exploited by the Union government, the army, the railways and other enterprises.

Colonization was not confined to faraway, exotic lands. Photography was soon adopted as part of the apparatus of state and private capital control in the Western world. Science in the 19th century, sponsored by a rigidly codified class system, had a vested interest in producing visual evidence to substantiate the assumptions which underpinned the social hierarchy. From the mid-19th century, photography was used by those sciences concerned with human beings – such as medicine, psychiatry, anthropology, even criminology – to make comparative studies of human 'types'.

The reference to criminology reminds us that such studies were class orientated, initiated by middle-class scientific professions to study not their own class, because that would be unseemly, but those whom they could cajole and control – the lower classes, the poor and insane, and the native peoples of colonized lands. The grandly proclaimed motive was the 'pursuit of knowledge', the more benign motive was to 'improve' and patronize, and the less benign motive was to control and reinforce the social order.

In the 1850s, Guillaume-Benjamin Duchenne de Boulogne in 72 France and Hugh Welch Diamond in England made comparative studies of psychiatric patients, Duchenne attaching electrodes to their heads and giving them electric shocks in order to study their

Dr Thomas Keith (Scottish, 1827–95)
The Castle and West Princes Street Gardens
early 1850s
Salted-paper print from waxed-paper negative

Dr Thomas Keith, a prominent Edinburgh surgeon, took Gustave Le Gray's waxed-paper negative system to the highest possible level in the early 1850s. His career as a photographer was a brief one – a few years and some two hundred negatives – but his images were among the most advanced and artistic of the period. His large negatives (measuring approximately twenty-eight centimetres square), give his pictures a monumental quality, and he used this unusual format with great skill and originality.

Keith mainly photographed in and around Edinburgh, where he concentrated upon the picturesque delights of the 'Auld Town' rather than the New. One of his favourite haunts was Greyfriars churchyard with its ancient tombs. There, he discovered that photography had a particular faculty for recording the effects of light on worn, ivy-covered stone.

This view of the Castle Esplanade from Princes Street Gardens is his most daring image, and as minimal as a painting by Ellsworth Kelly, both tonally and in terms of its stark composition. The gardens are in deep shadow and Keith balances this against a white sky, tilting the camera to create a diagonal line, slashing across the picture almost from corner to corner, with the Castle Rock at the top and the Free Church Assembly Hall at the bottom. It is a wholly photographic conception – as modern as tomorrow, decades ahead of its time.

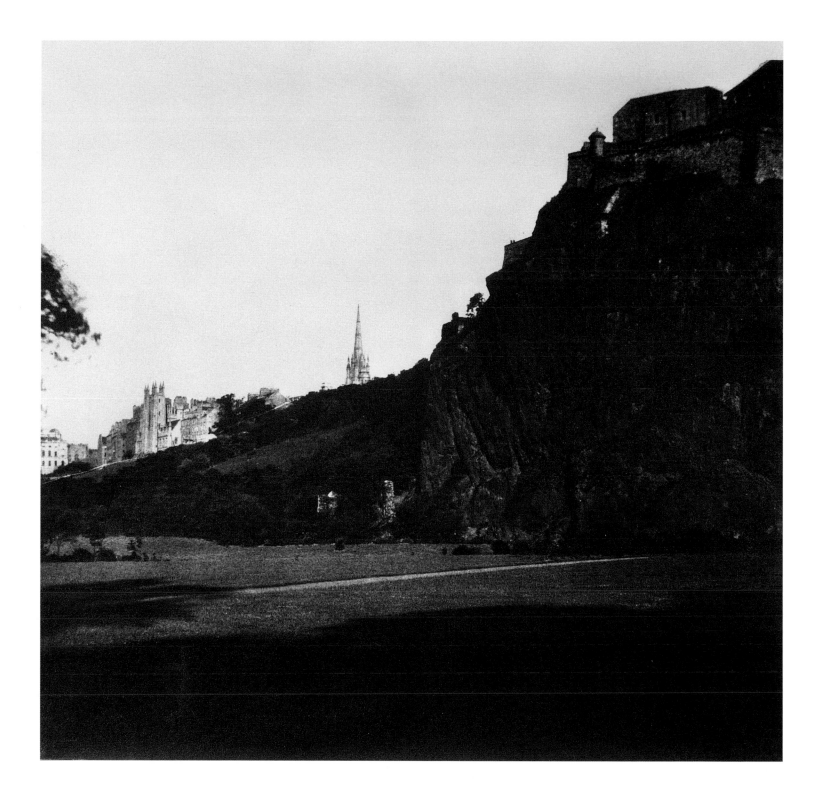

Early photographers could follow the aesthetics of painting when making pictures, but they could also follow their intuition. What Dr Thomas Keith saw here, upside down on the ground-glass screen of his camera, inspired a radical, minimal kind of image.

When commissioned to photograph the Crimean War, Roger Fenton arranged for the print publisher Thomas Agnew to market his photographs – and this coloured the nature of his report as much as a patriotic imperative to present a favourable view.

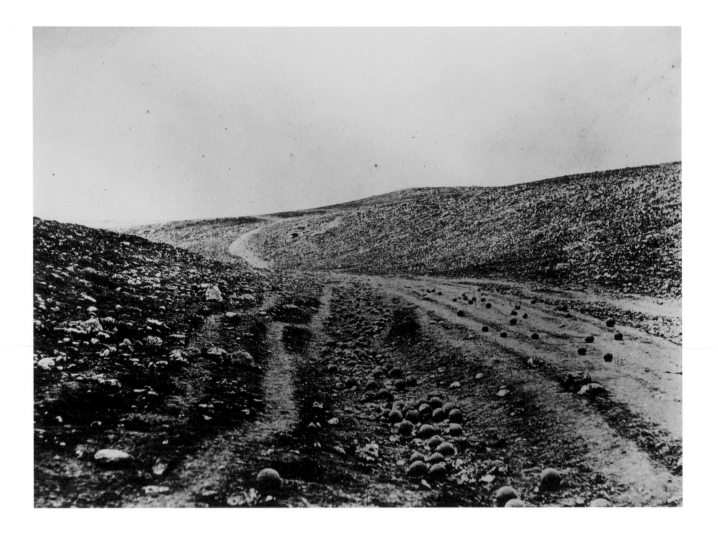

Roger Fenton (English, 1819–69)
Valley of the Shadow of Death 1855
Salted-paper print from wet-collodion negative

Fenton is widely regarded as the first war photographer, but his document of the Crimea is marked as much by what he left out – sickness and death – as what he included.

This was primarily a commercial decision. Although he could not show action, there was ample evidence of the fighting in the form of devastation and corpses, even enemy ones, but Fenton chose to make portraits of the army's officers and panoramic landscapes of the fields of battle. The officers he portrayed, and their families, were the most likely to buy his images, so Fenton's view of this botched war as a glorified pageant should have hit the mark. Unfortunately, despite praise for his photographs, no one

wanted to be reminded of the Crimea, so the venture was a commercial failure.

Of all Fenton's Crimean photographs, this one struck a chord, and has become his signature image. One reason is its resonant title – *Valley of the Shadow of Death*, from the 23rd Psalm – but it is also a powerful photograph. Stark and unyielding, it is proof that a good metaphor can often beat a good fact. For Fenton did not let facts spoil his effect. This bleak, cannonball-strewn road is several miles from where the gallant six hundred had made their futile charge – a year before the picture was taken. He made two negatives during the time these Russian cannonballs were gathered and piled up to be returned with interest. Above all, this image appeals to the imagination, and that can fill in the more unpalatable truths Fenton was loathe to reveal.

Paul Seawright was aware that he had 'made a Fenton' when he photographed these unexploded shells but he was not aiming for a cute postmodern reference. Commissioned as a war artist by the Imperial War Museum, he was documenting the aftermath of the West's incursion into Afghanistan following 9/11.

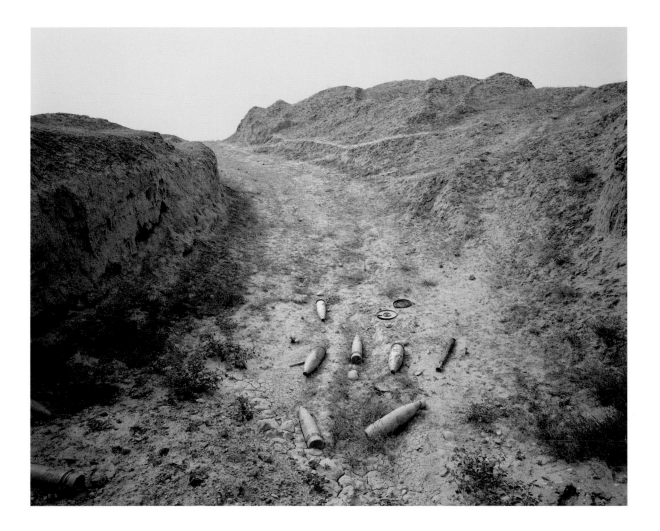

Paul Seawright (Irish, b.1965)
Afghanistan 2002
Chromogenic (Type C) colour print
From the series *Hidden*

There are, of course, interesting parallels here with Fenton and 19th-century war photography. But whereas 19th-century photographers could not photograph combat action, with Seawright it was a deliberate choice to photograph the aftermath of battle and the landscape of war. Seawright is a photographic artist and was interested in making a more contemplative, oblique work about Afghanistan. He is just one of the many photographers working today who are concerned with the issues attending the instant gratification of the hard-news photograph, and who prefer to adopt a more considered, complex approach.

Seawright photographed the desert landscape of Afghanistan, a country blighted by more than one imperialist war, in an understated, luminous way. As the title of the series – *Hidden* – suggests, Seawright is concerned not only with photographing the visible effects of war. Certainly, buildings were destroyed, lives lost, and military equipment and unexploded ordnance lies everywhere. However, besides the fact that peace has not yet come to Afghanistan, a perhaps even more deadly legacy of war dating back to the Russian occupation lies hidden in the soil.

Anti-personnel mines and radioactive pollution from uranium-tipped shells have an insidious, long-term effect. War has direct consequences for innocent people, but, even after the fighting is nominally over, the attrition continues. As Seawright's eloquent photographs demonstrate, modern warfare is also an environmental disaster.

In his famous picture, Fenton's assistants may have moved the cannonballs for pictorial advantage. Wisely, Seawright never went near those unexploded shells.

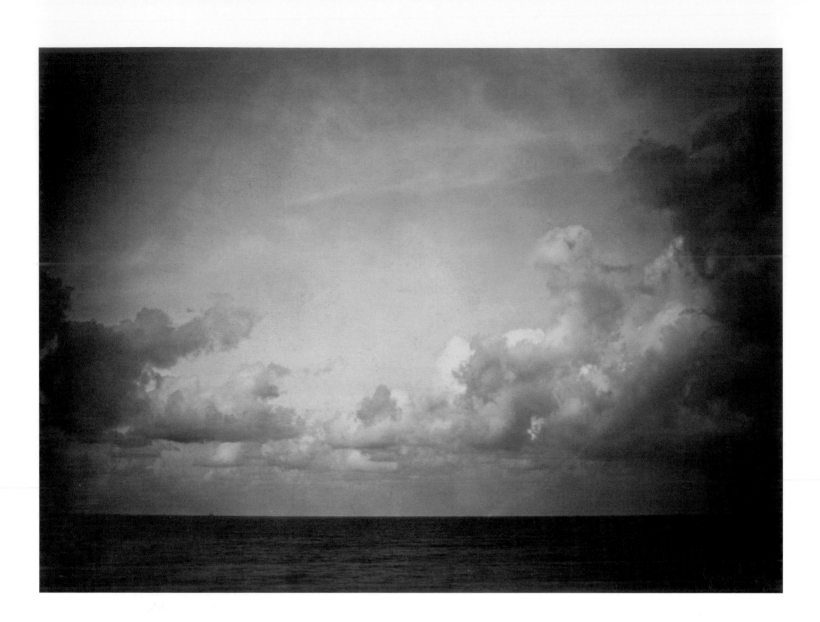

To counter the argument that photography delivered too much detail to be artistic, Gustave Le Gray proposed his 'theory of sacrifices'. Photographers should be prepared to lose overall sharpness in a picture to gain a more artistic effect. Here, he has chosen to lengthen the exposure, and the clouds, by moving slightly, have softened the overall detail.

Gustave Le Gray (French, 1820–84)
View on the Sea – The Cloudy Sky c. 1856
Albumen silver print from wet-collodion negative

Wet-collodion negatives were extremely sensitive to blue light. In slightly less technical terms, this means that if a photographer making a landscape exposed the land correctly, the sky would be overexposed and come out as a blank, bald white in the print. To overcome this problem, photographers would photograph at the beginning or end of the day, when there was less blue light. Or they would make two negatives, one exposed to capture detail in the sky, one on the land – or, in a case like this, the sea. When the two negatives were printed together, a correctly balanced landscape would be created. At least, that was the theory. To do it successfully in practice was rather more difficult.

One photographer who made a great success of combination printing was Gustave Le Gray, who used the technique to make some of the most admired photographs of the 1850s – his monumental seascapes. Although other photographers had tried to get interesting skies in their landscapes, Le Gray managed to create atmosphere.

This is one of Le Gray's more impressionistic seascapes, and, to judge by the underexposed (dark) strip of sea at the bottom, one where he made only one exposure. Le Gray's seascapes, though magnificent, can sometimes seem a little overcooked, but this is both one of his most 'photographic', yet most artistic – artistic, that is, in terms of photography rather than painting.

'emotions'. In Switzerland Carl Durheim was photographing around two hundred homeless people for a police register, the first of its kind. And in the 1880s and '90s Alphonse Bertillon used 'mugshot' photography to underwrite an elaborate typological system of criminal identification based on the measurement and comparison of body parts (anthropometry).

Not that anyone in the 19th century would recognize the tendentious nature of the scientific 'facts' collected by the camera. It was an age that largely accepted photographic evidence as 'pure' fact, the unvarnished truth. If the camera was perceived to 'lie', it was as a consequence of individual viewpoint and emphasis. The perception in no way challenged the cherished beliefs of the society that invented photography – namely, that European society and culture, and the white races, were inherently superior to everyone and everything else.

And the proper repository for these photographs was not framed upon salon walls, but books in the private library or institutional archive. Many of the fine 19th-century prints which now grace the walls of museums and individually fetch enormous prices at auction were originally pasted into books or albums. They were not considered art but illustration. Photography answered a deep human need to view the world in detail, and came along at a time when fierce debates raged in both the sciences and the arts. In the sciences, the focus was upon empirical observation. In art, it was realism. Photography – the half science, half art – added greatly to both these debates, literally affecting 19th-century perceptions of the world.

However, the point should be made that illustration did not have the somewhat derogatory connotation we give it today. Many of these documentary photographs were taken by highly refined amateurs, often trained in painting, who frequently brought a sophisticated eye to the task.

And during the 1850s, when the first photographic societies were formed, and salons imitating the exhibition salons of painting were initiated, the 'professional amateurs' who frequented them to discuss photography also had a surprisingly sophisticated appreciation of what we now call photo-aesthetics. Such photographers contributed to the fine books of photography published by companies such as Blanquart-Evrard in Lille or H. de Fonteny in Paris, books of artistic *études* or antiquarian or oriental travel pictures. A study of these books, and those published in England, shows these photographers unconsciously defining the art of photography – not pseudo-painting – as they worked. Sometimes they drew upon accepted pictorial traditions, sometimes – like the writer Maxime du Camp or archaeologist J.B. Greene in the Middle East – they found a stark new photographic language by responding uninhibitedly to what was in front of their eyes. They had ambitions for photography, not as an art that aped painting, but as one with its own particular precepts and language.

Consider two key photographers of the 1850s. Roger Fenton and Gustave Le Gray were English and French respectively, friends as well as colleagues (they had both studied with the French painter Paul Delaroche). Their careers were similar in profile, and their work exemplifies the increasing professionalism, the dichotomy between art and documentation, and also the shift from the paper to the glass negative. Both men exhibited their

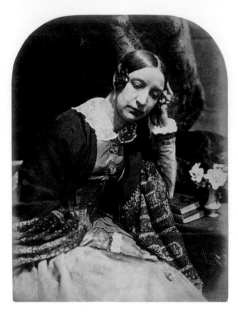

David Octavius Hill (Scottish, 1802–70)
and Robert Adamson (Scottish, 1821–48)
Miss Elizabeth Rigby (later Lady Eastlake)
c. 1844–45
Calotype

The Edinburgh duo David Octavius Hill and Robert Adamson are widely regarded as photography's first 'artists'. The calotype portraits they made are considered the first truly distinguished body of work to grace the new medium. This young subject, Elizabeth Rigby, would later endorse that verdict in her own eloquent prose, for, as Lady Elizabeth Eastlake, she was an early and perceptive photographic critic.

If the daguerreotype's primary characteristic was Holbeinesque lucidity, the calotype's forte was Rembrandtesque *chiaroscuro*, a quality especially utilized by Hill and Adamson. The broader effects produced by the fibrous paper negative, closer to the suggestive, romantic naturalism favoured by many painters of the day, were deemed more beautiful and artistic, as Lady Eastlake herself concluded.

Painter Hill had teamed up with photographer Adamson to make portraits of some four hundred or so dissident clergymen of the Free Church of Scotland. Hill wanted them as *aide-mémoires* for his proposed painting of the church's first general assembly in 1843, an event known as the Disruption. Eventually the pair's portrait gallery was expanded to include much of Edinburgh's intellectual society and even the fishing community of Newhaven.

The shadowy effect derives from the fact that Hill and Adamson's calotypes were taken in sunlight. Miss Elizabeth Rigby appears to be indoors, but she was most likely posed outdoors with suitable props. Indeed, the stone walls of their Calton Hill studio can just be made out behind her. The slightly frozen, if not pained, expression on her face might not be due entirely to the long exposure. She was probably shivering, even if the photograph was taken in the summer sunshine of Edinburgh – a woman willing to suffer for the new art, for which she was such an eloquent advocate.

prints in salons and exhibitions, but both made documentary images as well as 'art' photographs. Each man, indeed, seems to have moved effortlessly (or apparently effortlessly) between the documentary, the scientific and the self-consciously artistic photograph.

Fenton began his career in the early 1850s by making travel photographs in Russia and documenting statues and artefacts for the British Museum, as well as family 'snapshots' for Queen Victoria. In 1855 he made his famous trip to the Crimea, where he essentially defined the genre of documentary war photography, and on his return to England he made a series of large-format landscapes and studies of English cathedrals. He ended his decade-long involvement with the medium by making his most self-consciously painterly photographs, sumptuous still-lifes in the Dutch School mode so revered by English art collectors.

Le Gray's career followed a similar path. He made architectural, landscape, portrait and documentary photographs in an equally versatile manner. He achieved his greatest success with his 'marines', a series of large-format seascapes, in which, by means of judicious exposures and combination printing, he overcame a drawback of early photographic methods – blank white skies – to photograph the sea crowned by magnificent skyscapes.

But both Fenton and Le Gray, the two greatest photographers of the 1850s, had given up photography by 1860. Fenton, despising the increasing commercialism of photography, returned to his first profession, the law. Le Gray's departure from photography was even more spectacular. His photographic business having failed, he left debts, wife and children behind and went to the Middle East. He became a drawing teacher in Cairo, and took a few photographs in Egypt, but died there in 1884, never having returned home.

Although Le Gray was not a good businessman, the problems both he and Fenton faced stemmed from the uncertainty about photography's status. Le Gray twice courted rejection from the annual Paris Salon, arbiter of European taste in 19th-century art, and despite the success of his marine views must have felt the ambiguities surrounding the medium keenly.

Photographic criticism, too, had a sophisticated awareness of the problems. In a long and perceptive essay written in 1857, Lady Elizabeth Eastlake outlined the case for and against photography – in favour of it as a useful art, against it as a fine art. Lady Eastlake had been photographed in the mid-1840s by the great Edinburgh calotypists, Hill and Adamson, and she considered that their work '*remains to this day the most picturesque specimens of the new discovery*'. She makes no bones about preferring the fuzziness of paper-negative photography to the glass plate, basically lamenting it for the same reason others praised it, the phenomenal amount of detail it could resolve.

Yet she was also quite clear about photography's proper place within the scheme of things, which was not to make art but to record the world:

> *In this sense no photographic picture that ever was taken, in heaven, or earth, or in the waters underneath the earth, of any thing, or scene, however defective when measured by an artistic scale, is destitute of a special, and what we may call an historic interest … the facts of the age and of the hour are there.*

The flight from realism

Few would disagree with Lady Eastlake's words, but that did not prevent the amateurs who frequented the photographic societies and salons from pursuing a loftier mission. Sadly, they believed that in order to aspire to a fine art, photography had to ape painting, both conceptually and practically. Conceptually, photography had to aspire to beauty and idealism. Practically, the mechanical surface had to be modified. Sir William Newton, for example, suggested that photographs be taken slightly out of focus, '*with slightly uncertain and undefined forms – to make them more artistically beautiful*'.

Thus for the would-be 'high-art' photographer, the primary goal was to resolve the biggest problem set by the camera – the photographic print's mechanistic surface. For a photographer who wanted to make fine-art nudes, for example, the camera's veracity meant that the gentleman connoisseur of the undraped female body was confronted not with the idealized form of the nude, but by a provocative nakedness all too real in its proletarian and hirsute glory. In other words, the bourgeois art fancier was being asked to make the acquaintance not of Danaë or Ariadne, or even of some admired if notorious courtesan, but of Miss Smith or Mademoiselle Gervaise.

The flight from this kind of awful reality was achieved generally in two ways. Firstly, fine-art photographers could look to higher things for their subject-matter, to painting and literature rather than unruly life, and they could create their images, like a painter, in the studio, using models as characters from the great works of fiction or art in these photographic *tableaux vivants*. The more technically skilled among them could fabricate elaborate concoctions by combining different negatives to make complex fictions that aped the 'higher' themes of painting. Secondly, they could mitigate the camera's mechanical nature. They could throw the image out of focus to varying degrees. Or they could employ many of the printing processes that were introduced as the century progressed, photo-mechanical processes like photogravure, which used inks and could allow photographs to be printed on art papers, or oil pigment, which required the use of a brush (or roller) and, therefore, could produce an image that actually looked like a painting or a drawing.

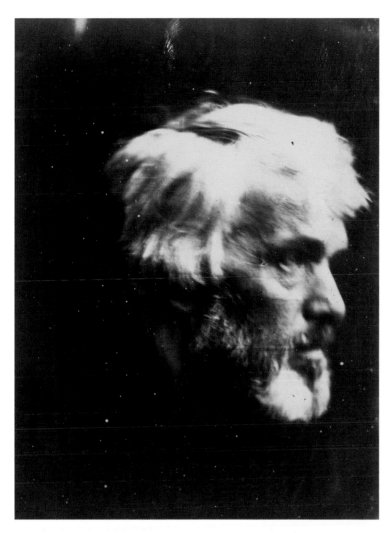

Julia Margaret Cameron (English, 1815–79)
Thomas Carlyle, profile 1867
Albumen silver print from wet-collodion negative

Julia Margaret Cameron broke all the rules of 1860s' photography, and was widely criticized for it. But by ignoring the accepted way of doing things, she made some of the greatest portraits of the 19th century. By all accounts, she bullied her sitters unmercifully. She went so close with her camera she couldn't get them in focus. Yet she made portraits that suggested the psychology of her subjects rather than their external aspect.

This famous portrait of the writer Thomas Carlyle is an image so blurred and out of focus that it is hardly more than a smudge. Its tonalities are so rudimentary that the picture consists of little more than sepia shadow and dirty yellow highlight, streaked with the careless application of the light-sensitive coating. Most people, getting such a result, would have thrown it in the dustbin.

But Mrs Cameron consistently did one thing that makes her almost unique among 19th-century portraitists. She filled the frame with her heads, and, whether in focus or not, that is enough to gain the viewer's attention. It creates a sense of psychological intimacy that a more distanced portrait lacks. Mrs Cameron knew this instinctively. So, a century later, did Diane Arbus.

She made two portraits of Carlyle, a side view and a frontal view. Both exude an energy that is irresistible, and totally at odds with the usual formality of the Victorian portrait. She suggested heroism and action in her portraits of men, while in her portraits of women it was intimacy and empathy. In equating men with action and women with repose, she reflected the conventional views of the time. But there was little else about her portraiture that was conventional.

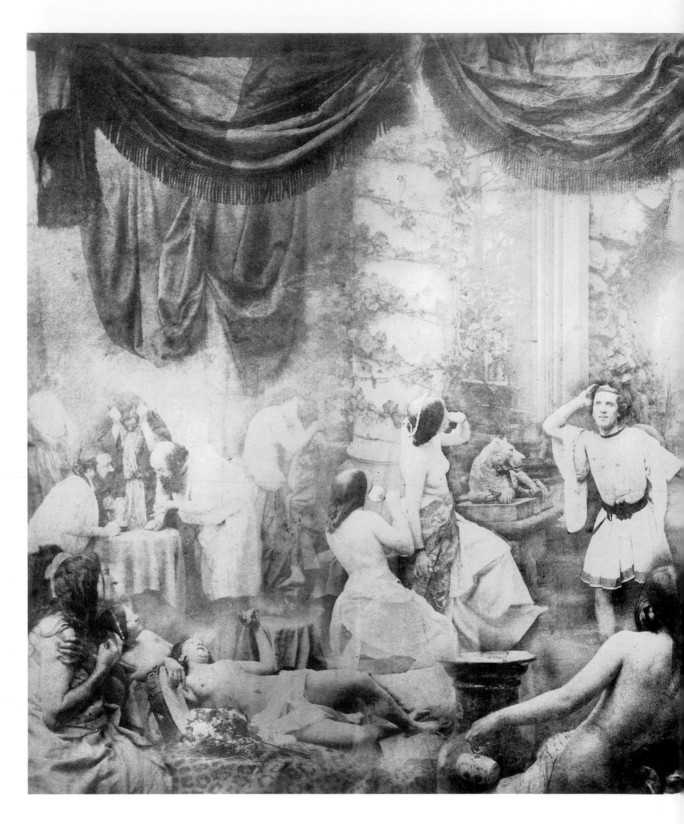

Oscar Rejlander (Swedish, 1813–75)
The Two Ways of Life 1857
Albumen silver combination-print from
wet-collodion negatives

Oscar Rejlander, an *emigré* Swede who had
opened a studio in Wolverhampton, first exhibited
The Two Ways of Life at the Manchester Art
Treasures Exhibition in 1857. The photograph had
been printed from a combination of over thirty
separate negatives and measured an impressive
79 x 41cm. It was an allegory of the two paths

through life, the ways of right and wrong. On the
right-hand side of the picture, Rejlander depicted
'Industry', on the left-hand side, 'Dissipation'.

The Two Ways of Life immediately became a
cause célèbre, not simply by virtue of its technical
achievement, or because of the impetus it gave to
the debate about truth and reality in photography,
but because eight of the thirty or so figures
populating the image were female nudes. True to
the spirit of 'morality' painting, these nudes were
situated primarily in the 'Dissipation' register.
The outcry, both for and against this display of

nudity, was considerable. But once championed
by Her Majesty Queen Victoria, Rejlander
was assured of a profitable outcome. The copy
she purchased was reported to have hung
in the Prince Consort's study, where he would
have been able to contemplate it at leisure,
and perhaps reflect that the figures on the
'Dissipation' side seemed to be having all the fun.

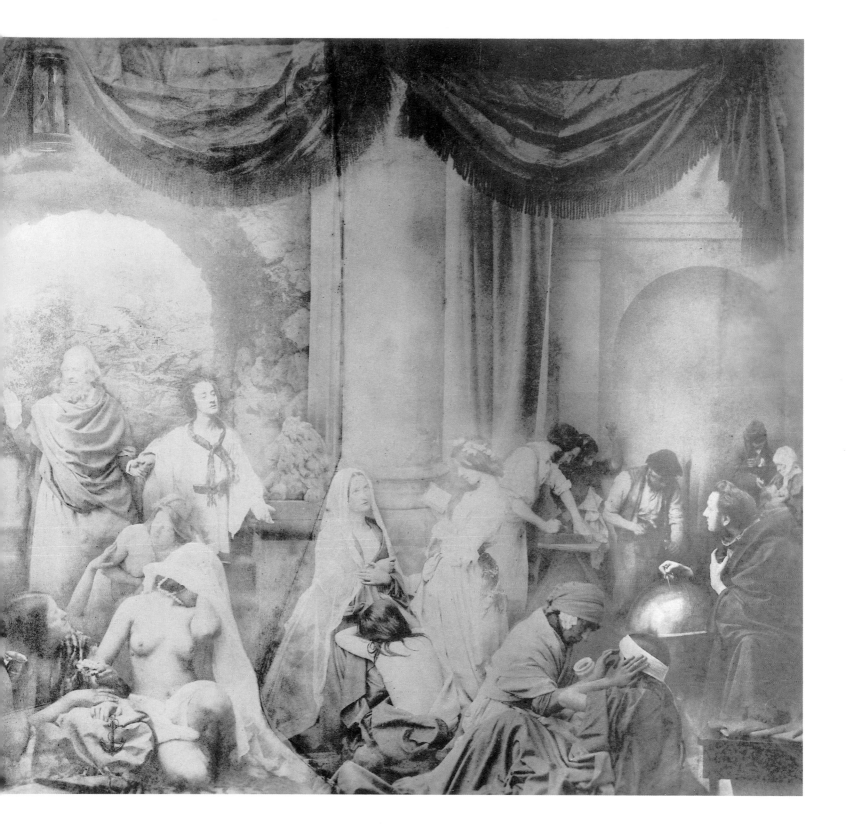

If Gustave Le Gray employed combination printing simply to 'improve' upon the natural landscape, Oscar Rejlander's use of complex printing techniques was even more ambitious. His photographic composition *The Two Ways of Life* sought to match salon painting not only in size, but in sentiment.

Photographs are taken, not made, and this presented a conceptual problem for those early photographers seeking to establish the medium's artistic credentials. Ambitious photographers, however, soon discovered the art of 'making' photographs. *River Scene, France,* by Camille Silvy, uses every manipulative device available to the ambitious photographer of the 1850s.

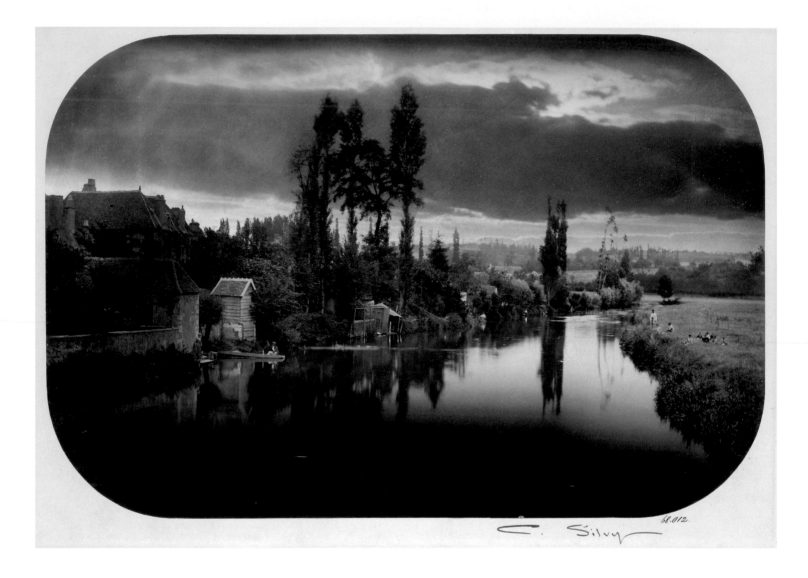

Camille Silvy (French, 1835–1910)
River Scene, France 1858
Albumen silver combination-print from wet-collodion negatives

Known primarily as a portrait photographer, Silvy also made highly regarded genre scenes and landscapes, of which this is the best known. It is a combination print with Silvy using cloud as well as 'land' negatives. But because there was some overlap and a visible join, he retouched the negative on the right-hand side to produce a horizontal white cloud that obscured the ugly junction. Not content with this, during printing he 'burned in' the edges and bottom of the print, 'holding back' the middle with an opaque mask so more light could pour on to the edges and make them darker, thus drawing the eye into the middle of the picture.

The result is an image which is as tightly controlled as any contemporary photograph that has been manipulated in a computer. Silvy began by making a documentary landscape, and then enhanced it so the photograph became a fiction, rooted in fact but close to the *plein air* landscapes of such painters as Camille Corot. Yet where the *plein air* painters sought to transcribe nature in a 'realistic' manner, Silvy's masterpiece is a superb example of a trend that has continued to this day, and which is probably on the increase as a result of the new computer technology. Not content with straight transcription, photographers look not so much to improve nature, but to declare that their intelligence is at work as much as the camera's.

In the mid-1850s, high-art photography was firmly established in the photographic societies and clubs, chiefly amongst the gentlemen (and lady) amateur photographers who held salons and exhibitions, patronized print-exchange clubs, and sponsored publications. Their two primary manifestos were William Lake Price's *A Manual of Photographic Manipulation* (1858), which was not only one of the first wholly aesthetic treatises on photography but in its title's use of the word 'manipulation' gives the high-art photographer's game away, and Henry Peach Robinson's *Pictorial Effect in Photography* (1869). Robinson's book, and his large tableaux, created from many negatives, with saccharine titles such as *Fading Away* and *She Never Told Her Love*, established him as the leading photographer and advocate of Victorian art photography.

But he was not responsible for probably the most famous example of 19th-century high-art *tableaux vivants*. This distinction goes to a Swedish immigrant to Britain, Oscar Rejlander, who in 1857 scored a notable *succès de scandale* with his large combination print *The Two Ways of Life*. Shown at an exhibition in Manchester, this allegorical image, depicting a sage guiding two young men towards manhood, provoked considerable controversy. The two halves of the picture symbolize good and evil, and the sage is trying to steer the youths along the path of goodness. The controversy was caused by the fact that several of the figures on the picture's left were nude, and such reality, however discreet, was considered shocking.

Despite such successes, the high-art movement had a somewhat limited influence, while the rest of photography went on its merry way. Only the art photographers themselves imagined they were the jewel in the crown of the empire of photography. Rejlander and Robinson have become footnotes, although important footnotes, in the history of photography, whereas a figure who emigrated from Kingston-upon-Thames to the United States, and who, like Fenton and Le Gray, was torn between the art and science aspects of the medium, has become one of the central figures in late 19th-century photography as it marched towards the modern era. His name was Eadweard Muybridge.

The contemporary equivalent of Rejlander's *The Two Ways of Life*, both in terms of their compositional technique and painterly ambitions, are the suburban American tableaux of Gregory Crewdson. Crewdson can stitch his negatives together using the magic of Photoshop, but to shoot his psychologically charged images he employs a battery of technicians on a scale worthy of Hollywood.

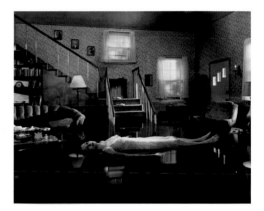

Gregory Crewdson (American, b. 1962)
Untitled (Ophelia) 2001
Digital (Type C) colour print
From the series *Twilight*

The *Twilight* series was shot in a Massachusetts small town, which Crewdson descended upon with a large production crew and a cast of actors to create scenes that might have emanated from horror or sci-fi movies. The work establishes an imagined suburban landscape that is both commonplace and strange.

Here, Crewdson's protagonist floats in her flooded living room, dressed in her lingerie. Her eyes are open, and her slippers are on the stairs, above the flood. She may be dead, but there is an ecstatic look on her face, and she is floating above the water rather than in it. As in many of Crewdson's tableaux, nothing makes sense and nothing is explained.

A clue might come from his background. His father was a psychoanalyst, who had his office in the basement of the family house. Crewdson's images, like Edward Hopper's, present psychological states rather than the real world. In Hopper's case, we could name perhaps loneliness, longing, anticipation or foreboding. Hopper's pictures, in their quiet way, were dark, but Crewdson's are even darker, so we are looking at such states as anxiety, alienation, confusion and dread. Crewdson's world, as indicated by all those figures either naked or in their underwear, suggests the dreams where we find ourselves wandering around naked in public. Whatever, his characters certainly do not seem to be having the fun enjoyed by Rejlander's dissipated women.

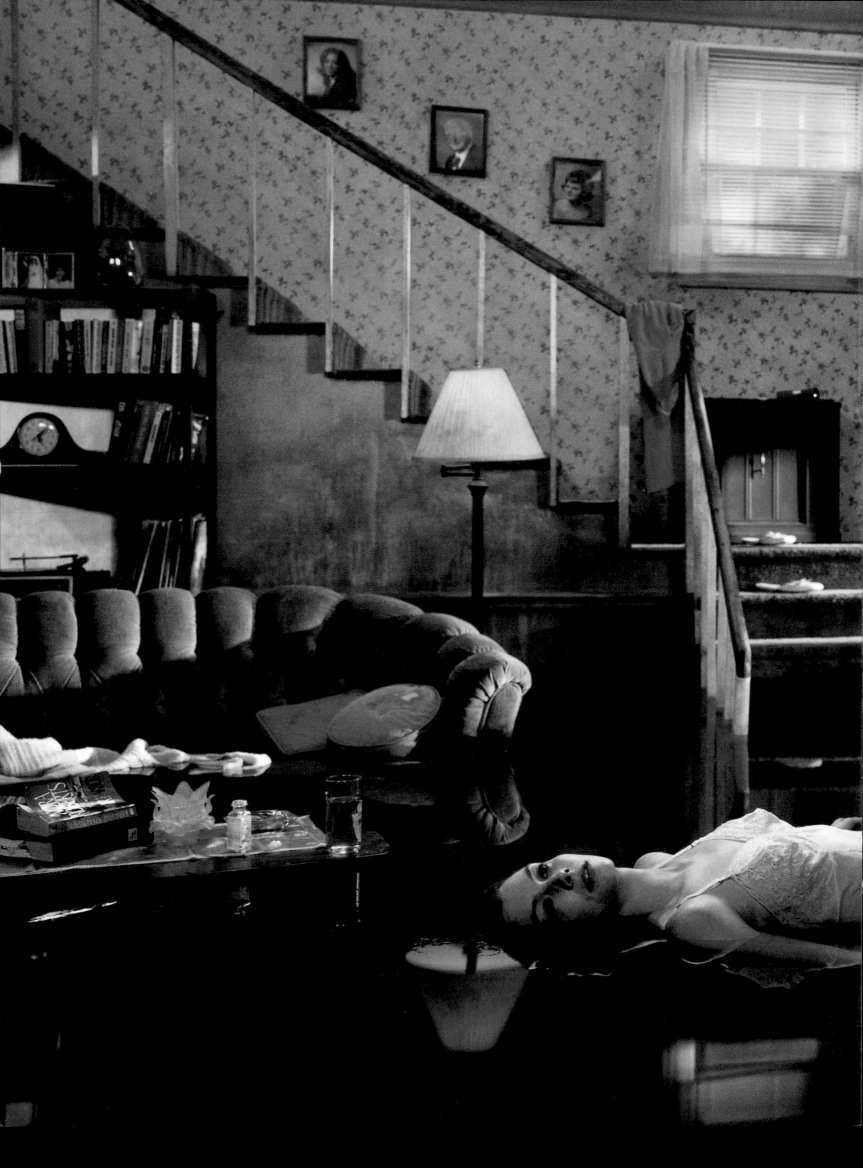

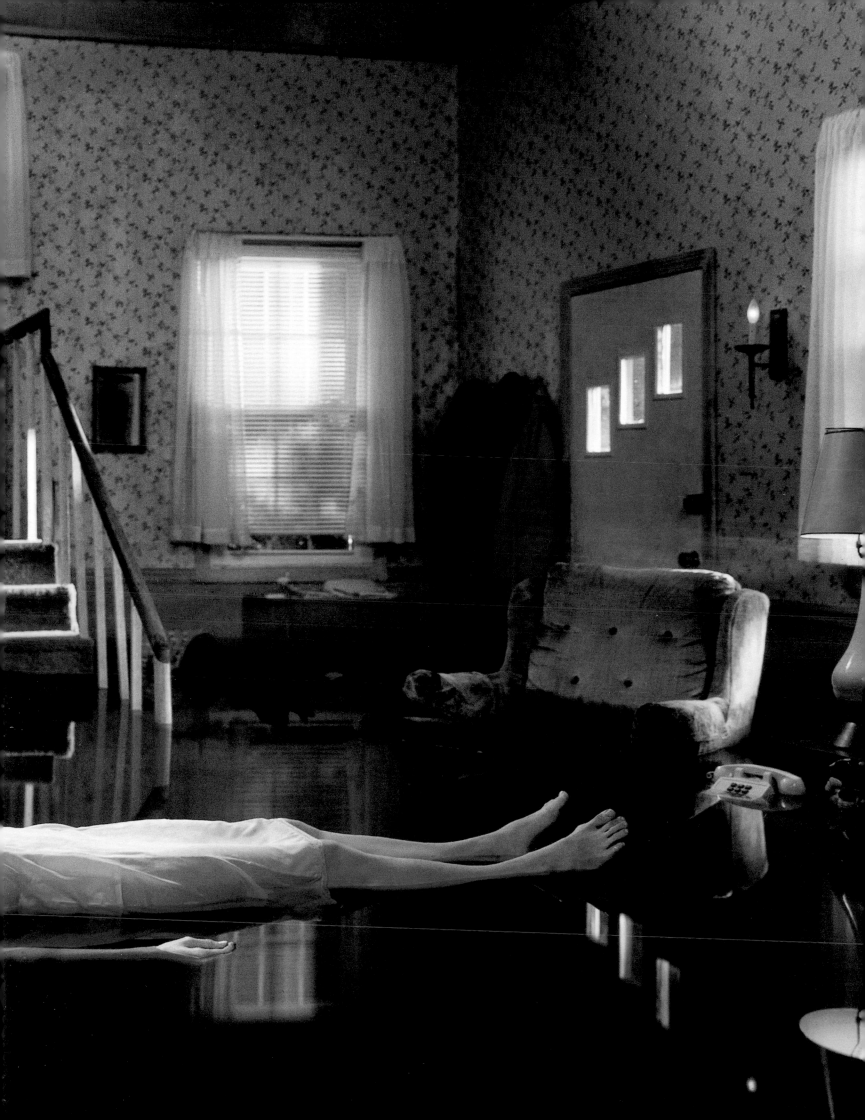

Bodies in motion

Muybridge is chiefly known for three bodies of work – firstly, early topographical landscapes taken in Panama, then grand, partly topographical, partly romantic landscapes taken in California, around Yosemite Valley, and, finally and most notably, a series of studies of animal and human movement made between 1878 and 1886. This last work resulted in the enormous 781-plate, eleven-volume publication *Animal Locomotion* (1887). Science, it seemed, was winning out over art.

In his momentous 1884–86 motion studies at the University of Pennsylvania, Muybridge was aided greatly by a technological advance made by a man who perhaps more than any other was responsible for modern photography. George Eastman's introduction of a cheap and widely available dry-plate process changed photography completely. Using prepared plates, it did away with the need for the travelling photographer to carry his darkroom with him, as was necessary for the wet-plate process, in which the plate had to be both coated and then developed on the spot, out of the light.

A good wet-plate photographer, working with large glass plates, would take around six to ten photographs on a hard day's shoot. With dry plates, he could take a hundred or more. Dry plates were also much more light sensitive, and so exposures were reduced to fractions of a second. The era of instantaneous photography had arrived. And, with Muybridge's sequences of humans and animals in motion as a spur, it was not long before 'moving' pictures became a reality, and the cinema was born.

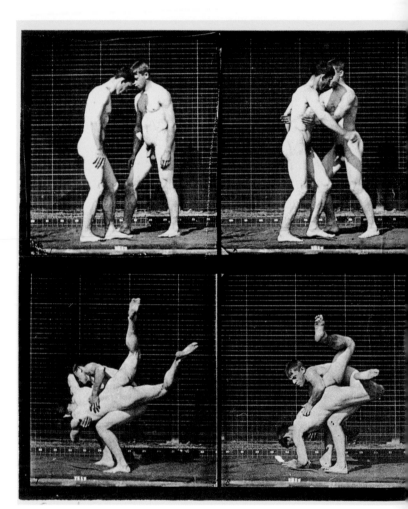

Eadweard Muybridge's multi-volume *Animal Locomotion* (1887) is one of the most significant photographic books of the 19th century, a series of sequential movement studies that contributed to the development of the motion picture. And yet its science is open to question. Muybridge missed out or repeated images in many sequences, rearranging them to create more aesthetically pleasing results.

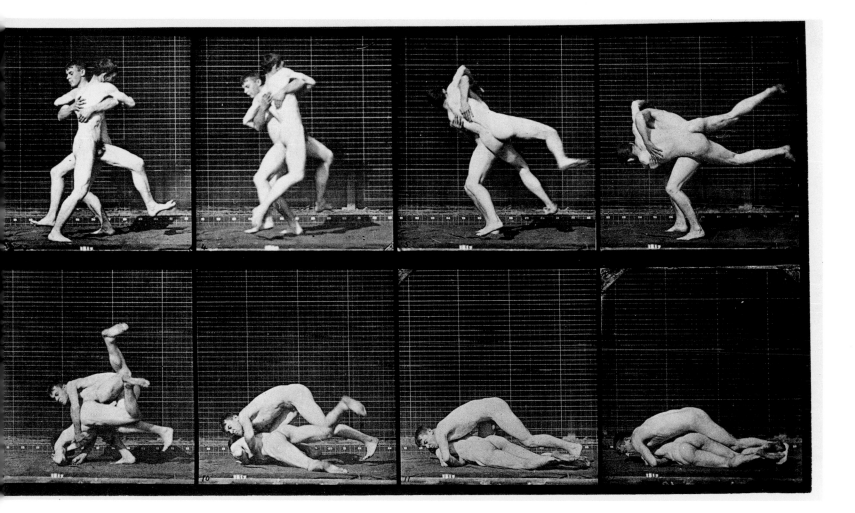

Eadweard Muybridge (English, 1830–1904)
Wrestling, Graeco-Roman
Collotype
From *Animal Locomotion* (plate 347) 1887

Muybridge, originally from Kingston-upon-Thames in southern England, was a photographer of landscapes in the American West when Leland Stanford, builder of the Central Pacific Railroad and horse breeder, commissioned him to study the movements of a trotting horse. Muybridge arranged an elaborate battery of cameras with rapid-shutter mechanisms attached to strings stretched across the racetrack at Stanford's Palo

Alto stud farm. With the horse tripping the shutters as it passed, he obtained a series of images proving that a horse has all four legs in the air for a fraction of a second while galloping. The railway magnate declined to subsidize further experiments, but the painter Thomas Eakins, intrigued by Muybridge's work, persuaded the University of Pennsylvania to fund him. Between 1884 and 1886, Muybridge produced twenty thousand negatives of people and animals in motion, published in 1887 in *Animal Locomotion*.

Scientific accuracy is not the only issue the work raises. There is also the issue of nudity.

It could be argued that it was necessary, as this was a medical study. But, given 19th-century strictures on sexual matters, scientific necessity cannot be the sole reason. It is clear, from the way Muybridge arranged the sequences, that their purpose was to stimulate as well as inform. Their potential to stimulate the erotic imagination as well as the aesthetic cannot be discounted. This must surely be why, in part at least, Francis Bacon and other artists were fascinated by Muybridge long after more accurate studies of movement were made.

Peter Henry Emerson was one of photography's great polemicists, firstly arguing for photography as a major artform. He then recanted, deeming it a minor artform at best, but not before putting his theories into practice and making one of the great photobooks, *Life and Landscape on the Norfolk Broads.*

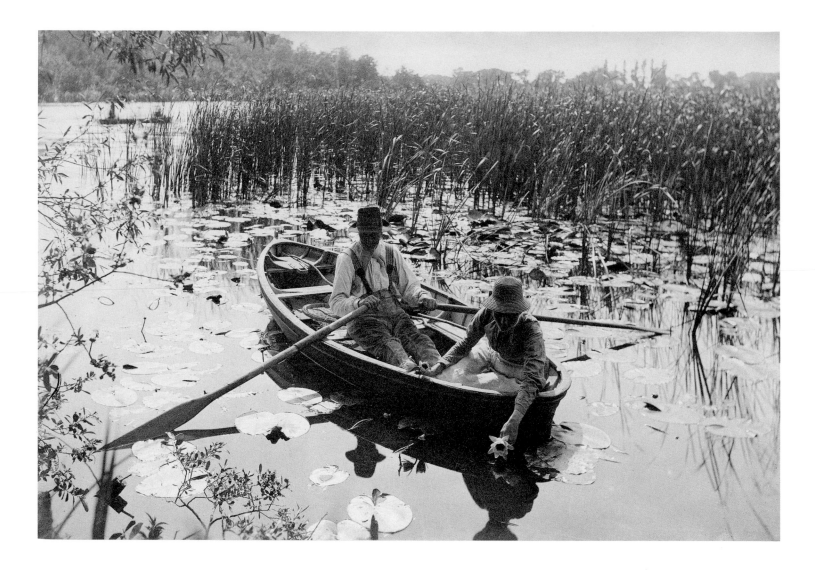

Peter Henry Emerson
(English, b. Cuba, 1856–1936)
Gathering Water Lilies 1886
Platinum print
From *Life and Landscape on the Norfolk Broads*
1886

In 1885, Emerson published *Naturalistic Photography,* an attack on Henry Peach Robinson and the pseudo-painters with their studio tableaux. Emerson argued for a photography that allowed the camera to view the world as the eye 'naturally' sees it. But his argument was that the human eye does not see everything in sharp focus. It focuses selectively, so the camera must do the same. The result was just another kind of photograph to please those who believed the sharper the image the less artistic it was.

Life and Landscape, made with T. F. Goodall, was illustrated with original platinum prints. It had an extensive text detailing the lives of those who made a living from the Norfolk Broads, like this couple gathering water lilies. The text talks of hard and bitter lives, but the pictures tend to belie these facts. Yet they are magnificent photographs, and in its way this is a documentary book. A valuable, if sentimental, record of a vanished way of life, it is carried out with genuine feeling. It is also a marriage of words and images, and the texts – part sociological, part anecdotal, mythical and empirical by turns – are a not inconsiderable part of the book's success.

John Szarkowski has argued that Emerson's theorizing about photography's artistic status caused a long-term rift between amateur and professional, to the medium's detriment. This may be true, but Emerson's own splendid photographs suggest that, when it comes to photographing, photographers are better using their eyes rather than theories.

The snapshooters

In 1888, George Eastman's Kodak Company of Rochester, New York, introduced another momentous step along the road to modern photography. The No. 1 Kodak camera came loaded with 'American film', a roll of paper coated with light-sensitive emulsion. Users could take a hundred pictures, and then send the camera back to Rochester, where the film would be developed and printed, and the camera reloaded and returned with the prints.

This was a proletarian revolution in photography. Previously, photography had been an expensive and rather complicated craft, requiring a fair degree of scientific knowledge. Now anyone could do it, quickly and cheaply without the necessity for tripods and complicated equipment. '*You press the button, we do the rest*': Kodak's famous slogan encouraged people to carry cameras around and photograph anything that caught their eye. The pictures, known as 'snapshots', and therefore reinforcing the idea of spontaneity, were circular and 6.35cm in diameter (see right), although later models eventually changed the format to the rectangular prints we know today.

This revolution not only changed photography socially, it changed art photography – not that art photographers, or pictorialists as they became known, would have acknowledged the existence of snapshooters beyond pouring scorn upon them. Now that the craft mystique had been exploded, pictorial photographers were driven further into the cul-de-sac of complicated hand-crafted photographic techniques. On a more positive note, the spontaneity of hand-held camera images crept into pictorialism, and, with that, an insidious invasion of modern, and therefore 'baser', motifs into art photography. But in general, as John Szarkowski has noted, the reaction of the serious, arty photo-amateur to hand cameras was one of despair:

> *It was a common article of faith that art was hard and artists rare; if photography was easy and everyone was a photographer, photography could hardly be taken seriously as an art.*

However, pictorialism did not go down without a fight. Indeed, the pictorialist impulse – to ignore the basic implications of photography – is with us today in many forms. As Pablo Picasso once maliciously observed of photographers, many still feel ambivalent about their medium: '*Every dentist would like to be a doctor, and every photographer would like to be a painter.*'

In 1901, in his book *Photography as a Fine Art*, Charles H. Caffin certainly agreed with such sentiments and made the old aesthetic–utilitarian (art–science) distinction, citing the following categories of subject-matter as 'utilitarian', and therefore outside the remit of the fine-art photographer – photography '*of machinery, of buildings and engineering works, of war-scenes and daily incidents used in illustrated newspapers*'. Art photography was once more shying away from the realities of contemporary life, retreating to romantic landscapes and moralizing genre scenes.

Caffin was fighting a losing battle, however, not least against some of the leading photographers of the pictorialist school themselves, and in particular its chief spokesman, Alfred Stieglitz, of whom Caffin had been a disciple. Stieglitz is undoubtedly, along with George Eastman, one of the two figures most responsible for modern photography. As George Fisher, a former CEO of the Eastman Kodak Company itself, once said, with admirable succinctness:

> *George Eastman put snapshots in wallets – Alfred Stieglitz put photographs on museum walls.*

At first, Stieglitz was not enamoured of Mr Eastman's snapshots or of the hand camera, but by the early 1890s he had begun to use one to make photographs of everyday life on the streets of Paris and New York, frequently photographing the cities at night and in bad weather. In an 1897 article, '*The Hand Camera – Its Present Importance*', he wrote: '*A shutter working at a speed of one-fourth to one-twenty-fifth of a second will answer all purposes. A little blur in a moving subject will often be an aid to giving the impression of action and motion.*'

Blur was also useful in mitigating the mechanical surface of a photograph, of course, but in this important article Stieglitz was beginning to define the modern photographer – the wanderer with an unseen camera, a stalker and a hunter after images, not of exalted subjects but everyday life in the modern metropolis.

Although modernity and the city had been subjects for the vernacular and documentary camera ever since the medium's invention, it was not until the 1890s and the fast-approaching millennium that they became acceptable themes for art photographers, partly because the notion of modernity was in the air, and partly because the new, faster, hand-held cameras provided a way to photograph the contingent and the everyday. The motor car and the skyscraper became potent symbols of the new, dynamic century. The machine age had dawned, and the city would become the primary subject of 20th-century photographers.

As pictorialism gradually segued into modernism, photographers in New York began to photograph the hustle and bustle of the city streets, and, above all, America's most distinctive symbol of modernity – the skyscraper.

Edward Steichen
(American, b. Luxembourg, 1879–1973)
The Flatiron 1904, printed 1909
Gum bichromate over platinum print

The most advanced pictorialists – such as Alfred Stieglitz and Alvin Langdon Coburn – were drawn to New York's first landmark skyscraper, the Flatiron Building, but Edward Steichen's interpretation topped them all. The Flatiron, on Twenty-third Street and Broadway, was so called because on plan its shape was that of a domestic iron of the time. Only twenty-three storeys high, its curved prow (the point of the iron) lent it a unique distinction.

In 1903, Stieglitz photographed it in the snow, contrasting the vertical form of the building with a slender tree trunk. In 1912, Coburn photographed the building at dusk, against a pattern of branches and a prominent street lamp; in the foreground are the blurred, scurrying figures of office workers at twilight. Dusk also features in Steichen's photograph, the most sumptuous of the three, indeed one of the most sumptuous photographs ever made. He contrasted the modernity of the building with the antiquity of a foreground hansom cab.

Steichen made only three prints, using the complicated printing method of gum bichromate over platinum to put colour into an essentially monochrome picture. He varied the base colour of each image by adding layers of pigment suspended in a light-sensitive solution of gum arabic and potassium bichromate. The painterly antecedents are clear. Its composition, like that of the Stieglitz version, owes much to the Japanese woodcuts of Hiroshige, and in its monochromatic colour and mood, perhaps the nocturnes of Atkinson Grimshaw or James McNeill Whistler. In both conception and technique, it is probably the ultimate expression of the pictorialist aesthetic.

Alfred Stieglitz's career marks a steady progression from the soft-edged painterliness of pictorialism to the hard-edged photographic precision of modernism.

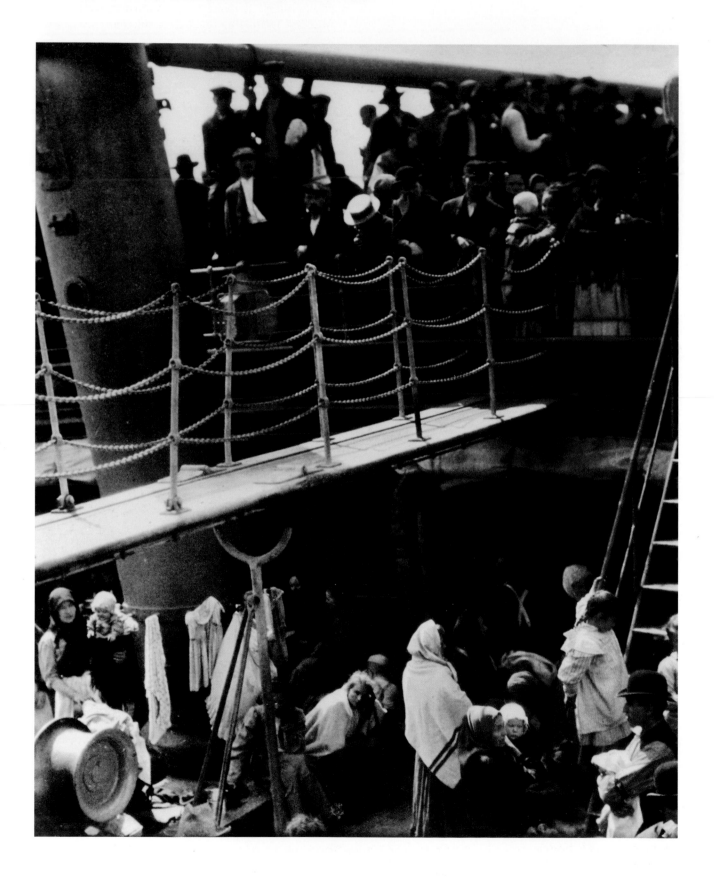

The Steerage is located at a point roughly halfway along that journey, retaining something of pictorialism's fuzziness, but treating a modern subject in a modern way.

The poetic possibilities of facts

Stieglitz was not just a photographer. He was a tireless champion of photography and modern art, a strange mixture of conservative and radical. In 1903, he began publishing his own quarterly magazine, *Camera Work*, a vehicle for his decidedly firm views. In 1905, he founded a gallery – first known as the Photo-Secession Gallery, then 291, and finally An American Place. In it, he not only showed contemporary photographs but the work of avant-garde European artists, such as Picasso, Matisse and Rodin, and later artists of the young American School, such as Georgia O'Keeffe and Marsden Hartley.

His vision for photography gradually changed, moving from pictorialism and the aping of painting modes to a purist position in which he held that photography had a vocabulary of its own, related to the fact that it was a direct transcription of reality. The photographic artist must not interfere with this process – indeed, it was the photographer's task to make this transcription as direct as possible. But by means of his inherent vision, his 'seeing', he would transcend mere transcription and explore the poetic possibilities of facts. As Charles H. Caffin had put it, the camera '*will record facts, but not as facts*'.

Stieglitz continued to publish his magazine *Camera Work* until 1917, finishing with a double issue in which he presented the work of a young photographer named Paul Strand, who he thought represented the future of photography. Stieglitz's introduction was typically understated:

> *The work is brutally direct. Devoid of all flim-flam; devoid of trickery and of any 'ism'; devoid of any attempt to mystify an ignorant public, including the photographers themselves. These photographs are the direct expression of today.*

Three different bodies of work by Strand were shown in *Camera Work*. Firstly, there were city scenes, usually showing modes of transport and people on the move. Secondly, there was a series of abstract still-lifes, photographs of common objects and shadows in which space and scale were indeterminate, in the manner of a Cézanne or cubist still-life. And thirdly, most startling of all, there were a number of close-up, candid portraits of poor people on the New York streets, taken not to make a social point but an aesthetic one. One image especially, of a blind woman, remains one of the most shocking photographs ever made, a picture of unprecedented directness.

Alfred Stieglitz (American, 1864–1946)
The Steerage 1907
Photogravure

In 1907, Stieglitz was travelling to Europe on the liner *Kaiser Wilhelm II*. From a vantage point on the first-class upper deck, he saw passengers crowded into two levels of the steerage decks:

The scene fascinated me: A round straw hat; the funnel leaning left, the stairway leaning right; the white drawbridge, its railings made of chain; white suspenders crossed on the back of a man below; circular iron machinery; a mast cut into the sky, completing a triangle. I stood spellbound for a while. I saw shapes related to one another – a picture of shapes, and underlying it, a new vision that held me.

The new vision was a formal one. Modernist photography is about the frame and the way elements are disposed within it. That is, it is about the photographer expressing him or herself. Stieglitz was inspired to take *The Steerage* because he recognized a felicitous arrangement of forms – a potential picture.

But that did not mean he was either devoid of feeling for his subjects or that the social meaning of the photograph as an image of modern life escaped him. The title connotes class, but there is also an element of gender, with men on the upper deck and women on the lower. The picture's formal layering thus reflects society's class and gender layering.

In later years, Stieglitz felt that *The Steerage* was the photograph which, above all others, represented what he was about – capturing with his camera perfectly related shapes that communicated both intelligence and emotion.

What Stieglitz and Strand were ushering in was photographic modernism, a photography that fully accepted the unadorned realism of the medium, yet used it aesthetically to make an art photography that looked superficially like documentary photography but had quite different intentions, partly formal, partly metaphorical and allusive – '*facts, but not as facts*'.

This approach became known as 'straight photography'. Reviewing a Strand exhibition in 1916, Charles H. Caffin extolled its virtues:

> *There has been no tampering with the negative, nor have any alterations been made at any part of the process between the snapping of the shutter and the mounting of the picture.*

No tampering. This became an article of faith with the early photographic modernists, especially in the United States. Modernist photography developed somewhat differently in Europe – as we will see in Chapter Two – but for American modernists the purity of the medium was paramount. Image sharpness and tonal quality were also important, and there was almost a fetish about obtaining the 'fine' print, one in which tonal values shone like a jewel. After three-quarters of a century, art photography finally adopted the aesthetic of the daguerreotype.

Inspired by the work of both Stieglitz and Strand, a young photographer on America's West Coast, Edward Weston, abruptly changed tack in the mid-1920s. Having achieved some success by employing a soft-focus pictorialist approach, Weston suddenly threw that over for the new hard-edged style. Like many modernists, he tended to favour abstraction (at least early on), seeing it as an arena where the formal, metaphorical, even mystical overtones he sought would not be sidetracked by too much intrusion from the 'real' world.

He obtained his effects by isolating his subjects – the human body, vegetables, rocks – in close-up, thus bringing out their physical and metaphorical qualities. It was said that he photographed rocks like people and people like rocks. His most famous picture is *Pepper No. 30* (1930), a close-up of a voluptuous, suggestive pepper. Quite what it is suggestive of is open to conjecture, but that is the point. Weston himself explained it, and the whole object of such photographic modernism, as follows:

> *It is classic, completely satisfying – a pepper – but more than a pepper, in that it is completely outside subject matter.*

In such images, photography had at last become, it would seem, a fully fledged modern art on a par with painting. The empire of photography had expanded – or perhaps shrunk – to become the world in a grain of sand.

Edward Weston (American, 1886–1958)
Pepper No. 30 1930
Gelatin silver print

A photographer of a very different cut to Weston, Walker Evans, once said that he wanted his photographs to be '*literate, authoritative, and transcendent*'. *Pepper No. 30* exemplifies those tenets to perfection. It is a literate and certainly authoritative pepper, a very model of a perfect pepper. We are asked decisively to consider the whole notion of 'pepper'. Weston followed the modernist call for clarity by using a large-view camera and contact printed the 20.3 x 25.4cm negative for maximum clarity. So this pepper is so real as to be almost hyper-real, rendered slightly more than life size.

And the transcendence? Here, Weston seems to combine two traditions. Firstly, the transcendent tendency in much American art, in which the divine or the spiritual is discerned within objects. '*Not the poetry of a poet about things, but the poetry of things themselves*', as poet and philosopher George Santayana put it.

Secondly, Weston tapped into the formal symbolism certain European abstract painters sought around that time. Although this is clearly a pepper, other readings are suggested. It could be a rock, confirming the interdependence of all natural things. Or, as many have contended, a body, or two intertwined bodies. It certainly is the most sensuous pepper ever photographed, although Weston denied any erotic connotations.

But however we read it, and the reading is in the eye of the beholder, Weston surely achieved his goal of creating a modernist masterpiece. And what happened to his most renowned model? Apparently it ended up in a salad.

Edward Weston's *Pepper No. 30* (1930) is one of modernist photography's icons because it demonstrates precisely what the straight modernist approach is all about. As Weston modestly wrote of this magnificent photograph in his daybooks: 'It is classic, completely satisfying – a pepper – but more than a pepper'.

development and the quality of his or her 'eye'. If a photographer's primary intention was to make art, so much the better, and it was, therefore, the high modernist art photographers, such as Alfred Stieglitz and Edward Weston, who were generally placed at the pinnacle of the museum's canon of 'greats'. Anyone given the accolade of a one-person show at MoMA was well on the way to being considered for inclusion in the canon.

There was, it is true, one telling detail about the mounting of the Lartigue exhibition, and it represented both a practical and a philosophical consideration. For the images' change of context, from private to public, from family album to art museum, professionally enlarged prints were made, and Szarkowski hung the pictures in rows, exactly as one would hang an exhibition by Edward Weston, though it is unlikely Weston would have approved. He once wrote scornfully (in an earlier era) about '*hundreds of tired businessmen or tradesmen and idle women who play with photography as a holiday hobby – and then offer the results as "art"*'.

Nevertheless, however displayed, a deliberate challenge like the showing of Lartigue's snapshots at MoMA raises a number of questions. Firstly, if formal consideration predominates when judging photographs – how well they are composed, their lighting, timing, and so on – does that diminish the importance of their subject-matter? Whether one chooses to photograph white horses or atrocities in Iraq is surely a fundamental choice on the part of a photographer. Secondly, since Lartigue's photography was totally intuitive, was his work simply a series of unplanned accidents? And who should judge its aesthetic merit anyway? What makes Lartigue's work better than another snapshooter's, and what does the whole business of elevating an amateur – a child – to equal status with professionals say about photography as an art?

In Szarkowski's own view, he certainly was not negating the content of Lartigue's photographs. For him, a photograph 'works' or doesn't work in formal terms, and it works – or not – irrespective of content. There is a clear link between the two, which might be defined by saying that form is at the service of content. But content, equally, is at the service of form. And if art is defined by intention on the part of its maker, then there was as much intentionality in the work of Lartigue as in the work of Weston, though the intention was clearly of a different order. There was a consistency about the way Lartigue did things. He discovered that the camera could suspend people and animals in mid-air. He liked the effect and used it again and again. That is what photographers mean by developing a consistent vision.

Two years later, in 1966, Szarkowski was looking at the snapshot once more. His exhibition *The Photographer's Eye* took photographs from all periods and of all kinds, from art to commercial to snapshots, and investigated their formal similarities in order to explore a common language of photography. Taking five categories – The Thing Itself, Detail, The Frame, Time and The Vantage Point – his aim was to show how vastly differing kinds of photography either consciously or unconsciously use these basic elements to make successful photographs. As he wrote, the exhibition was concerned '*with photographic style and photographic tradition; with the sense of possibilities that a photographer today takes to his work*'.

By including snapshots and everyday commercial photographs in the exhibition – 'vernacular' photography as it is called – alongside established 'greats' of the medium, Szarkowski was again making a strong statement about the art of photography. In one sense, his approach negated the long road from 19th-century art photography to modernism. Yet, in another sense, by considering all photography aesthetically, he was validating the modernist view. Of course, 'decontextualizing' or changing a photograph's context, in this case by regarding snapshots in an aesthetic sense, enrages anti-modernist theorists, because considering photographs in primarily formal terms tends to obscure their other meanings – the significance of their subject-matter, for instance, or the socio-cultural circumstances of their making.

But what became known as the 'snapshot aesthetic', the somewhat unplanned look of snapshots, was important to Szarkowski for two reasons. First, it related to the basic impulse at the root of photography – its ABC, one might say. Our essential impulse is to point, shoot and collect that memory trace, which is why Szarkowski could write in all seriousness:

Photography in the hands of amateur practitioners [holds] *the greatest potential for isolating the aesthetic values intrinsic to the medium.*

Second, during his first decade at MoMA many serious, ambitious photographers were trying to work in that spontaneous, open way.

Szarkowski's exhibitions of both 'real' snapshooters and professionals working in the snapshot mode further increased interest in this humblest form of photography. Photographers learned from it and applied it to their own practice. With the result that today the snapshot is appreciated, studied and collected, and the snapshot mode is an integral part of photographic expression.

And Jacques-Henri Lartigue? When he grew up, he learned more about photography and became a 'better' photographer, but he never made better photographs than those joyous images he took in the halcyon years of his childhood.

189

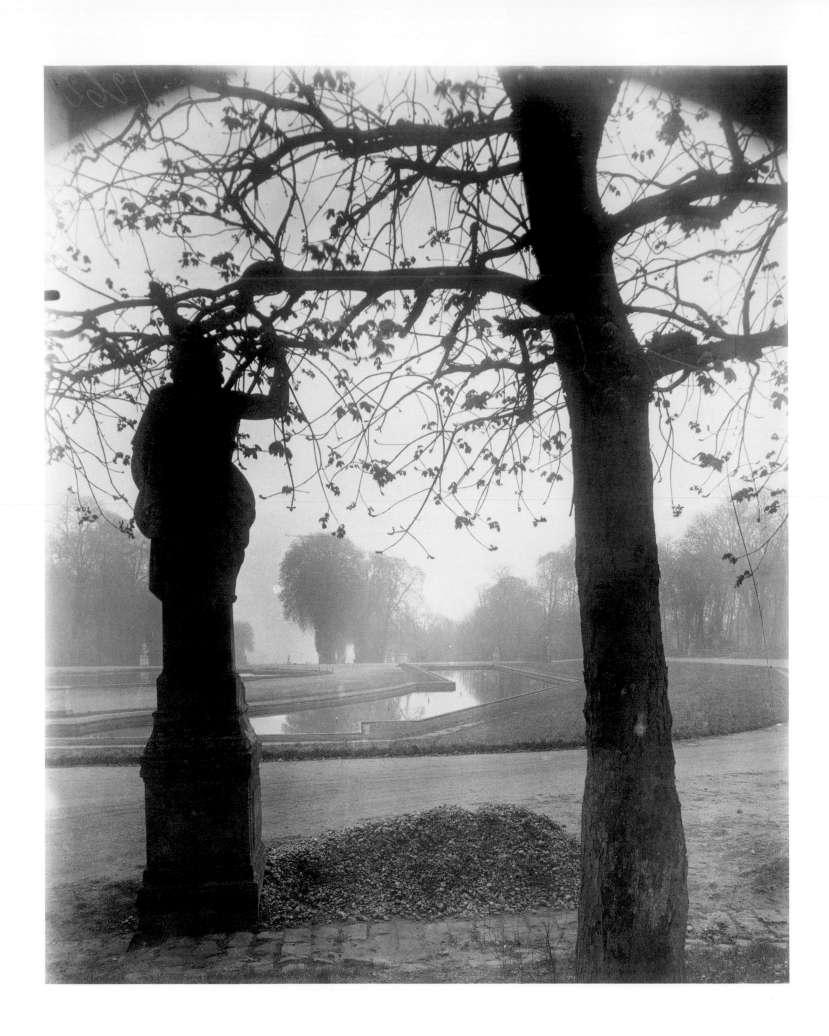

Prelude
The best example of what a photographer might be

Some forty years after his death in 1927, director John Szarkowski did a 'Lartigue' on Atget. New York's MoMA had bought about six thousand Atget negatives and prints, and, over more than a decade, mounted exhibitions and published five monographs on his work.

Certain critics see this – just like the Lartigue exhibition – as an example of false consciousness on the part of the museum establishment but there is a crucial difference. Atget, one-time photographic journeyman or not, stands at the heart of what we know photography to be. He is a bridge between 19th- and 20th-century photography, between documentary and modern art photography, between self-consciousness in photography and the vernacular. His work, unlike Lartigue's, was an inspiration to some of the 20th century's best photographers – from Walker Evans to Berenice Abbott to Bill Brandt and succeeding generations. Compared to them, Atget might indeed have been a tradesman, but as critic Max Kozloff has written:

> The viewer of these images falls prey to a loveliness unbounded by any consideration of trade.

During his lifetime, Atget was discovered by photography's avant-garde because he lived in the same Montparnasse street as the American surrealist and photographer Man Ray. Man Ray saw unconscious surreal properties in Atget's pictures and had him published a few times in La révolution surréaliste. But it was a young assistant of Man Ray's, Berenice Abbott, who considered the directness and honesty of Atget's vision accorded with her notion of the straight, modernist documentary ideal. When Atget died in 1927, Abbott and a friend, Julien Levy, bought half the contents of his studio. It was this that ended up at MoMA in 1969.

Like literature, photography abounds in what is termed the 'intentional fallacy', which argues that an artist may intend one thing and actually achieve another. D.H. Lawrence put it differently: 'Trust the tale, not the teller.' Atget may not have realized his achievement in any coherent sense – his work was an inventory of objects and not an artistic œuvre – and yet each time he looked into the camera he knew exactly what he was doing, and that at the very least has provided photographers with an encyclopaedia of how to compose photographs in dynamic, interesting and unexpected ways. But that is not all. To quote Max Kozloff again:

> If an Atget image were endowed with all the [formal] grace in the world, but bereft of Atget's time-honoured sense of the world, we would not recognise or care that the image is his. It would be truly soft in content, regardless of how well masses are arranged within the frame.

Clearly, despite the disapprobation of those who hate his elevation to photography's pinnacle, Atget has been, and is, a touchstone for photographers. So just what is it that he touches upon?

Atget's work represents in so many areas what, for serious photographers, is the essence of photography. It begins with the notion of the photograph as a memory trace and the kinds of associations that can throw up. Atget used 19th-century methods, a large camera upon a tripod and lengthy exposures, so his Paris streets, like Daguerre's, are largely devoid of people – empty stage-sets – or, as the critic Walter Benjamin contended, scenes where crimes had been committed. He talked of the 'infernal emptiness' of Atget's pictures. This sense of the mysterious, the uneasy, taps into photography's inherent surrealism and also its incipient melancholy.

The French photographer Eugène Atget made no artistic claims for his pictures, selling them to government archives or private clients who wanted them as visual references. Calling them simply 'documents for artists', he no more thought of them as art than did the young Lartigue his snapshots. But his ten thousand photographs of Paris – its streets, architecture and parks – represent for many the essence of the photographic art.

Eugène Atget (French, 1857–1927)
St Cloud, March, 9 in the Morning 1921
Albumen silver print from dry-plate negative

We are also made aware of photography's relationship with history in Atget, although history slips in and out of his pictures in different ways. He photographed a disappearing world, an old Paris rather than a 'modern' Paris, and much of this has now totally disappeared. His streets are generally unpeopled, but there is a powerful sense of lived lives in his work. Fascinatingly, there is also a vivid sense of his own life – though concerned with selling his pictures, he photographed a Paris that seemed peculiarly his own. This is particularly relevant for young photographers today, many of whom are concerned with telling their own tales as well as those of their subjects.

Atget engages with what is probably the central theme of 20th-century photography – the city – and does so in a way that is both objective and subjective. His pictures have an immediacy that is more unusual in photography than one might suppose. We often feel that we can walk into them. And his images collectively give a sense of the way he moved around from district to district. We see the city very much through his eyes, for his documentation of it, although the basis for his livelihood, was quite particular and frequently unrelated, it appears, to his commercial practice. What he did not photograph – the Eiffel Tower, for instance – is as important as what he actually photographed. The late pictures are very different from the early ones, and it would seem that he began his career as an everyday working documentary photographer, nothing more, and then

something gradually gripped him. One feels – and it is never overt or articulated – that his own vision of Paris rather than his clients' became increasingly important to him, until photography became the place where he most fully touched the world. We are brought into direct contact with a real Paris and a Paris of Atget's imagination.

Above all, Atget confirms that photography is an accumulative, collective medium. It began as a way of collecting the world, and still functions extremely effectively in that role. Fine individual photographs are all very well, but the most vital bodies of work in photographic history have been, so to speak, one giant photo-essay, those that have tended to survey a world or a theme, incorporating all the complexities that might entail, as in a novel or a film. Berenice Abbott called a book she published on Atget *The World of Atget*, a pertinent title because Atget's work is a world, a world we can enter and explore, yet also an unknowable, secret world, and that is inexhaustibly fascinating.

Perhaps John Szarkowski, one of Atget's great advocates, summed him up best, back when MoMA held a first exhibition of their prize acquisition in 1969:

What Eugène Atget was, without doubt, was a photographer: part hunter, part historian, part artisan, magpie, teacher, taxonomist and poet. The body of work he produced in his thirty working years provides perhaps the best example of what a photographer might be.

Eugène Atget (French, 1857–1927)
Boulevard de Strasbourg, Corsets, Paris 1912
Albumen silver print from dry-plate negative

2

The *Film and Photo* exhibition (known as FiFo), held in Stuttgart in 1929, included the work of Eugène Atget.
But the show's expansive programme also embraced the leading Russian avant-garde artist, El Lissitzky.

His famous self-portrait *The Constructor* is intended to be an image of the modern artist.
The model is, of course, Lissitzky himself, ideal man of the 20th century.

El Lissitzky (Russian, 1890–1941)
The Constructor 1924
Photomontage

Lissitzky's vision for photography was both anti-pictorialist and multi-faceted. Above all, photography was to be at the service of the proletariat, part of the modernist revolution in which all art would act as a catalyst for social change. The artist, as Margit Rowell has written, would function firstly *'as a "worker", comparable to the proletarian worker, and eventually as a "constructor" or "engineer". The notion of art as the expression of individual genius was officially proscribed, and replaced by an art that would be politically effective, socially useful, and mass produced'.*

Photography would play a vital role in the new society. It would be both proletarian artform and mass medium, combining with typography and graphic art to maximize its potential as a means of communication. Lissitzky's brief sojourn in Germany during the 1920s brought him into contact with the most advanced techniques in advertising, a capitalist strategy he put to full use in propaganda upon his return to Russia.

The Constructor, one of several self-portraits he made in 1924, became an emblematic image for Lissitzky. In this key modernist statement, head, hand and instruments are collaged to introduce the future man. Vision passes through the eye to the hand, which holds a compass to trace the scientific basis for the new world order. But Lissitzky, it seems, cannot shake off his own genius. The circle also traces a halo, proclaiming him a saint or prophet of the future.

Political tools for political animals

FiFo was an exhibition calculated to make an important statement about modern photography, and it brought together leading modernist photographers from the United States – Edward Weston, for instance, with some of his purist abstractions – and from Europe. But the Europeans had been forging a different approach to modernist photography, one that became known as the 'New Vision'.

The European view tended to be broader than the American, which was firmly based around art and formalism, and the importance of the 'fine' framed print hanging in a gallery. In Europe, photography was regarded much more as a cultural force, and a socially progressive one at that. In modern art generally, old bourgeois precepts of 'fine art' were being replaced with an art based upon popular culture rather than 'high' culture. And photography, seen in Europe as one of the popular arts, was perceived as a modern way of viewing and explaining the world to the modern man. In this context entrenched cultural hierarchies meant less, so as well as exhibiting photographs by the leading modern photographers, and by leading European artists who were experimenting with the medium, FiFo included vernacular uses of photography – showing news, advertising, scientific and record work. And the corset shop of the journeyman Atget.

Several books were published to coincide with what was seen as a highly significant exhibition. As well as the official catalogue, there was Franz Roh and Jan Tschihold's *Photo-Eye* and Werner Gräf's *Here Comes the New Photographer!* The latter was conceived as a how-to-do-it guide to the New Vision. But by then it was clear that there was not one single, unified New Vision in the 1920s and '30s, there were several.

Modern photography in Europe had developed after the First World War, and was indelibly marked by it. Although the United States had fought in the war, few Americans were directly affected by it, unlike the continent over which it was fought. And revolution had marked Europe too. The Russian revolution of 1917 changed the political map of the continent, and it should be remembered that a socialist revolution came within a whisker of succeeding in Germany in 1918, an event that had repercussions for many years.

In Europe, the arts in general, not just photography, were closely connected to the volatile political situation following the war. There were a number of broad approaches to European modernist photography on display at FiFo, but all of them, to one degree or another, were informed by politics. The New Photographer, it was assumed, would naturally be a political animal. And the New Photography would be a political tool, a means not only of looking at the world, but of analysing the way it worked too.

The broadest and most political of the various tributaries that fed into the river of the New Vision was Russian constructivism. The constructivists, such as El Lissitzky, saw themselves not as artists but as 'workers', and repudiated the traditional arts as redundant tools of decadent bourgeois culture. They embraced the machine arts – typography, photography, film – which they believed would create a new art for the new modern society, an art that would be not only politically progressive and socially useful, but mass-produced, machine art for the machine age.

In the German city of Dessau in 1919, a radical institution combining constructivist ideas with arts and crafts socialism had

Hannah Höch (German, 1889–1978)
Cut with the Kitchen Knife Dada through
the Last Weimar Beer Belly Cultural Epoch
of Germany 1919
Photomontage

Hannah Höch's work was usually concerned with women's role in society, and the idea of montage itself was symbolically relevant to a feminist artist like her. Scissors, a household implement, and the notion of cutting out images linked the form to the domestic sphere, something done on the kitchen table and therefore a household task.

This collage deals both with that central issue and dada's political dissatisfaction with the Weimar Republic. Thus various dada slogans compete with images of modern life. Near the top, for example, the words 'Anti-Dada movement' are pasted over portraits of Kaiser Wilhelm II, Weimar government officials, generals and an unemployment office. Further down, Höch's imagery refers to women's suffrage and domestic drudgery. She features women in modern dress, collages those images with pieces of embroidery and lace, and then contrasts traditional domesticity with pictures of progressive women – actresses, dancers, athletes and poets – even including her own portrait as a 'signature'.

This, quite rightly, is Hannah Höch's most celebrated collage. She is credited with developing the art of photocollage along with her partner, Raoul Hausmann, but she made the more pointed and complex montages. A brilliant amalgam of words and pictures, this is a stunning demonstration both of political montage and the fact that great photographic images can be made with appropriated photographs.

When is a photograph not a photograph? When it is a photocollage or photomontage. You just cut out found images and paste them together. In this famous early example, the German dadaist Hannah Höch took the scissors idea and ran with it.

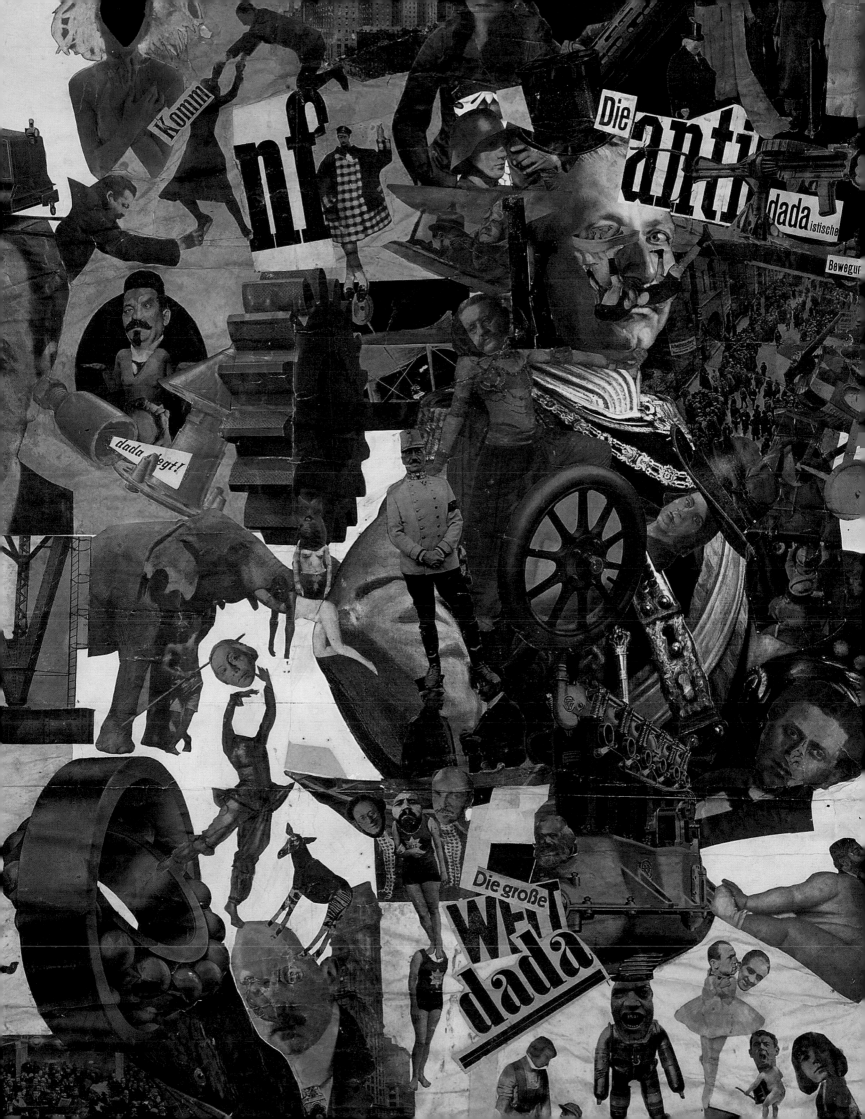

The New Vision was exactly what the term implied, a new view of the world. New Vision photography was characterized by bird's-eye views, worm's-eye views, extreme close-ups and vertiginous angles.

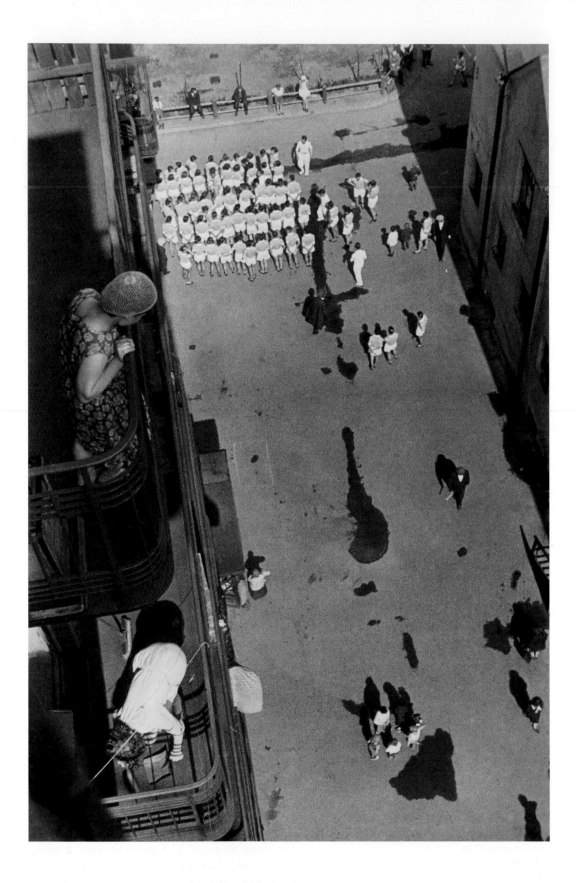

But the New Vision also had a socio-cultural intention for the world. It would sweep away bourgeois traditions and herald a new art for 20th-century man and a wholly progressive, equitable society.

Aleksandr Rodchenko (Russian, 1891–1956)
Assembling for a Demonstration 1928
Gelatin silver print

The vertiginous views and odd angles that
were such a feature of New Vision photography
were so eye catching that they could be used
to persuade. Thus, in a totalitarian state like
Soviet Russia, New Vision techniques were
adopted in propaganda, while in the democracies
they were seen in both documentary and
advertising photography.

In Russia, the leading exponents of the
New Vision were Aleksandr Rodchenko and
El Lissitzky, both of them artists, typographers,
graphic designers and photographers,
20th-century renaissance men. The New Vision
renaissance itself was nominally anti-formal
and determinedly multi-disciplinary. At first, New
Vision photography was part of the constructivist
movement, which was concerned with creating
an abstract modern art that would further the
revolution. Later Stalin proscribed modern art
in favour of socialist realism, but Rodchenko
and others continued to explore constructivist
ideas in propaganda photography, right under
Stalin's nose, as it were.

Here, Rodchenko points his camera
down from a balcony at a crowd assembling
for a politically approved demonstration.
The nominal subject might be the demonstration,
but Rodchenko was clearly just as interested
in the patterns this surprising view creates.
Our attention is taken not so much by the
assembled demonstrators, but the women
spectators below us, and even the patterns
made by water stains following a rain shower
or road cleaning.

been set up for teaching the new arts. The Bauhaus, under the
directorship of the architect Walter Gropius, was the first 'modern'
art school. Students were taught an appreciation of form and
design in a broad-based 'foundation course', and then how to
apply this basic knowledge to specialist disciplines, such as
painting, architecture, interior design, graphics, film and
photography – even fashion, theatrical design and dance.

It was not until 1923 that the Bauhaus became a vital centre
for the dissemination of new ideas on photography, when the
Hungarian artist László Moholy-Nagy was hired to run the
foundation course. Moholy-Nagy had a keen appreciation of
photography, and in 1925 published *Painting Photography Film*,
the primary manifesto for the European brand of modernist
photography, criticizing the sentimentality of pictorialism and
advocating the New Vision.

His New Vision was based firmly upon the application of
optical science and objectivity to photography. Photography's
capacity to see what the human eye cannot, or to see the world
in unexpected and challenging ways, would free contemporary
man from bourgeois aesthetics, creating a 'modern' vision, both
objective and true. The basic 'fault' of the camera, its tendency
indiscriminately to record everything within its field of vision,
became its great virtue. This indiscrimination, which could render
the work of professionals and amateurs, artists and journeymen
almost indistinguishable, would lay the foundations for a
universal enlightenment.

Moholy's manifesto was the philosophical basis for much of
the work seen at FiFo, but a second influence was also important.
This was another artistic movement which, like constructivism,
had developed out of the horrors of the First World War, a
nihilistic, anarchic, anti-bourgeois movement that preached the
overthrow of established art. Dada, which utilized the random
creation of disturbing and shocking images to achieve its effects,
had close links with constructivism at first, but later in Paris
developed into a broader movement – surrealism.

The surrealists channelled the anarchy of dada into an
investigation of the unconscious world. Theirs was an art driven
by the power of dreams and spontaneous happenstance. They
were intrigued by photography, partly because of its mechanical
nature, and partly because of its innate ability to slip unexpectedly
between reality and unreality. Like the constructivists and New
Vision photographers, they experimented freely with the medium,
using not just straight photography but chemically manipulated
images and also photomontage, a favourite strategy of both
dadaists and constructivists.

Photomontage – sticking photographs together to make
a new image – is almost as old as photography itself, but was
'rediscovered' around 1919 by the Berlin dadaists. It was both
figurative and abstract, real yet illusory, commonplace yet
marvellous, simple yet complex, a technique that could satisfy
the artistic ambitions of its practitioners while putting over a
message. Furthermore, it seemed closer in concept than straight
photography to that great proletarian artform, the cinema, and
was used to beguile and persuade in advertising and propaganda
photography. In his portfolio *Electricity* (1931), the leading
surrealist photographer, Man Ray, used a whole battery of such
techniques in one of the great monuments of surreal photography.

László Moholy-Nagy (Hungarian, 1895–1946)
Untitled photogram (ellipse and straight lines)
1927
Gelatin silver print

If the photographic modernism of the 1920s and '30s demolished photographic convention and built a new, streamlined medium for the machine age, it did so partly by reinventing some of photography's oldest techniques. One forgotten technique re-introduced by modernists such as László Moholy-Nagy was the photogram, which did not even require a camera.

A photogram is made by placing objects on a sheet of photographic paper in a darkroom, and then switching on the light. The forms of the objects come out white after development, while the areas which received light are black, creating in effect a negative image. That is the principle, but by using translucent objects, or by holding them at varying distances from the paper, much more complex effects of transparency and opacity, blur and sharpness, and tonal variation can be achieved.

The photogram was an ideal technique for students on the Bauhaus foundation course. It was a combination of science and craft, simple to learn yet capable of complex and beautiful results, figurative and abstract at the same time. Like photocollage, the photogram cut across artistic boundaries. Like photography itself, it was in part automatic machine art, yet dependent upon the imagination of the maker, although in theory anyone could do it.

The New Vision approach is based primarily upon letting the camera do what the camera can do, which is to view the world in an objective, mechanistic way – as Moholy-Nagy put it, '*In the photographic camera we have the most reliable aid to a beginning of objective vision*.' It's a typically modernist call to respect the inherent qualities of a medium – form follows function – but very different from the purist dogma of American 'straight' photograpy. Moholy-Nagy, heavily influenced by the constructivists, embraced film, montage, typography, news and utilitarian photography, and even photography without a camera.

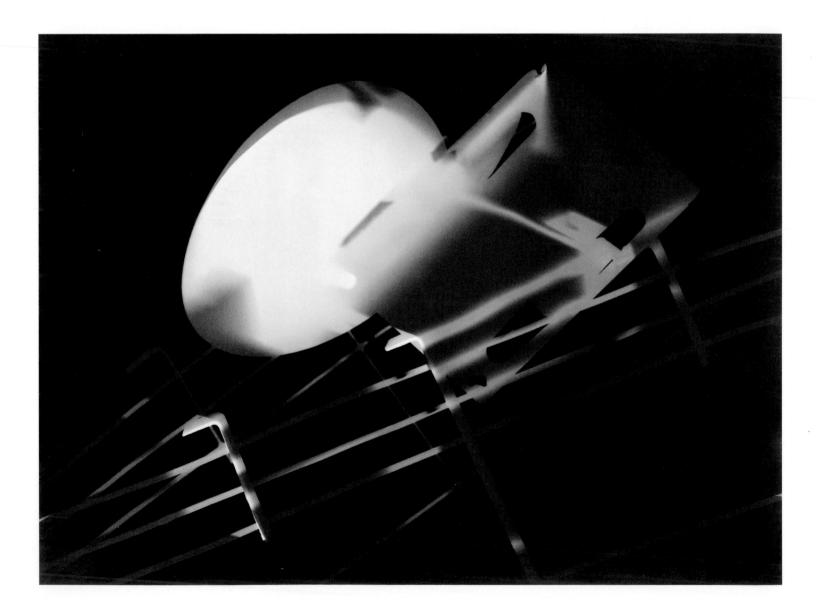

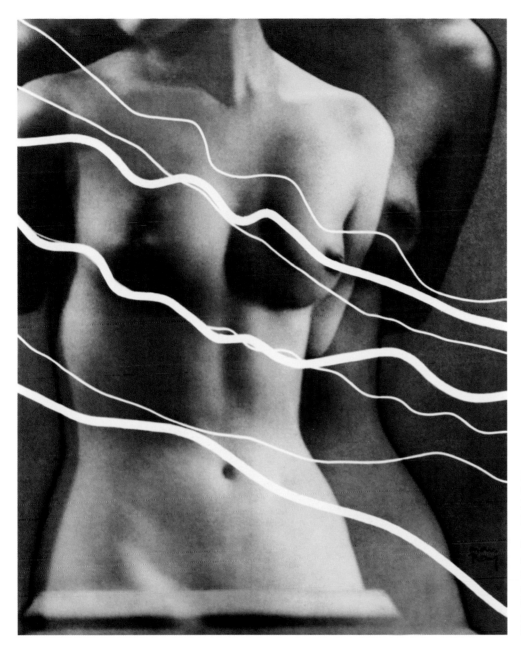

Man Ray (Emmanuel Radnitzky)
(American, 1890–1976)
Photogravure
From *Electricity* 1931

Whoever thought of commissioning Man Ray – whether for his previous work or the association of his name with energy – made a brilliant choice. He produced some of his best work for the *Electricity* portfolio, and the collaboration represents one of the most successful unions between commerce and the artistic avant-garde.

The ten images in the suite of photogravures are primarily photograms – or rayograms, as Man Ray modestly renamed the technique – combined with solarized images and collaged elements. Solarized images, in which there is a degree of tonal reversal, are particularly good at suggesting pulsating energy. Man Ray used this technique, and the negative photogram, to make visible the invisible. His subjects ranged widely, from the domestic to the industrial, used for their symbolic effect. They included light switches, cooking implements, irons and the moon, but *Electricity*'s most famous image derives from a series he made of his assistant, the fashion model and later war photographer, Lee Miller.

Judicious cropping and the placement of the arms reduces Miller to a torso, an anonymous object, but that was the idea – to suggest the eternal feminine, and to root the new, modern energy system in tradition. The Greek goddess segues into the domestic goddess. And if, as they say, sex sells, this is possibly the ultimate advertising photograph.

This sensuous and beautiful image, of wavy lines of light playing across the naked torso of a woman, is one of Man Ray's best, and best-known, pictures, a classic of surreal photography. Yet it was part of a portfolio extolling the joys of electricity, the modern power – a commercial assignment for the Paris Electricity Supply Company. It was, in effect, a hand-out to some of the company's best customers.

Albert Renger-Patzsch (German, 1897–1966)
Flatirons for Shoe Manufacture c. 1926
Gelatin silver print
From *The World Is Beautiful* 1928

Things was the title originally proposed for Albert Renger-Patzsch's *The World Is Beautiful*, but a commercially minded publisher vetoed the photographer's suggestion and created instead one of the best-known titles in photobook history. It is, however, a widely misunderstood work, regarded either as a European version of the Edward Weston approach to photographic modernism, or as a key monument of the German New Objectivity art movement. *The World Is Beautiful* is neither.

The New Objectivity was an essentially political, as well as aesthetic, movement. Its chief exponents were left-wing opponents of the Weimar Republic, angrily lampooning it in paintings that were savagely satirical. A book about the world being beautiful hardly equates with that kind of approach. Renger-Patzsch, indeed, was closer in approach to Weston, but lacked the transcendentalist ideas that accompanied American 'straight' photography.

Nevertheless, *The World Is Beautiful* is a wholly formalist book, and ignores completely the socio-political aspect of the New Vision. As well as the images of nature and industry – such as the viper, the smokestacks, and the row of irons shown here – Renger-Patzsch revealed his essential conservatism by ending the book with saccharine photographs of church interiors, and, if that left any doubt about his ideological leanings, a final picture of a pair of hands clasped in prayer.

As the row of irons demonstrates, the one aspect of the New Vision that Renger-Patzsch exploited to the full was the close-up. This is a book of close-ups, and Renger-Patzsch was characterized somewhat disparagingly as '*the photographer of detail*'. His method tended to abstract the world, and left little room for readings except those of a formal nature. So, although *The World Is Beautiful* had a wide influence upon modernist photography, it did not have a deep or useful influence, except as something to oppose.

While the American modernists seemed to be concerned with narrowing photography's focus, the Europeans were concerned with widening it. Paradoxically, many of the best European photographers were artists, like Moholy-Nagy or the dadaist/ surrealist Man Ray (albeit an expatriate American), but photography's status, whether art or not, hardly concerned them. They were interested in what photography could do, in what they could do with photography, but also in what anonymous professionals or amateurs could do with it. Indeed, the most important feature of FiFo and the New Vision was that they promoted a democracy of vision in photography, establishing its place within society as much as in the arts.

The third trend to be observed in the FiFo exhibition is of fundamental importance because it represents a constant and widespread approach to the medium. In its contemporary manifestation it is now called the 'typological approach', and the term describes the process of making innumerable similar photographs of the same kind of thing, or examining something by type, as Atget did when he made series on shopfronts, on decorative ironwork or small trades. Or as Muybridge did in the 19th century with his motion studies, or Edward S. Curtis around the turn of the 20th century with his studies of Native American tribes. It could also be termed the 'survey approach', for it relates back to the basic impulse of early photography to go out and collect the world, to make an inventory of things and categorize them. Timothy O'Sullivan, for instance, had photographed for several US Department of War's sponsored surveys of the West after the American Civil War. And the 1850s' Missions Héliographiques, an initiative by the French government to document French architecture and ancient monuments, is another example.

In the 1920s, the typological approach was a particular feature of German photography, seen in several classic photobooks published at the end of that decade. Karl Blossfeldt's *Art Forms in Nature* (1928) and Albert Renger-Patzsch's *The World Is Beautiful* (1928) are both regarded as photographic examples of the New Objectivity art movement. However, whereas the painters of that movement – such as Otto Dix and George Grosz – were anything but objective, making scabrous, politically satirical paintings of the iniquities of the bourgeoisie, Blossfeldt's close-ups of plants and Renger-Patzsch's details of things seem mismatched to the rest of the movement. Their elegant abstractions are essentially conservative in spirit, and closer to Edward Weston (at least superficially) than the grotesque caricatures of Dix or Grosz.

Far closer to New Objectivity's political aims was August Sander's *Face of Our Time* (1929), a book that could be considered a preliminary report on the photographer's ambitious documentation of the social structure of the Weimar republic, which he called *Man in the Twentieth Century*. *Face of Our Time* reproduces only sixty out of the thousands of images Sander took, photographing German society's 'types', that is to say, the various classes that constituted a highly stratified society. Sander believed that by 'objectively' recording them an accurate picture could be built up. As Alfred Döblin wrote in the book's introduction:

Just as one can only achieve an understanding of nature or of the history of the physical organs by studying comparative anatomy, so this photographer has practised a kind of comparative

Karl Blossfeldt (German, 1865–1932)
Aristolochia clematitis c. 1928
Photogravure
From *Art Forms in Nature* 1928

Karl Blossfeldt's *Art Forms in Nature* (1928) is regarded as a cornerstone of the New Objectivity tendency in German photography, scientific photography crossing boundaries to be regarded as art. It is a link between 19th-century photography, whose purpose was mainly to collect and classify, and conceptual photography of the 1970s, which often arranged similar photographs in a matrix for comparative analysis.

Blossfeldt taught courses on the sculpture of living plants at the Musuem of Applied Arts in Berlin, so the photographic work that has made him famous – begun in 1900 – was made for the purpose of teaching his students the direct visual link between plants and artistic form. His close-ups of plant forms, however, with each plant isolated against a plain background, exhibited an abstract quality that brought them to the attention of art collector Karl Nierendorf, who encouraged Blossfeldt to show them as images in their own right. Their modernist aura in turn attracted artists, so Blossfeldt's photographs, especially his best-selling book, rather than the plants themselves, became a primary pattern book for designers.

Art Forms in Nature was constructed with a formal rigour and philosophical consistency that ensured its success, both as science and as art. It is an absolutely prime example of the typological movement in German photography. Blossfeldt's plant forms also illustrate modernism's project to present a new vision of the commonplace and the ordinary, and then invest it with metaphorical or associative meanings. Here, the associations conjured up by Blossfeldt are cultural rather than metaphysical, and that has been the tendency since the 1920s in what could be termed German 'landscape' photography, unlike the transcendental modernism practised in the United States, where nature and metaphysics were pre-eminent.

photography and achieved a scientific viewpoint above and beyond that of the photographer of detail. We are free to interpret his photographs any way we wish, and taken as a whole, they provide superb material for the cultural, class, and economic history of the last thirty years.

However, Döblin's observation on freedom of interpretation gives the game away about photography's objectivity. Sander's own politics intrude intriguingly into the project – very much to its advantage. We know from the pictures just who he sympathizes with, proving that documentary photography, no matter how nominally objective, always contains a point of view.

Sander and Atget are the key European figures of the 1920s, not least because the large survey project is the most ambitious thing a photographer can do. In photography, more can actually be more. Sander prefigures the work of Bernd and Hilla Becher in the 1970s and '80s, the photographers and teachers who inspired the Düsseldorf School – the 'new' New Objectivity movement – a key contemporary photographic trend. Atget, with his surreal undertones and tantalizing hint of the personal, inspired several generations of later photographers to document their eras in a way that managed to be both subjective and objective.

It is significant that most of the bodies of work I have mentioned in this chapter have been books. The 1920s and '30s were important for two technical developments which affected photography considerably. Cameras became smaller, lighter and faster to use, culminating in the introduction of Oskar Barnack's Leica in 1925, the first 35mm camera. This new breed of camera enabled pictures to be taken unobtrusively and in low-level light conditions that had defeated earlier photographers. Coupled with this, Edouard Martin's rotary printing cylinder of 1910 made printing, including the seamless integration of photographs with text, cheaper and easier, enabling books and magazines to be printed and sold in greater numbers than ever before.

Following the First World War, the volatile political situation in Europe – revolution in Russia, economic depression in Germany – had produced a demand by the mass public for information which books and magazines, and the new medium of radio, could now satisfy. Photographically illustrated magazines proliferated in the 1920s and '30s, developing a novel way of linking photographs to tell a story. The 'picture story', or 'photoessay', was simply a narrative in photographs. It could be about a news event or a more light-hearted yet no less serious look at modern life, as, for example, the well-known *'Day in the Life of...'* features. The growth of photographically illustrated magazines rapidly spawned a new profession – the photojournalist. By the mid-1930s, the New Photography had become primarily documentary, and much of the work was made entirely to be viewed on the printed page – in books and magazines.

August Sander (German, 1876–1964)
Young Farmers on Their Way to a Dance, Westerwald 1913–14
Gelatin silver print

August Sander began his monumental project *Man in the Twentieth Century* in 1912 – when he decided to photograph the farmers and inhabitants of the countryside just outside Cologne. It finished in the 1930s, when the Nazis came to power. With his camera equipment strapped to his bicycle, he would cycle the country lanes where he himself grew up, looking for subjects like the young farmers (opposite), who gave him one of his most enduring masterpieces.

The picture demonstrates perfectly Sander's particular genius as a portraitist. It is a fine balance between social observation and psychological insight, between Sander's intellect and his feelings. Three young farmers, dressed in their best suits, dandyish canes in hand, pose at the roadside. They are on their way to a dance, it is thought, or just out for a Sunday stroll, perhaps to eye up some girls in the next village.

Details of dress make up the sociological, objective aspect of the image. The psychological aspect is contained in the pose, in their facial expressions or gestures. It is uncertain, although one can sense a certain tension, which is carried mainly by the gap between the front two figures and the rear one. Their expressions give little away. They gaze at the photographer with what might be suspicion, but is possibly just reserve, or maybe bemusement at being accosted by a photographer with tripod, heavy camera and black hood on a country road.

A further point: meanings of photographs change with time. This was a great photograph the moment it was taken, but our reaction to it is surely heightened when we realize it was taken on the eve of the Great War – an event which certainly had a profound effect upon the lives of the three, an event which possibly took their lives away.

August Sander
(German, 1876–1964)
*The Boxers:
Paul Roderstein,
Hein Hesse* 1928
Gelatin silver print

Bernd (German, b. 1931)
and Hilla (German, b. 1934) Becher
Blast Furnace Heads 1970s
Gelatin silver prints

Each water tower, blast furnace or minehead the Bechers photograph is taken head on, from roughly the same distance with a flat perspective, and in a dull, even, grey light. They have applied this method for over forty years, making the kind of detailed, long-scaled photographs normally seen in engineers' offices, but showing them framed in art galleries in grids.

At first regarded as conceptual sculptors rather than photographers, they have created a phenomenally successful career from essentially one picture, repeated over and over again, but it is an endlessly fascinating picture because each variant is complete in itself and different, rather like an array of butterfly sub-species. And, like the lepidopterist's dead butterflies pinned to boards for comparison, the Bechers' 'specimens' of industrial structures are pinned to gallery walls in grids for much the same reason.

The typological approach they revived has become almost ubiquitous in what one might term 'conceptual' photography, and shows little sign of abating in popularity. It influenced their pupils at the Düsseldorf School of Art, several of whom have gone on to enjoy careers at least as successful as that of their teachers, and have in their turn influenced art students worldwide. But none followed the Bechers' advice more rigorously than they themselves. Find a subject and pursue it obsessively for your whole career.

Bernd and Hilla Becher revived August Sander's methodical approach in the 1960s when they began to photograph 19th-century industrial buildings, initially because Bernd was interested in making paintings of them. But their carefully made 'records' of these functional structures became not only a valuable documentary archive but amongst the best-known and best-loved artworks of the late 20th century.

To teach and to persuade

Government agencies in the European democracies and the United States used the perceived veracity of documentary photography – both still and film – to teach and persuade their citizens. The term 'documentary' itself was coined, it is generally believed, by the Scottish filmmaker John Grierson, an influential figure in the documentary movement on both sides of the Atlantic. Grierson had a Calvinist background like that of another Scot who believed in educating the masses through the mass media – John Reith, first Director-General of the BBC. And their ideas found counterparts in Rooseveldt's New Deal administration in the United States. As Grierson himself defined it, documentary was the *'selective dramatisation of facts in terms of their human consequences'*, and, further, a means of educating *'our generation in the nature of the modern world and its implications in citizenship'*.

Totalitarian states of the '30s – notably Russia, Germany, Italy – used the documentary approach too, in their propaganda programmes. Of course, propaganda is regarded as something that totalitarian states do, but there was little essential difference between their work and the documentary programmes of the democracies. However, fearing socialist undertones, American initiatives were always called 'documentary' or 'publicity'.

The best known of the government documentary surveys of the 1930s was organized in the United States by Roy Stryker as part of the New Deal. It was carried out by the photographic unit of the Resettlement Administration (RA), soon renamed the Farm Security Administration (FSA), an organization set up to resettle distressed farmers in homes and jobs. Stryker hired around twenty 87-88 of the best American photographers, such as Walker Evans and Dorothea Lange, not only to document the work of the agency but to record life in the small towns most hit by the Great Depression. Between 1935 and 1942, many thousands of photographs were taken by the unit's photographers, building up an invaluable and, given the agency's objectives, dispassionate view of the Depression. Evans made some of his best work while with the unit, as did Dorothea Lange. One of the era's most famous icons, 77 *Migrant Mother* (1936), is hers.

The work of the FSA photographers was freely available to any publisher who wanted to use it. Clearly, it was made to persuade the public of the agency's viability, but such is the tricky nature of photographic representation that even the most 'factual' of documentary photographs can have their meanings altered drastically by context, by the text of a caption, or by juxtaposing them with other photographs. Some of the FSA photographs turned up in a nasty, thoroughly anti-semitic German propaganda book, *U.S.A. – Naked!* (1943), where they were made to 'say' the opposite of what Roy Stryker certainly would have intended.

Of course, grand documentary surveys by government agencies can be benign or malign, according to one's political viewpoint. Even a survey such as the FSA must be seen as a means of social control, and the use of photography for this purpose is as old as the medium itself. Even a project like John Thomson's famous 77 *Street Life in London* (1877–78), for example, regarded as the first great work in the 'social-documentary' mode, and evincing proper concern for the poor, has an element of looking at the 'other'. Indeed, Thomson had photographed ethnographic 'types' in China in much the same way. But it should be stressed that Thomson's view was far more sympathetic and engaged than others in the 19th century and was a forerunner of a project like August Sander's *Man in the Twentieth Century*.

But prejudicial surveys did not end in the 19th century. Nazi propaganda used every facet of 19th-century pseudo-science to 'prove' that Jews and others on their hate lists were inferior human beings. So one is a little uneasy about a project like *Facies Dolorosa* (1934) by the distinguished German diagnostician Dr Hans Killian. His photographs of severely ill patients were intended as a diagnostic tool, but the rhetoric of the pictures sends out decidedly mixed messages.

Dr Hugh Welch Diamond (English, 1809–86)
Seated Woman with Bird c. 1855
Albumen silver print

Dr Hugh Diamond made a major contribution to the founding of the Photographic Society (later the Royal Photographic Society) in the 1850s, and was an editor of its magazine, *The Photographic Journal*. He was also a doctor, and subscribed to the dubious 'science' of physiognomy, in which the face was regarded as the mirror of the soul, and far-reaching conclusions – right or wrong – were drawn from superficial observations.

In 1848, Dr Diamond became superintendent of the female department of the Surrey County Lunatic Asylum, and began a systematic survey of his patients. His predecessor had commissioned engraved portraits, but Diamond believed photography was a much more accurate method of recording appearance, both for their personal records and as an aid in diagnosis and treatment.

Around 1855 he made this photograph of a patient holding a dead bird. It is his best-known picture because to modern eyes the bird lends a mysterious, even surreal air to what is essentially a plain documentary photograph. Wearing a straw hat, a blanket draped over her shoulders, the woman stares somewhat uncomprehendingly at the camera, cradling the dead bird in her arms like a baby, though that is probably a Freudian interpretation. The picture is full of questions. Does she mourn the bird's death, or was she the cause of it? Is the bird a surrogate child?

We do not know the woman's diagnosis, or whether the photograph – or any of his photographs – aided Diamond. He claimed success for his photography, and published a treatise, *On the Application of Photography to the Physiognomy and Mental Phenomena of Insanity* (1856), but it is unlikely. We can conclude with reasonable certainty that *Seated Woman with Bird* did not perform too well in its day as a diagnostic tool, but today resonates powerfully as a photographic work of art.

Inoperabler Magenkrebs bei einem alten Mann

52

76

Dr Hans Killian (German, n.d.)
Collotype
From *Facies Dolorosa* 1934

left to right
Inoperable Cancer in an Old Man
*Early Sarcoma of the Tibia, with Possible
Secondary Cancer*

Killian took his photographs close-up, and to
the side, as if he were a visiting friend, sitting by
the bedside. Carefully lit, impeccably composed
and reproduced in a beautiful, soft gravure, they
are more aesthetic than the normal medical
photograph. But counterbalancing any feeling
of empathy this might evoke, there is a coldness.
The images are mercilessly objective, as medical
photographs should be, and it is this disjunction
that makes them compelling and sinister.

If this strange balance of the objective and
subjective is disquieting, Nazi-era ideology must
also be taken into account. Like Dr Diamond's
pictures, these sit firmly within the 19th-century
tradition of social control by empirical observation
and photographic classification. The Nazis used
the notion that criminal tendencies or racial
inferiority could be detected by physiognomic
observation and comparison to support genocide.

Dr Killian certainly practised with Nazi
approval and it is believed that he was a party
member. But even without the benefit of hindsight
these pictures, with their clash of message, are
troubling. Given the later track record of the Nazis,
this aspect becomes more insistent, although one
should point out that the book was published in
many editions, some of them after 1945.

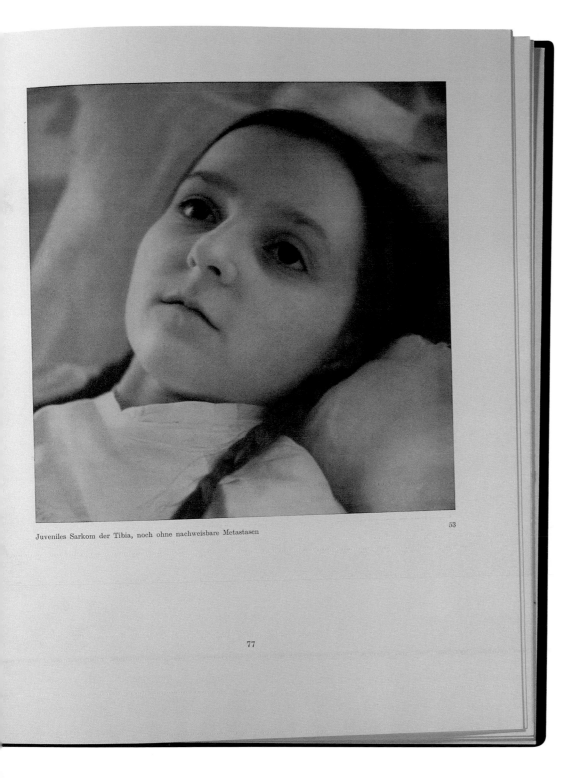

Juveniles Sarkom der Tibia, noch ohne nachweisbare Metastasen

53

77

Dr Hans Killian's _Facies Dolorosa_ features photographs of seriously ill patients in hospital. The book's ostensible aim was to be a visual record for medical diagnosticians. But Killian worked during the Nazi era, and there are questions to be asked about both its real usefulness and the somewhat confused messages projected by the photographs themselves.

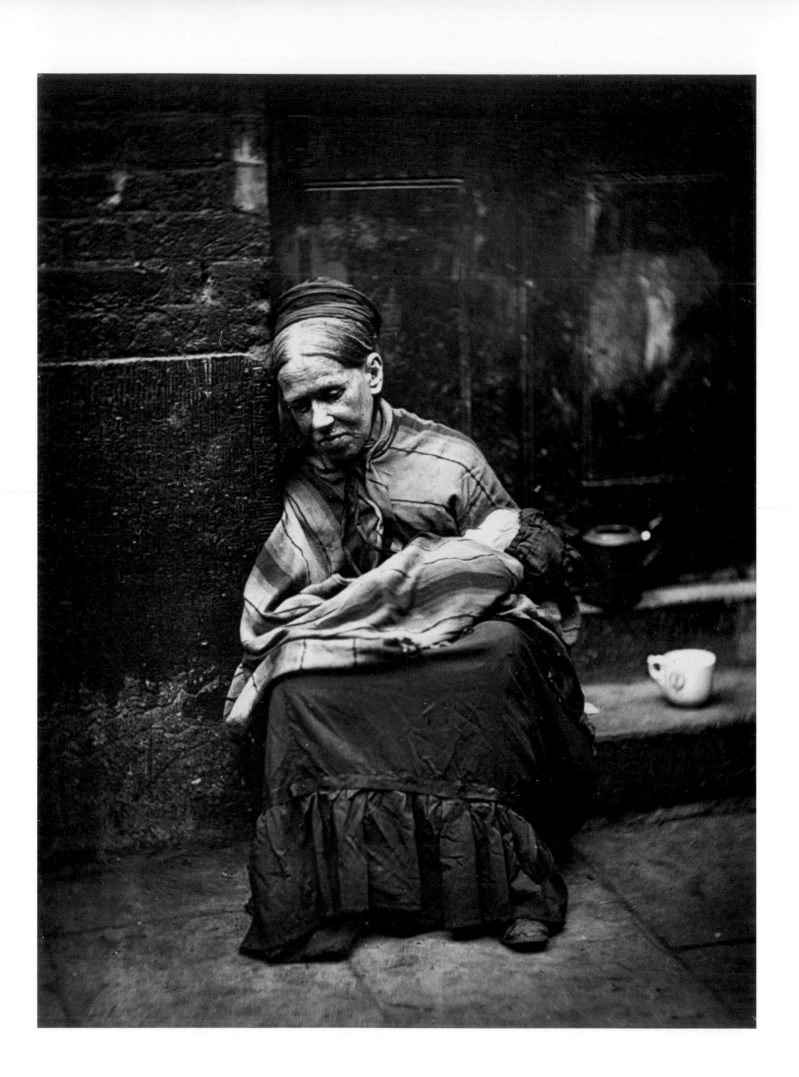

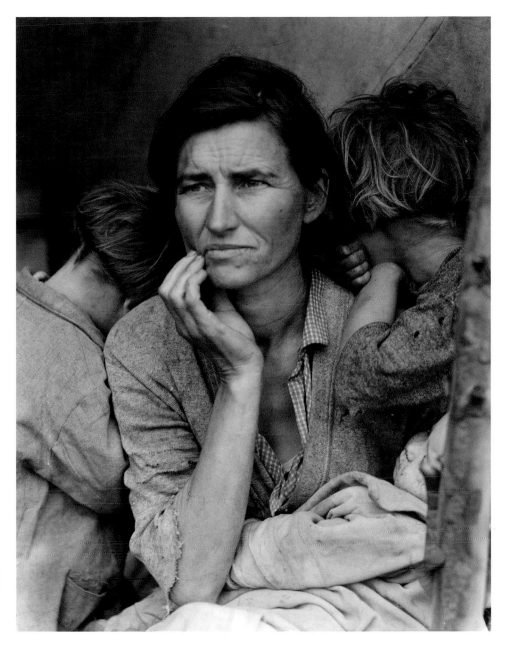

John Thomson (Scottish, 1837–1921)
The Crawler 1877–78
Woodburytype
From *Street Life in London* 1877–78

John Thomson's book *Street Life in London*,
first issued in twelve monthly parts with original
carbon prints, has been called the beginning
of the social-documentary genre, but some have
considered Thomson's pictures to be somewhat
dubious as social documents because they were
staged and took a popular journalistic approach.

They also represented a middle-class
photographer photographing the 'lower orders',
but that was a common feature of Victorian
photography. Thomson learned to deal with those
outside his cultural milieu when he photographed
in China, and he applied a similar anthropological
technique, dealing with 'types' rather than
individuals, when he turned to life on the streets
of London.

Thomson was also working within a long-
established tradition of popular illustration, the
Small Trades or *Cries of London* genre, not only
translating it into photographic terms but doing it
superbly. He made complex ensembles of figures
on the London streets that may have been in the
'directorial' mode, yet they retain an immediacy
that keeps them fresh even today. And *Street Life
in London* was not just a slightly prurient look
at the exotic poor for middle-class readers. It had
a lively and sympathetic text by the journalist
Adolphe Smith that was reformist in intention.

If one picture can represent the book and its
importance, it is this one. Here, Thomson seems
to go beyond 'type' for once in a thoroughly
modern manner and engages with his subject as
an individual. She was a 'crawler', an old woman,
as Smith's text says, who was 'so reduced by vice
and poverty' that she did not have the strength
even to beg. Both picture and text are calculated
to gain our sympathy, but this remains a superb
example of Thomson's work and the putative
social-documentary genre.

Dorothea Lange (American, 1895–1965)
Migrant Mother, Nipomo, California 1936
Gelatin silver print

Migrant Mother by Dorothea Lange is the most
famous image of all those taken by the Farm
Security Administration's photographic unit,
run by Roy Stryker. Lange was the most politically
committed of the FSA team, and she was also
the most empathetic.

She photographed the exodus of poor
farmers from the 'Dustbowl' of Oklahoma
to California, an episode in American history
portrayed so memorably in John Steinbeck's
novel *The Grapes of Wrath* (1939). With her
husband, the sociologist Paul Schuster Taylor,
Lange made *An American Exodus* (1939),
which told a similar story. Mention of the book
is relevant because *Migrant Mother* was not
included in it. Lange thought the picture was too
emotive, that it would be seen as propagandist.
For her, documentary was a serious, sober

business, sociology with a camera. She felt she
was seeking truth, not self-expression.

Migrant Mother was made while Lange
was travelling home to San Francisco in the rain.
She passed a sign that read 'Pea-Pickers' Camp'
and drove for another twenty miles, before
something compelled her to turn back and visit
the camp. She saw the wet and hungry mother,
Florence Owens Thompson, aged thirty-two,
sitting under a makeshift shelter.

Lange took six images, moving in closer all
the time, until she focused only upon the mother's
face and arms, with two children turning their
heads away. She was right to be wary of this
photograph. It is so powerful that it has had
a life of its own, transcending the documentary
to mean whatever anyone looking at it wants it to
mean. This is not to imply that there is anything
untruthful about it, but the others in the sequence
demonstrate that even fashioning a meaningful
documentary picture is an art – one that Lange
was rather good at.

Послеобеденный отдых

Газета „Друг народа"

Герои войны —
„великой и
последней"

Ее последняя скамья

Ilya Ehrenburg (Russian, 1891–1967)
Letterpress reproductions
From *My Paris* 1933

Made during a period when Paris was swarming
with great photographers, like André Kertész
and Brassaï, Ehrenburg's book *My Paris* must be
amongst the most unsentimental ever produced
about the city that is said to inspire romance.
He was photographing not long after Atget's first
posthumous monograph was published in 1931,
and it seems clear that he knew the book, for he
not only shot many of the themes that exercised
Atget, he echoed certain pictures quite precisely
in his images of shop mannequins, fairground
horses and street workers.

The most startling and original photographs
in *My Paris* are of Parisian down-and-outs.
Ehrenburg was an early convert to the Leica
35mm camera, and with it he took rough and
ready, candid and quite startling pictures of the
proletarian street user. Paris was the bourgeois
city *par excellence*, the primary European
destination of the foreign tourist, but Ehrenburg
ignored all this. Adopting New Vision angles,
probably as a result of trying to take his pictures
unobserved, he photographed sights and people
both the bourgeoisie and tourist would have
overlooked – the invisible people of the streets.
He photographed drunks on benches, ragged
urchins, beggars, itinerant street-workers and the
homeless, accompanying the images
with a dry social commentary that makes clear
his criticisms of capitalism.

The pictures are lively, very much snapshots
and oblivious to fine technique. *My Paris* is almost
unique in the bibliography of photobooks, a frank,
bleak view of the Parisian underclasses, superbly
designed by El Lissitzky, and containing some of
the best photography ever to appear in a Soviet
propaganda book.

The more commercial documentary photographers of the '30s
certainly had this combination of dubious attributes, their
snooping often calculated solely to take a telling photograph.

Four photographers might be considered as examples of this
breed, and it is wholly pertinent that they were all cosmopolitan
individuals, working in great cities. The four are the Russian Ilya
Ehrenburg and the Hungarian Brassaï, working in Paris, the
American of Russian descent, Weegee, working in New York, and
the German-born Englishman Bill Brandt, working in London.

Ilya Ehrenburg, Russian revolutionary, propagandist and
writer, extolled the virtues of the Soviet system from Paris, where
he lived for many years. In 1933, the Soviet state publishing-house,
IZOGIZ, published his photographs of the city in *My Paris*. His view
was not quite most people's view of the city of light. There was no
Eiffel Tower, certainly no Folies Bergères.

Ehrenburg was prowling the streets with a Leica. The images
are raw, but lively and immediate, and one wonders whether the
young Henri Cartier-Bresson saw the book and was inspired by it,
because Ehrenburg's photographs have something of a rough-
hewn Bresson about them, although the Russian's ostensible
purpose was not to capture graceful decisive moments. He was
interested rather in the poverty-stricken underbelly of the city,
something generally ignored by tourists. And yet one feels that
Ehrenburg's motives were not entirely political. He is pictured no
fewer than three times in the book with his Leica, of which he was
clearly inordinately proud, so it is likely he became enamoured
of the thrill of the chase and the camera's ability to steal an image.

In the introduction to his book *Photo-Eye*, Franz Roh stated that
the world was not only '*beautiful*', but '*exciting, weird, and cruel*'.
The remark was a coded criticism of Albert Renger-Patzsch's book
but also an invitation for photographers to pander to their own
curiosity and the voyeuristic sensibilities of viewers. One example
of this was the 1930s fashion for night photography. This enabled
the photographer to act as a spy, delving into the lives of socially
transgressive elements in society – night people and criminals –
with all the sensationalism of dime thriller-novels.

Brassaï, the Hungarian photographer living in Paris, became
renowned for his pictures of nocturnal Paris, which he published
in *Paris by Night* (1933), and which spawned a number of imitators.
Brassaï's mysterious night views, for the most part of the elegant
quarters of the city, were only one side of his Parisian night work,
however. The other side was his investigation of the city's more
colourful aspects – the brothels, dancehalls, homosexual clubs,
with a cast of characters that included prostitutes, pimps,
lesbians, transvestites and gangsters. These 'hidden' images
were published in less reputable publications, such as the 1934
Voluptés de Paris, and, although word spread, were published
generally only in the 1970s as *The Secret Paris of the Thirties* (1976).

The American photographer Weegee's *Naked City* (1945) was
another kind of raw photobook, in the style of the tabloid press.
If Brassaï's nocturnal world was erotic, Weegee's was violent.
He was an ambulance chaser, tuning a radio into the police
frequencies so he could be first on the spot when a gangster was
shot or there was a tenement fire. His persona and the characters
he photographed were straight out of Damon Runyon. Weegee
might have been a man of the people but he photographed the
people with as much cruelty as tenderness.

84

His view of 1930s America is so persuasive, his photographs so complex and authoritative, that John Szarkowski has remarked, '*It is difficult to know now with certainty whether Walker Evans recorded the America of his youth, or invented it.*' Image after image combines complex form with complex content. The pictures are full of bitter irony and poignancy, piling up metaphors about the gap between intention and reality, about sight, about violence and poverty, about restricted lives behind mean façades, about the indomitable hope of those little people who attempt to fashion, however crudely, their own piece of the American Dream. How deftly Evans found individual pictures that underscore his larger intentions. How well he took his cue from film and literature to give the book a clear but fluid narrative structure, a sense that it must be 'read' as well as looked at.

No matter how marvellous the individual images, no matter how well observed and constructed, their ultimate impact is as part of the narrative sequence. In *American Photographs*, Walker Evans demonstrated that photography need not be just about simple formalism, simple propaganda or simple sociology. It could carry all the complexity of an artist's musings upon the nature of culture and human experience. And in doing so, he greatly expanded the potential of the photographic book, creating a sequence of images which has stood the test of time, bearing the depth and allusive richness of an epic poem, a major film or novel.

In the book's *Afterword*, Lincoln Kirstein made claims for Evans that must have seemed highly exaggerated at the time, but which now appear as measured as Evans's pictures:

Compare this vision of a continent as it is, not as it might be or as it was with any other coherent vision that we have had since World War I. What poet has said as much? What painter has shown as much?

His is an art that combines the objectivity of the camera – '*the great, the incredible instrument of symbolic actuality*,' he called it – with the subjectivity of a photographer who knew not only how to take a great picture but also how to group pictures together with intelligence and intent.

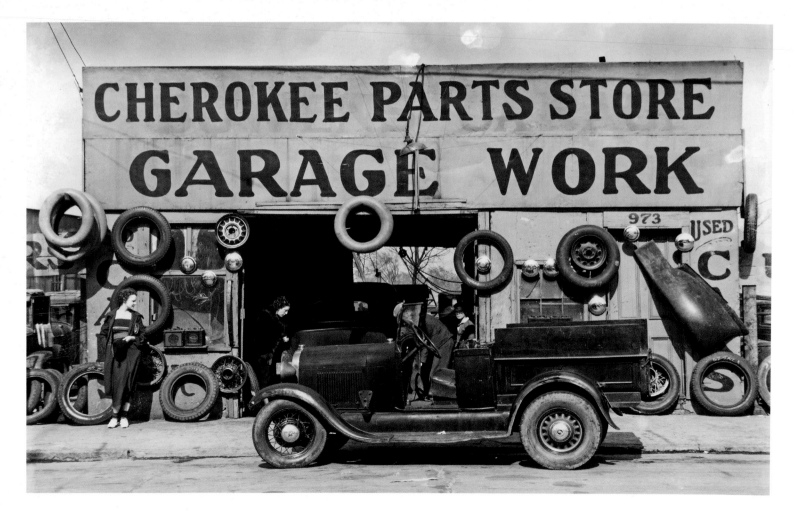

Walker Evans (American, 1903–75)
Garage in Southern City Outskirts **1936**
Gelatin silver print

And it does not matter what kind of evidence as long as it was directly obtained. George Rodger was the first photographer into Bergen–Belsen concentration camp. Sometime afterwards he recalled that at one point, while taking pictures, he was mortified to realize he was arranging corpses in harmonious compositions in his viewfinder. But this, of course, is the first task of the photographer, to make the 'best' photographs possible. Later in 1945, a booklet, *KZ: Five Concentration Camps*, was distributed by the American forces to the German population to inform them what had been carried out in their name. The images spoke for themselves, but someone edited the pictures and someone designed the book so that the pictures had maximum impact.

On the other hand, groups of Jews who had survived the camps gathered together any kind of photograph they could lay their hands on, and, without the resources to print them on a printing press, rephotographed them and made books of rough copy prints, just so they could be distributed in some way. Ironically, much of this material came from the Nazis themselves, who had photographed every stage of their extermination of the Jews and others, for they wanted a historical record of the 'purification' that would attend the founding of the Thousand-Year Reich.

Other well-known photographers also photographed the camps. Lee Miller, once Man Ray's assistant and model, and wife of the English surrealist Roland Penrose, photographed both Buchenwald and Dachau, working for *Vogue* magazine. '*I implore you to believe this is true,*' she cabled her editor. Remarkably the fashion magazine ran some of her most graphic images, and as her son Anthony Penrose has written:

> Vogue's *printing of Lee's material represented an achievement in fashion publishing which has never been repeated. The gore and violence of her articles feature boldly in the pages, accentuated by Alex Kroll's striking choice of pictures and his brilliant layouts creating what can only be described as a Surrealistic effect. The grim skeletal corpses of Buchenwald are separated by a few thicknesses of paper from delightful recipes to be prepared by beautiful women dressed in sumptuous gowns.*

This 'Surrealistic effect' was also seen in the 7 May 1945 issue of *Life* magazine, which showed Margaret Bourke-White's images of Buchenwald alongside pictures by Rodger, Robert Capa, Peter Stackpole and others, grim photographs of death and destruction set amongst colour advertisements and lifestyle tips. But that is the nature of illustrated magazines in a consumer economy. And if a few people are actually prompted to think seriously after news photographs appear in *Vogue*, then that is justification. It was imperative that the facts of the Holocaust appear – anywhere.

Perhaps a single photograph or one group of photographs is an enigmatic and uncertain witness of history, but the tens of thousands documenting the Holocaust are quite another matter, even if one could take some of them and make them say more or less anything. Photographs are certainly not 'pure' documentary records and usually need supplementary documentation, such as words, before they can function as prime witnesses. A Nazi 'mugshot' of someone about to be transported to the camps is a poignant symbol of the Holocaust, but if the same photograph is found stuck on an index card, with prisoner details attached, it becomes something else. It becomes evidence.

There is a certain body of academic opinion, deriving mainly from Marxist theorizing, that is especially suspicious of photography, particularly in its role as witness. '*Strictly speaking, what does any photograph tell us?*' asked critic Susan Sontag. The playwright Bertolt Brecht used the example of the Krupp armaments factory. A photograph of its exterior tells us nothing of what is going on inside. Even if a photographer gained access and photographed guns on an assembly line, that still would not tell us why they were being made (except for the obvious reason), who is ordering them, and so on. Photographs by themselves would not indict Krupp, but they might help. Any case in a court of law, any critique or thesis is built up from any number of small facts assembled to make the final argument.

But possibly the simple witnessing and evidencing of an event such as the Holocaust cannot be enough for those seeking to comprehend what is almost beyond comprehension. And so the consolation of art might have its place. Following the war, a number of bodies of photographic work were published that regarded the terrible events in an oblique and poetic, yet affecting and profound way.

In 1946, photographer Pierre Jahan published a book in collaboration with Jean Cocteau – *Death and the Statues*. Jahan had found a pile of statues in a Parisian breaker's yard or warehouse, ripped from their plinths by the Nazis to be melted down for their metal. It was a statue graveyard of disembodied heads and disarticulated limbs, photographed at a time when others were photographing human graveyards. These simple photographs of broken statues speak eloquently – not about the camps directly – but about barbarism, about loss and about the trashing of culture, and form one of the best responses by a French photographer to the war, proving that poetry is sometimes as necessary to understanding as factual documentation. As Cocteau wrote in his accompanying text:

> The job of the poet (a job which can't be learned) consists of placing those objects of the world which have become invisible due to the glue of habit in an unusual position which strikes the soul and gives them a tragic force.

We are as far as we can get from the unadorned documentary response made by George Rodger and others, and yet photographs such as Jahan's have become not only part of photographic history, but of cultural history. And that, of course, is not an immutable truth. Like photography, history is a constantly changing construct, always open to reinterpretation.

3

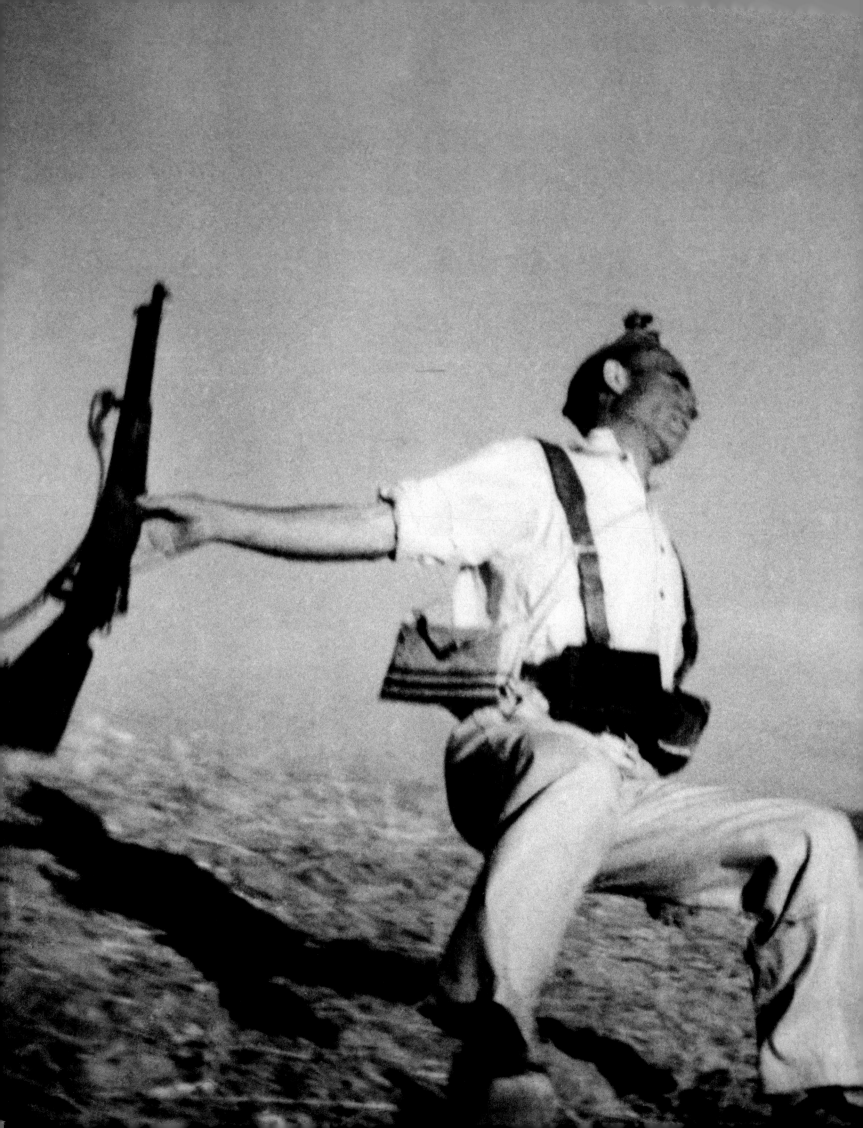

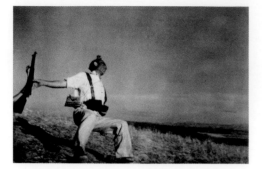

Robert Capa (American, b. Hungary, 1913–54)
*Loyalist Militiaman at the Moment of Death,
Cerro Muriano, September 5, 1936*
Gelatin silver print

During the Spanish Civil War, on 5 September 1936, near Cerro Muriano on the Córdoba front, a militiaman fighting for the Loyalist republican side was hit by a bullet. As he fell to the ground the moment of his death was caught on film by a young Hungarian photojournalist, Robert Capa. For years, the subject of one of the most renowned war photographs ever made was unknown. We now know him to have been Federico Borrell García, aged twenty-four, who came from Alcoy in southern Spain.

The falling soldier's identity is important because for some years there were allegations that Capa's famous photograph had been faked, staged on manoeuvres arranged specially for photographers during a lull in the fighting. These doubts were raised most notably by the journalist Phillip Knightley in his 1975 book, *The First Casualty*, a study of how war correspondents have sometimes been cavalier with the truth.

Richard Whelan, Capa's biographer, was stung by the charge and after extensive research found Borrell's name and the probable manner of his death, shot as he climbed out of a gully in which Capa and his compatriots had taken cover, thus explaining the low angle from which the image was made. Whelan writes:

To insist upon knowing whether [it] *actually shows a man at the moment he has been hit by a bullet is both morbid and trivializing, for the picture's greatness ultimately lies in its symbolic implications, not in its literal accuracy as a report on the death of a particular man.*

That may be true, but Whelan is being slightly disingenuous. Given the efforts he made to 'clear' Capa's reputation, he obviously understands that in this current climate of uncertainty about photography's veracity, we should be able to trust the most iconic of war photographs.

Keeping pace with history

The Second World War began with a rehearsal, a preliminary struggle between democracy and fascism in Spain. And during the Spanish Civil War (1936–39), modern war photography as we know it began. It was the first major conflict in which the new 35mm cameras were used, cameras fast enough and unobtrusive enough to freeze fast-moving action – to keep pace with history. A young Hungarian photographer who had changed his name from André Friedmann to the more glamorous Robert Capa took his 35mm camera into the thick of battle, and placed the viewers of his images there too, creating a new photographic rhetoric of immediacy. '*If your pictures aren't good enough,*' he once said, '*you aren't close enough.*' And he also advised against being too fussy with focusing. A slight degree of fuzziness suggested a trembling hand, a personal reaction to war that would resonate readily with any viewer.

Capa's dispatches gained him the dubious appellation of '*the world's greatest war photographer*' from *Life* magazine. And one of his pictures, taken near the town of Córdoba, is often described as '*the greatest war photograph of all time*'. This photograph, entitled *Loyalist Militiaman at the Moment of Death, Cerro Muriano, September 5, 1936*, was published in the 12 July 1937 issue of *Life*, with a caption that read, '*Robert Capa's camera catches a Spanish soldier the instant he is dropped by a bullet through the head in front of Córdoba.*'

The picture struck a chord. Some of it had to do with the thrill of watching the very 'moment of death'. Much of it had to do with the image's immediacy. Viewers had the feeling that they were looking at the face of history itself, peopled with real human beings caught up in great events, something very different from a litany of dry facts and figures in a history book. Capa's reportage was not the dispassionate objectivity of a Victorian cameraman at war, forced by slow equipment to photograph calmly long after the battle was over. Capa was a committed anti-fascist. He was telling the truth as he saw it, but it was a 'truth' already part-determined by his politics, as was Ernest Hemingway's reporting of the same war. A fascist sympathizer seeing Capa's photograph would have had a totally different reaction. The response 'good shot' would have referred not to the photographer but the Nationalist soldier who had killed an enemy.

Capa's image of the falling Republican soldier remained an icon of war until 1975. Then, in a book on the issues surrounding war photography, *The First Casualty*, Phillip Knightley suggested that the picture was fake, in the sense that the 'death' had been a piece of playacting during manoeuvres when there was a lull in the fighting, manoeuvres set up specially for Capa to get some 'action' photographs. Knightley's accusation, seconded by others, has since been disproved, and Capa's image can be considered genuine, but the furore the speculation caused illustrates just how much we want to believe photography. Even in this media-savvy age, when one would think that most people consume any photograph with not a pinch but a whole cellar of salt.

Lee Miller (American, 1907–77)
Nazi Suicide, Leipzig April 1945
Gelatin silver print

Fashion model, surrealist muse, artist, beauty – the facts of Lee Miller's life read so much like a novel or a Hollywood movie that sometimes they have tended to obscure her worth as a serious photographer. In the most serious arena of all, war photography, she made a body of work at the end of the Second World War that is second to none.

Miller became one of the few female war correspondents in the European war zone in 1944. Travelling with US troops soon after D-Day, she covered such events as the siege of St Malo, the liberation of Paris, the fighting in Alsace, the crossing of the Rhine and the liberation of Buchenwald and Dachau.

It was her coverage of the liberation of the camps and the last days of the Third Reich that has probably become her most enduring work. The concentration camps had a profound effect upon her and she seems to have suffered psychologically from the experience, as did many witnesses of such horrors. But this did not prevent her from documenting the atrocities clearly, precisely and without exaggeration.

She also photographed the corpses of Nazis who preferred suicide to surrender after the Third Reich's collapse, and this image demonstrates how cool and dispassionate was her reporting of such events. Rather than face the Russians, the whole family of the mayor of Leipzig killed themselves. The daughter pictured here might almost be asleep except for the distinctive rictus of death, which has slightly distorted her features. Miller's own words describe the scene vividly:

Leaning back on the sofa is a girl with extraordinarily pretty teeth, waxen and dusty. Her nurse's uniform is sprinkled with plaster from the battle for the city hall which raged outside after their deaths.

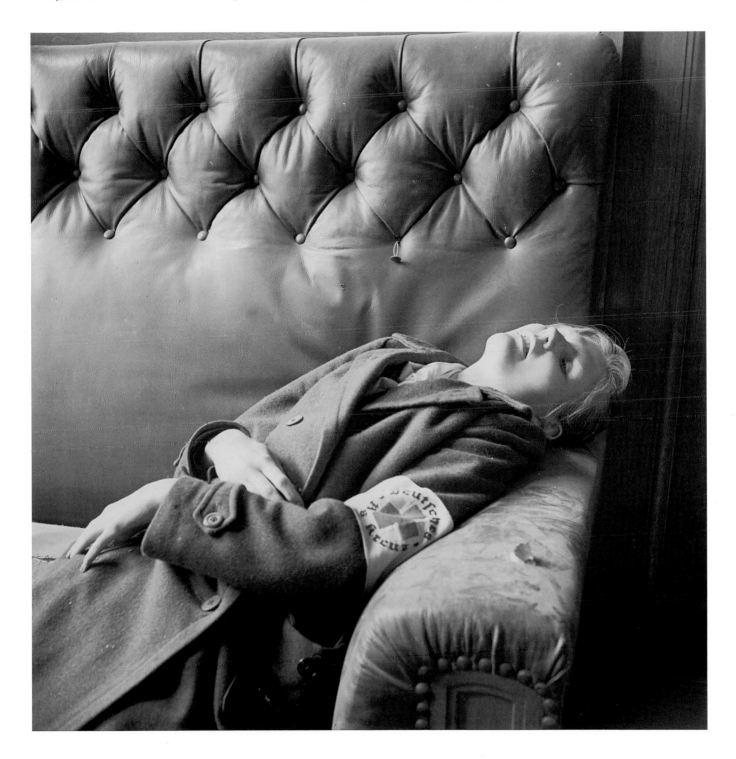

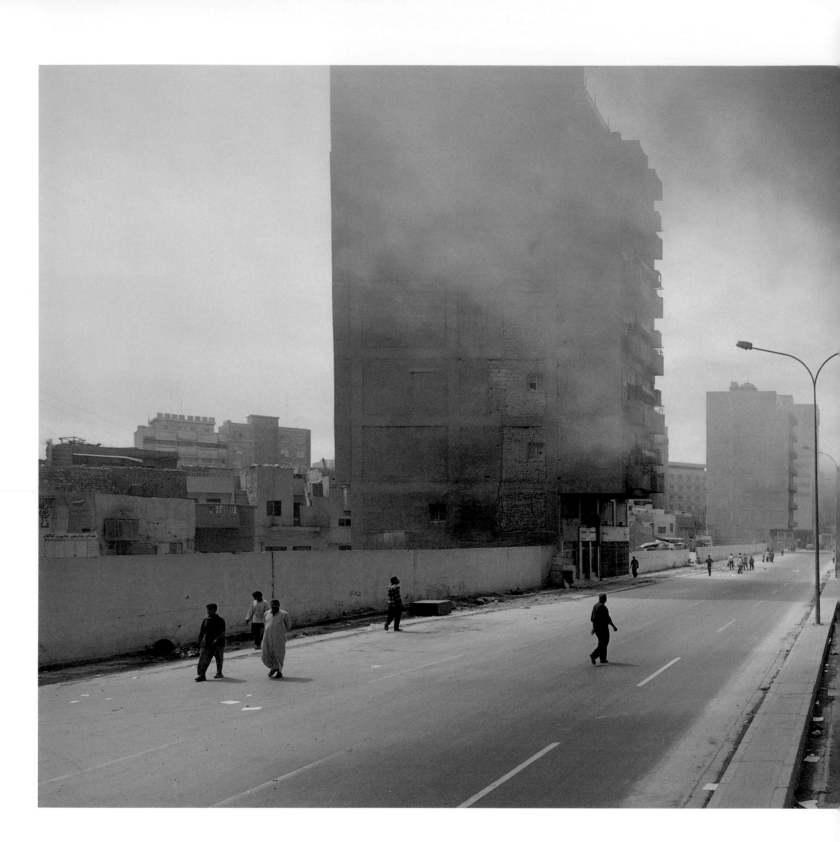

Luc Delahaye (French, b. 1962)
Baghdad #4 2003
Chromogenic (Type C) colour print
From the series *History*

Documentary photography is all about context –
where it is shown, how it is presented, the
information surrounding it. All can have a crucial
bearing upon the ultimate message it transmits.
In *History* Delahaye deliberately takes what
are in effect documentary photographs, and
presents them out of their normal context,
thereby questioning not only their meaning as

documents, but the meaning of all photographs.
This is not to say they have no meaning as
documentary photographs – as 'history' – but
that they also comment upon their own existence,
raising questions about representation and truth
at every turn. Delahaye's photographs, in short,
are art – not just because they are enormously
enlarged and hung in art galleries, but because
they tackle these issues in such a complex,
intelligent and intriguing way.

Delahaye takes his panoramic images
in various war zones, and also at what might be
termed staged historical events – international

conferences and the like – events organized
as much for the benefit of the communications
industries as for their own sake.

Photography, it has been said, is the 'new
history painting'. And Delahaye has acknowledged
this, admitting, in effect, that photography – even
news photography – is as fictional as painting,
as full of artifice. He is also hinting that historical
events today can be said to be run – far-fetched
though this may seem – not only for profit but for
the media. War itself is simply an event 'fabricated
to be photographed', albeit on a vast, inhuman
and immoral scale.

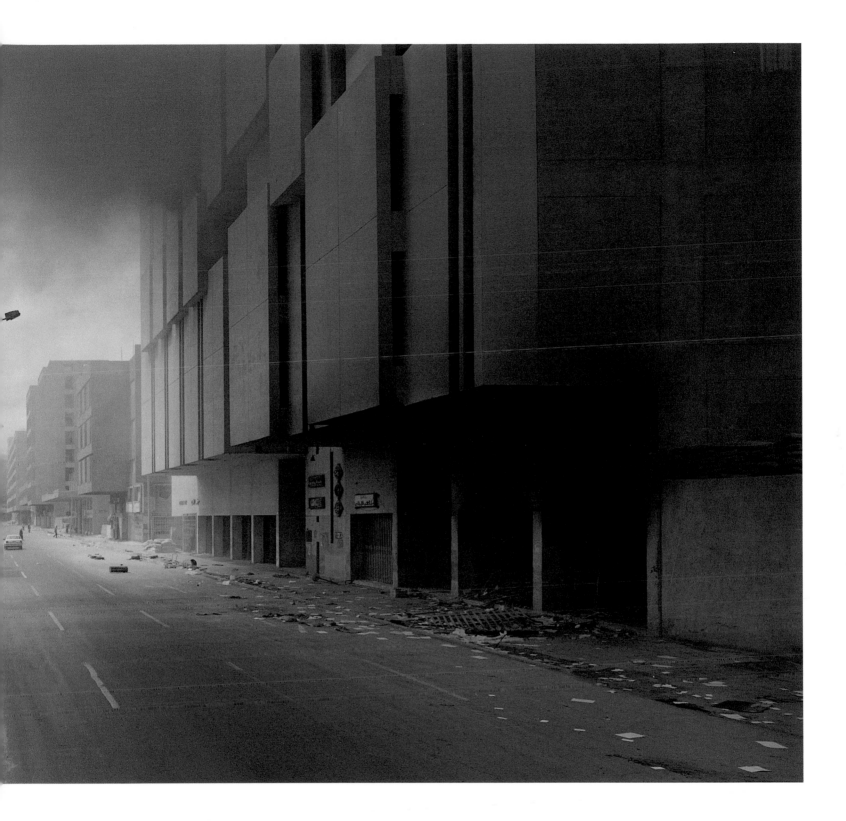

Luc Delahaye first rose to prominence as a photojournalist, covering wars that have continued almost unabated to the present day. He now regards himself as an artist and in 2001 began the series *History*, an important work that says much about the issues surrounding contemporary documentary photography.

Henryk Ross was appointed official photographer by the Jewish council of Lodz ghetto in Poland and took thousands of pictures documenting life there before most of its inhabitants were deported to the death camps.

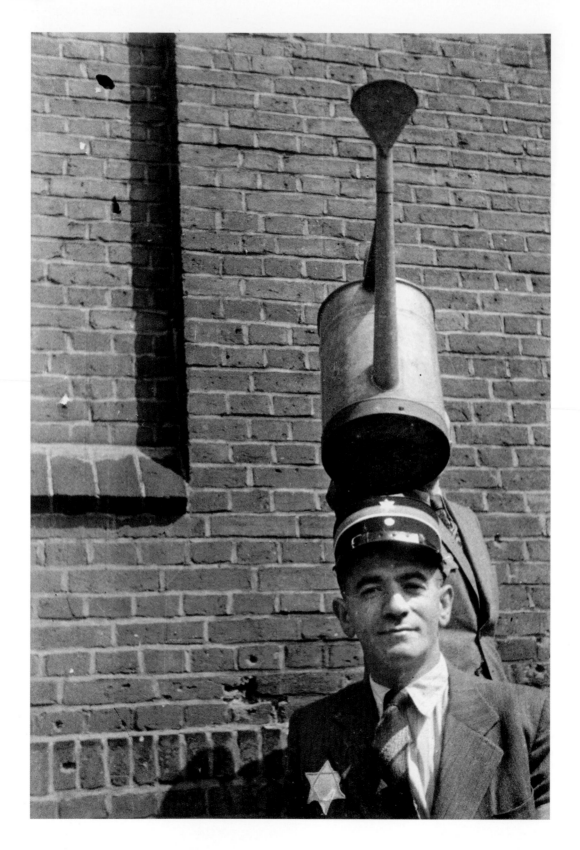

Ross himself survived, buried some six thousand negatives and returned after the war to retrieve them. They tell a fascinating and harrowing story, painting a two-sided picture of ghetto life.

Henryk Ross (Polish, 1910–91)
Lodz Ghetto 1944
Gelatin silver print

As an official photographer, Ross was obliged
to photograph the sanctioned view of the Lodz
ghetto, and that meant the social life of the
Nazi-appointed Jewish administrators, under
the direction of the notorious Chaim Rumkowski.
Ross photographed weddings, bar-mitzvahs,
parties and other gatherings, showing apparently
happy and well-fed people, the ghetto elite,
such as this young man clowning for the camera.

But secretly, at some risk to himself, Ross
was also photographing the starving majority
of the inhabitants, the executions, and the
deportations, with people being herded into
a truck marked 'Gas 1'.

The two sides of Ross's practice have proved
controversial. Some have felt that by working for
Rumkowski Ross received privileges other ghetto
inhabitants did not get, and by presenting an
'official' view, he in effect collaborated with the
Nazis. Others have pointed out that Ross did
record the more harrowing aspects of the ghetto,
not without danger, and that the archive is a fully
rounded and valuable document.

In the end, those who ran the ghetto for
the Nazis did not themselves escape the death
camps, and perhaps the unexpected photographs
of more 'normal' aspects of life are therefore the
most poignant. And while it is true that some Jews
aided the Nazis by administering the ghetto, for
whatever reasons, only those who were there, or
in similar situations, can judge the compromises
made to remain in such a terrible place.

The unruly image

In photographing history, context is everything. Everything is
open to interpretation, and reinterpretation. Capa was furious
when one of his pictures appeared in a right-wing magazine,
cropped, and suggesting a meaning quite the opposite to that he
had intended. Many photographers – Henri Cartier-Bresson being
a notable example – will not allow their pictures to be published
unless uncropped, or in an approved cropping. This is not just
an aesthetic fad. It is a question of authorship.

But when a photographic story is published, just who is the
author? A photographer takes a group of pictures, yet other
people make decisions about the published work – editors who
select and sequence the images, designers who lay them out,
giving prominence to some, playing down others, even writers
who provide captions. And what about the company they keep?
The meaning a photographer gives initially to his or her
photographs can be totally distorted in the publishing process,
even by a magazine that is essentially on the photographer's side.
And that is assuming the pictures are published at all.

Life magazine could happily show the 'reality' of war with
Capa's images from Spain or from the Japanese invasion of China
in the late '30s, for the corpses they graphically depicted were
foreign, not American. And the same magazine rushed Capa's
D-Day photographs into print, but would they have been so eager
if the landings had been unsuccessful?

During the Second World War, government censors in the
United States and Britain dictated what information – and that
included photographs – was given to the public at home. Showing
the dead of one's own side was usually prohibited, and corpses
tended to be shown only when it was clear what the outcome
would be. Then, at the end of the war, the facts of the Holocaust
were released to a horrified public, partly because they needed
to be, and partly as a justification for the sacrifice of war. 91–92

Strict control of photographic information in wartime, even in
countries with a nominally free press, is the norm. But it is always
more difficult when the war is an unpopular one, or becomes
unpopular. The one war which appeared to escape American
government control was Vietnam, largely because it was the first
television war, and almost instantaneous images were beamed
into American living rooms. It is often contended that these
unruly pictures, including images of American casualties, began
the anti-war movement, but this is not quite true. Photographs do
not influence politics. It is the other way round.

Nevertheless, photography's perceived role in undermining
American nerve in Vietnam has meant that, in later wars in which
the West has been involved, the media have been much more
tightly controlled. British photographer Don McCullin, who made 111
such memorable images in Vietnam, was refused accreditation to
cover the Falklands War. And the first Gulf War, between Bush Snr
and Saddam Hussein, was perhaps the most controlled of all, with
most pictures coming from weapon-system cameras operated by
the coalition forces. It was a war apparently without death, a high-
tech, video-game war, fought out of range of the on-the-ground
press and their cameras. Only at the end, when Iraqi forces fleeing
on the road to Basra were mauled mercilessly from the air, did an
iconic image of the twisted and charred corpse of an Iraqi bring
home the reality. And that image was quickly suppressed.

Walter Hahn (German, 1889–1969)
Incinerating corpses in the old market, Dresden,
25 February 1945
Gelatin silver print

On 13/14 February 1945, the RAF and USAF dropped hundreds of tons of incendiary bombs on the city of Dresden. The exact number of civilian dead has been a matter for conjecture, though it was less than the figures propagandists have bandied about.

The Dresden bombing caused controversy amongst historians. Some have claimed it was unnecessary. The war had been effectively won, and Dresden was a largely civilian city that contributed little to the German war effort. Others, however, have claimed that, while Dresden may not have had heavy industries, it was a leading centre of precision manufacturing, especially of optical instruments that had many military applications. The bombing of Dresden, they have argued, was entirely justifiable, and in the long run helped to prevent casualties.

The controversy is alive to this day, with some asserting that the fire bombing of Dresden was simply a vindictive way of punishing ordinary Germans, and should be seen as a war crime.

In 1949, local Dresden photographer Richard Peter published *Dresden: A Camera Accuses*, a book which ran to an edition of fifty thousand and showed eloquent pictures of the city in ruins, a mute, poetic accusation against the British and Americans – by then, of course, the Democratic Republic's capitalist enemies in the West.

At the time of the bombing, the most graphic photographs were taken by Walter Hahn. He took many horrific pictures of the charred corpses laid out in rows on the streets, or piled high like stacks of cordwood. This image testifies that, whatever the rights and wrongs, war itself is a crime.

Photographic images were used to show that German civilians had suffered as much as anyone else during the Second World War – and the focus of this effort was the Dresden bombings.

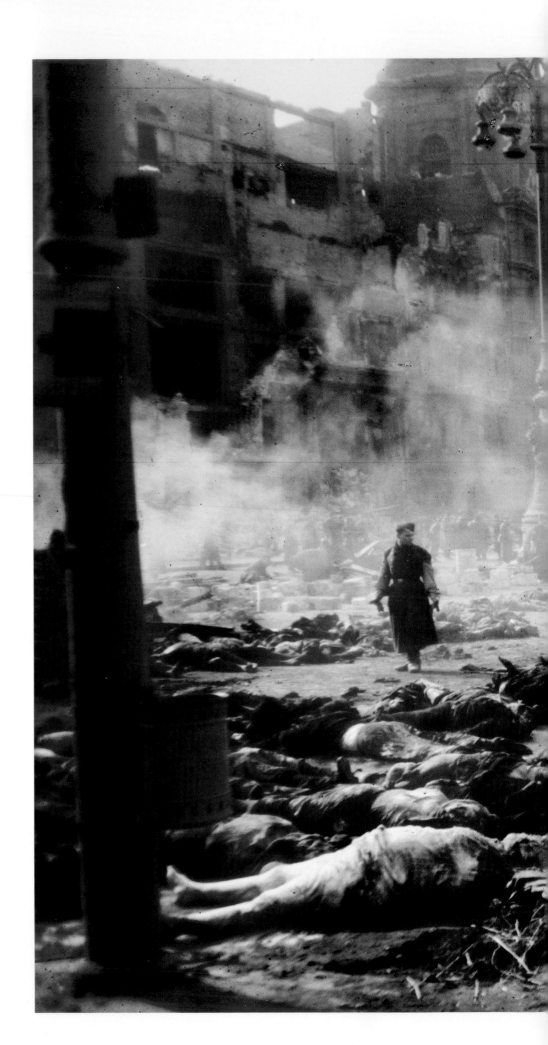

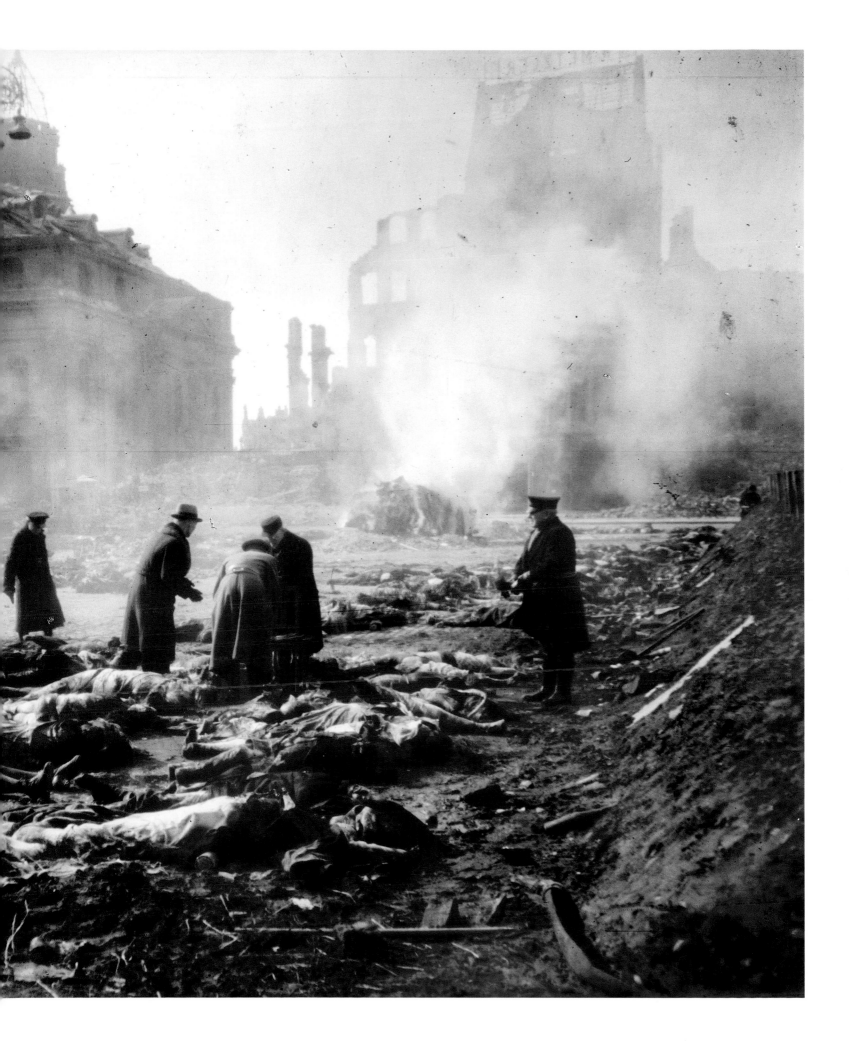

Snatching the significant moment

In 1952, a leading French photojournalist, Henri Cartier-Bresson, published a book of his pictures. It was a book which not only made him one of the most renowned photographers in the world, but introduced a new and very persuasive way of thinking about photography. *The Decisive Moment* was not the book's original title but that of its English-language version. Its original French title, *Images à la Sauvette*, means images taken on the wing, on the 'fly' – stolen images – a somewhat less positive connotation. But the idea of the 'decisive moment', the instant when a prescient photographer anticipates a significant moment in the continuous flux of life and captures it in a fraction of a second, has become one of the most seductive notions in photography.

It is a notion often misunderstood. The decisive moment is not necessarily the instant of peak action – the soldier dropping as the bullet hits him in Capa's picture, the woman denouncing a suspected Gestapo stool pigeon in an image Cartier-Bresson took at the end of the war. It refers, rather, to the moment when every element in the viewfinder coalesces to make a picture, an image. And that is open to misinterpretation too, because it could be taken to mean the coming together of the picture in formal terms, the point at which every formal element is in a state of balance, in perfect harmony. That also is frequently the case, but a photograph where every formal element is perfect is not necessarily the decisive moment either. In fact, the decisive moment is better defined as the moment when form and content come together to produce an image in which the formal, emotional, poetic and intellectual elements have substance – in effect, where they give an image a real meaning.

There is a copy of *The Decisive Moment* in the library of another well-known photographer, one of Cartier-Bresson's colleagues in the Magnum photo-agency. Cartier-Bresson has inscribed the title page for his friend and fellow seeker after photographic truth, altering the book's sacred title as follows:

Some ~~THE~~ DECISIVE MOMENTs (maybe?)

From that inscription, tongue-in-cheek though it may be, it is clear that the photographer was well aware of the paradoxes involved in snatching a moment out of the air and freezing it, dislocating it from its context, and conferring upon it a significance it may or may not be able to bear. A picture has been created, but a picture of what? He was afraid that in the wrong hands photography of this kind could simply reduce the world to a series of clever patterns, visual jokes and, worst of all, anecdotes, which he considered the '*enemy of photography*'.

Henri Cartier-Bresson (French, 1908–2004)
Dessau 1945
Gelatin silver print

At the time he made this famous photograph, Cartier-Bresson, who had worked as a film cameraman before the war for directors such as Jean Renoir, was making a film for the American Office of War Information. Called *The Return*, it documented repatriation from the Nazi camps. Prisoners freed by the Allies could not usually return home immediately, and were housed in transit camps while they waited to be processed. This scene took place in a transit camp near Dessau, run at the time by the Americans but soon to be handed over to the Soviets.

A colleague of Cartier-Bresson's, standing beside him, shot film footage of this drama, as a French detainee accused another woman of informing for the Gestapo. She yelled at the woman and hit her in the face, bloodying her nose, but the frame Cartier-Bresson chose to print from those he shot was one taken when the French woman began to berate the accused, a classic moment that came to symbolize Europe in 1945, and also the concerns of Magnum, the photo-agency he helped to found in 1947.

The decisive moment is sometimes but not always also the historical moment. But here Cartier-Bresson has organized all the elements in the frame, caught a moment of peak action ...

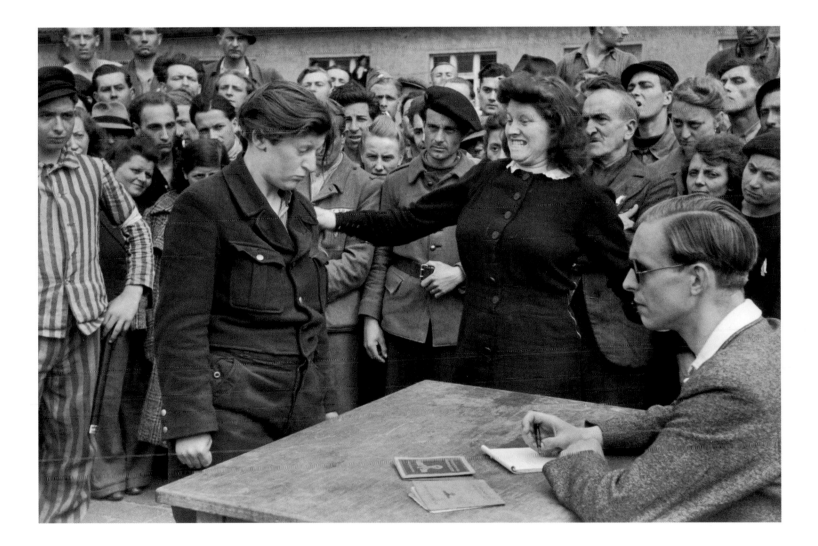

... and made a photograph that is a witness to a particular moment in history. We are there –
in 1945, the half-year or so when the infamies of the Nazis became known to a shocked world.

Robert Doisneau (French, 1912–94)
The Kiss at the Hôtel de Ville, Paris 1950
Gelatin silver print

Robert Doisneau was arguably the epitome of the feelgood humanist photographer. And, like Henri Cartier-Bresson, he was the photographer post-war European photography needed. His pictures were often humorous, and they skirted, but – most of the time, at least – never quite crossed the fine line between sentiment and outright sentimentality.

He was also the post-war photographer *par excellence* of Paris, associated with the city as much as Atget or Brassaï. But whereas Atget had more than a hint of elegiac melancholy about his vision, Doisneau photographed Paris with a smile. His vision, which was just as fictional as Atget's, was tied to a cultural and populist view of the city rather than anything more personal.

The Kiss was part of an assignment to show Paris as the city of romance, and was originally published on a double-page spread in *Life* magazine showing couples kissing passionately.

Doisneau later admitted using actors for all of the shots so that he could opt for slowish shutter speeds and depict each pair of lovers as a still centre around which the rest of city life swirled. At first, the picture attracted little attention. It was not the lead image in the story. But gradually it engaged the affections of poster-buying visitors to Paris – a set-up decisive-moment image that not only caught a post-war mood perfectly, but confirmed the reputation of the French capital as the city for lovers.

Robert Doisneau's *The Kiss at the Hôtel de Ville* has become one of the most iconic photographs of all time, and one of the best-selling photographic posters. We know now that Doisneau's best-known photograph was staged with hired models to act as the young lovers kissing passionately in the street, but that has not diminished the popularity of the image one iota.

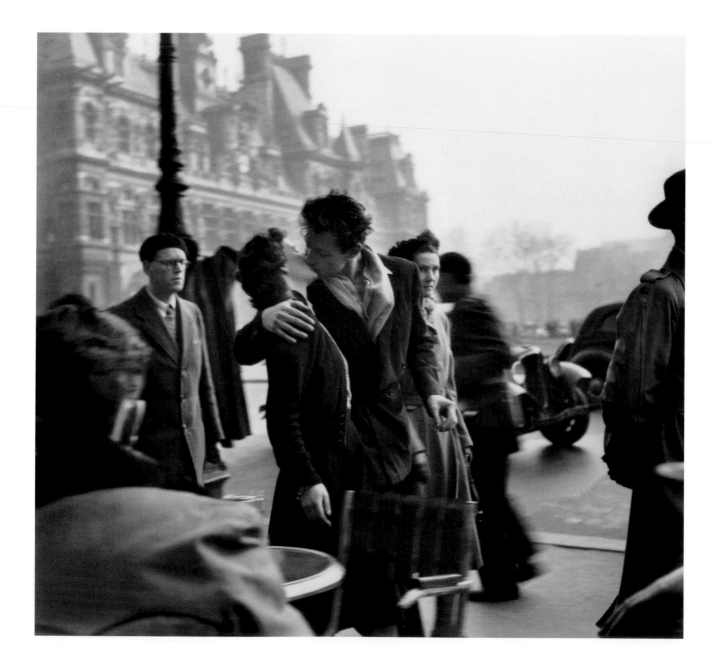

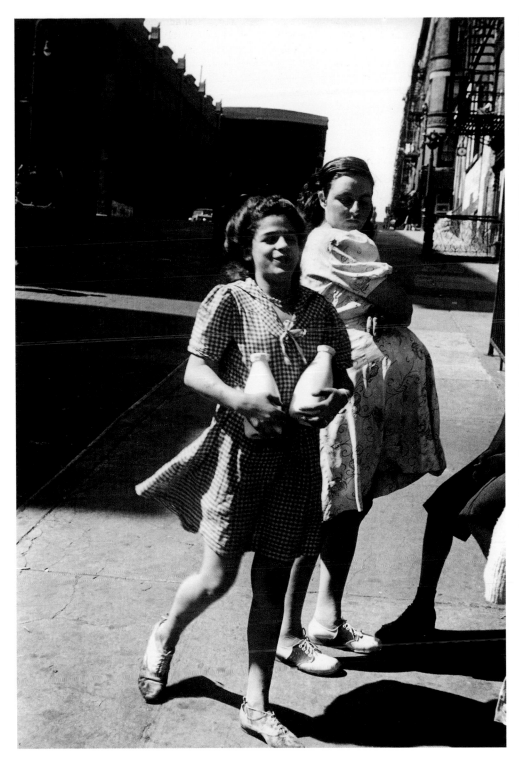

Helen Levitt (American, b. 1913)
New York c. 1942
Gelatin silver print
From *A Way of Seeing* 1965

Max Kozloff has written that Levitt always kept her distance from her subjects, but that it was a warm distance, and this sums up her style exactly. She was sharp, even tough, in her approach, and wholly free of the smug sentimentality that could afflict even the best of the French humanist photographers. One might say that Levitt practised a streetwise New York version of the humanist approach, a slightly more brittle humanism that, although in the main optimistic, still retained a trace of hard-bitten realism.

Levitt, too, did not subscribe to the perfection of the decisive-moment approach. Her pictures could be a little awkward in composition, slightly off-kilter. She was not so much interested in obtaining a perfect composition as an image that captured the energies of the street, and if the picture was a little rough around the edges, so was the street.

It took her some time to win the reputation that her photographs deserved, possibly because she was a woman, possibly because her imagery apparently dealt with small rather than large themes. This is a typical Levitt picture, two teenagers strutting their stuff on a street in uptown New York, the bottle girl clearly making fun of her pregnant friend. It's a photograph that doesn't pretend to be candid, but retains an air of absolute spontaneity. Above all, it crackles with street energy. One can easily imagine the exchange of repartee between Levitt (by all accounts a feisty woman) and her young subjects.

Helen Levitt's New York portraits of children, made mainly in the 1940s and '50s, are among the most joyous examples of the street-photography genre. Taken in mainly poor areas, including Harlem, Levitt was never condescending towards her subjects, and hers is not a sentimental view.

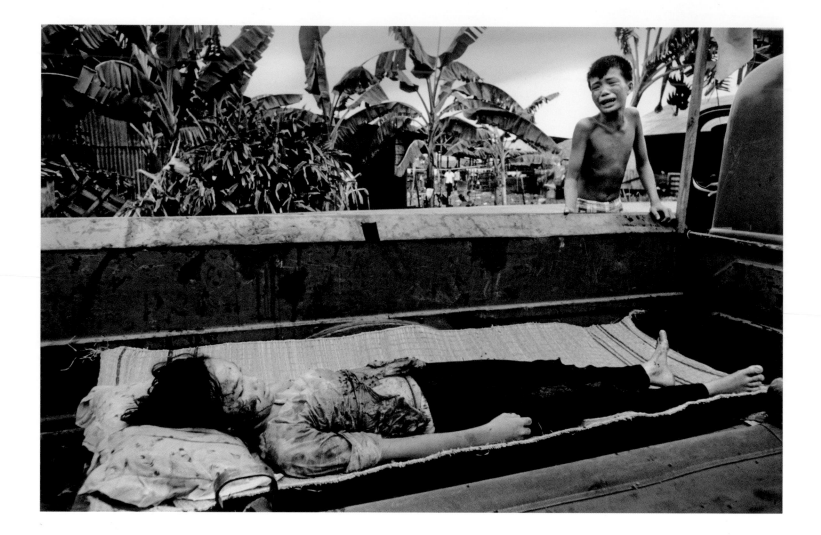

Philip Jones Griffiths (Welsh, b. 1936)
Boy with Dead Sister, Saigon 1968
Gelatin silver print

There are, broadly speaking, two approaches to photojournalism. There is the approach that tries to maintain a distance, a cool objectivity, and the approach that is involved, that is pointedly political. In his 1971 book *Vietnam inc.*, Philip Jones Griffiths adopted the latter approach. He believed that the United States' involvement in Vietnam was wrong and set out to show why.

This is not to say that Jones Griffiths forgot his obligations as a reporter. Each photograph shows what it shows – here, a dead child in the back of a truck. But that single photograph, though a powerful and moving demonstration of war's horrors, tells us nothing – except that children become caught up in the horror. For many photographers, that is enough, but Jones Griffiths aimed to take photographs as building blocks in a larger structure.

Recognizing that the meaning of a single photograph can be highly ambiguous, he used the form of the photobook to build up both a narrative and an argument, combining sequences of photographs and text to set out his treatise for the viewer. The result was the best photobook to emerge from the Vietnam War, an exemplary demonstration of how to argue a case using documentary photographs.

The Vietnam War was essentially a colonial war, he argues, a brutal crushing of freedoms in the name of 'freedom'. It became a disaster for the United States because politicians in Washington had little understanding of the country in which they were intervening:

The American miscalculations made in Vietnam are overshadowed by and stem from the folly of the original view that deemed it possible for a society like America's to impose itself on that of the Vietnamese.

Status and control

Five years before the publication of *The Decisive Moment*, in 1947, Cartier-Bresson had been given the accolade of a retrospective at MoMA in New York. It had been rumoured that he was killed in the war, so the museum staff were delighted when he was able to come to New York to prepare the show himself. While there that year, he met up for lunch in MoMA's penthouse restaurant with two friends from pre-war Paris, Robert Capa and David Seymour (known as Chim), and an American colleague, Bill Vandivert.

Besides the pleasure of eating non-rationed food, the talk was of the future and the post-war market for photography. Following the conflict, the issue of control, of self-determination, had become a pressing one for photographers. They had endured censorship during the war, but that was only part of it. Many sensed that, following an inevitable period of reconstruction, new markets would open up for reportage photography.

For some time before this lunch, the four had been discussing Capa's idea for a cooperative agency run by photographers, in which the members would retain ownership of their pictures' copyright, rather than the magazines who commissioned stories (the normal practice at that time). If members owned their copyrights, they reckoned, they could generate multiple reproduction fees on photo-essays and individual photographs, giving them income which they could plough back into their own projects and these could also be sold on. The deal was clinched over lunch, and (the story goes) Capa, being a lover of the good life, suggested the name 'Magnum', after his favourite tipple.

The founding of Magum was not just about the economics of photographing for the illustrated press. It was also about the status of the photographer, and a raising of the standards of reportage photography. The five founders of Magnum (the fifth was George Rodger, not present at the famous lunch) were not only concerned about getting a degree of control and financial independence in their work. They were also aware that there was a lot to photograph, and many potentially interesting stories to be tackled. Europe and Japan were being reconstructed after the war, many colonial states, such as India, were clamouring for independence, and the state of Israel was in the process of a troubled birth. The latter was of particular interest to Capa and Seymour, who were both Jewish.

Bill Vandivert soon dropped out and Magnum's remaining founders – Cartier-Bresson, Seymour, Capa and Rodger – decided to divide the world between them in terms of photographic coverage. Cartier-Bresson chose the Far East, Seymour Europe and the Middle East, Capa had a roving brief, and Rodger, still shaken by Belsen, went off to Africa, '*to get away where the world was clean*'.

Cartier-Bresson's decisive moments would define the aesthetic of post-war photojournalism – the roving reporter with the small camera capturing those little magic moments that explain man to man. But Magnum as an institution defined the ethic of the calling, and laid out its scope and its ambition.

Eddie Adams (American, 1933–2004)
Execution of a Suspected Vietcong, Saigon 1968
Gelatin silver print

This picture raises many questions about news photography and its ethics. Firstly, was the man killed because the news media were gathered around? There can be no categorical answer, but it would not be the first or the last time that the press have provoked events. And how many more atrocities are committed off camera? On balance, independent witnesses to such events are better than no witnesses at all.

Secondly, however perfect an example of the decisive moment, however effective as an image that made a real difference, the picture bears only a tangential relationship to the actual event. That is one of its miracles. It is both a devastatingly accurate report of what happened and a total distortion.

Adams's photograph froze a micro-second and monumentalized it, turning it instantly into an iconic moment of great import. But the moving-picture footage taken of the event, which is clearly shocking, says something else. The film shocks because the execution was so casual – a human

life was snuffed out almost without thought. There was no iconic moment. The gun was placed to the head and the trigger pulled almost in the time it took Adams to press the shutter.

The whole episode is exemplary – as a demonstration of the power of still photography, as a justification for honest reportage, and as a pointed example of the differences between media. It also reminds us of man's inhumanity to his fellow man.

When Nguyen Ngoc Loan, the Saigon chief of police, held a revolver to the head of a suspected Vietcong, Eddie Adams raised his camera to his eye, just in case. The policeman fired, and Adams instinctively pressed the shutter, creating a photographic icon of the Vietnam War, and an image that fuelled anti-war sentiments in the United States.

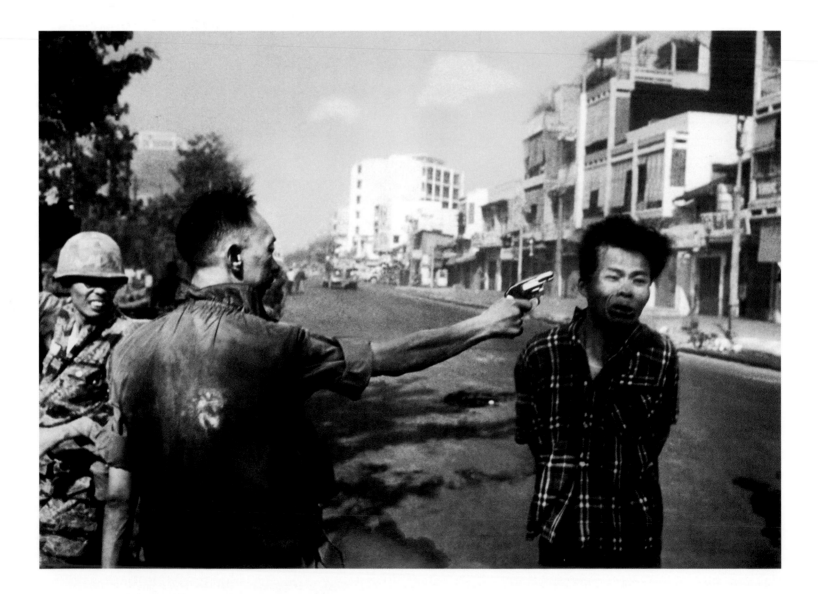

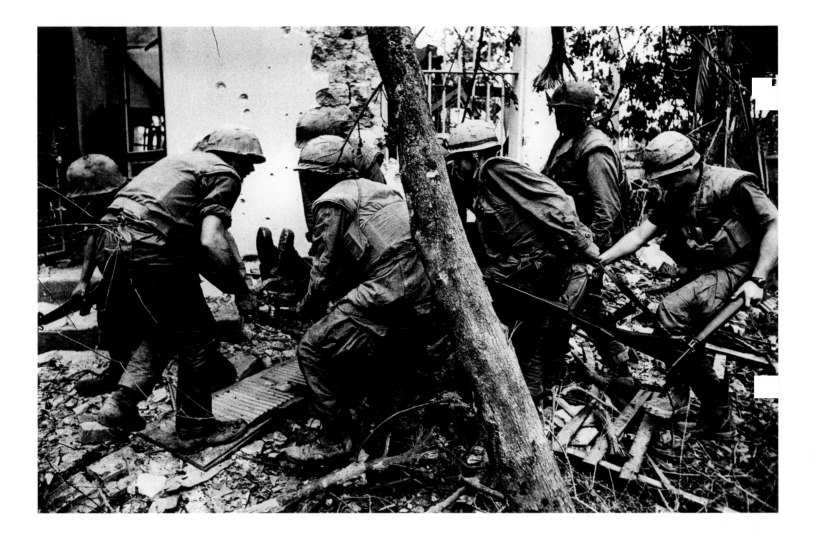

Don McCullin (English, b. 1935)
US Marines Evacuating Wounded Buddy, Hue
1968
Gelatin silver print

Without criticizing his ability to construct powerful picture essays, it seems fair to say that McCullin's forte as a war photographer was the taking of memorable individual images. In all the conflicts he covered from the 1960s to the '80s – Cyprus, Biafra, Vietnam, Cambodia and Palestine – he was responsible for some of the most iconic photographs to emerge from each.

That is, he has been the author of some of the most instantly recognizable war photographs of the past fifty years. Those who have never been in a combat situation can have little idea of the qualities required by a photographer such as McCullin. The courage needed wilfully to take oneself into dangerous areas and the discipline to photograph calmly, to the best of one's ability, in situations where nerves are stretched to breaking point are equally extraordinary. The photographer who can compose elegant (if that is the right word) photographs in such conditions is rare, and McCullin was consistently at the top of this particular tree during his estimable career as a war photographer.

This complex and graphic image – worthy of Goya – comes from one of the Vietnam War's few major battles. The war was essentially a guerrilla affair, a war of attrition, but at the beginning of 1968 North Vietnamese army forces launched the Tet Offensive. One of their strategic targets in a countrywide series of attacks was South Vietnam's third largest city, Hue, which they captured and held for twenty-five days. McCullin's image of marines carrying away a wounded buddy was taken during the bitter struggle to retake the city, as US marines and the South Vietnamese army fought pitched street-battles with communist forces. When the city was retaken, it was discovered that over three thousand of its citizens had been murdered in one of the war's many atrocities.

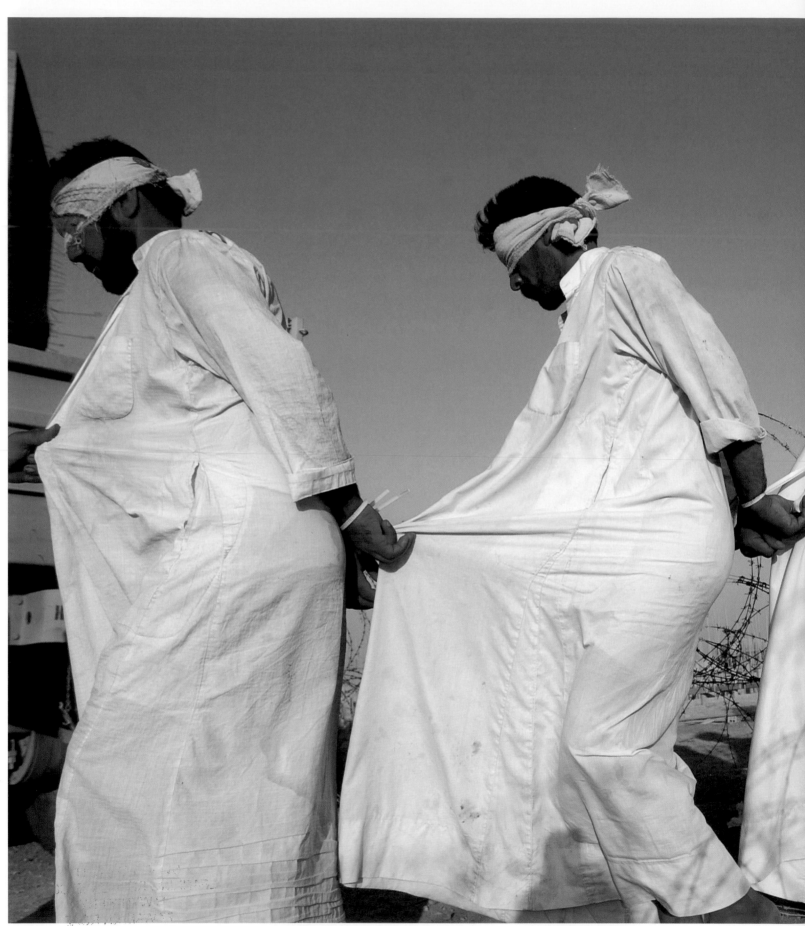

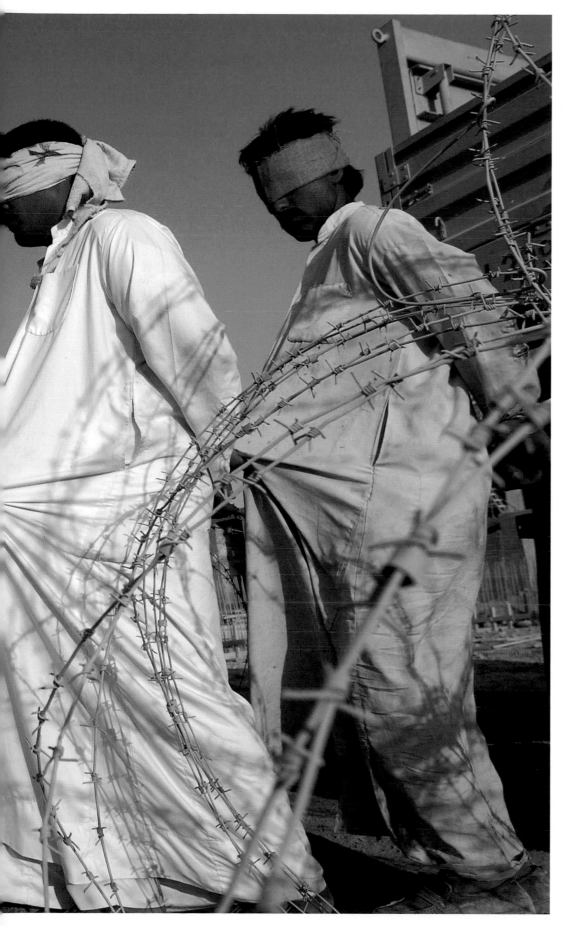

Geert van Kesteren (Dutch, b. 1966)
Now They Gonna Do the Elephant Walk, Tikrit, Iraq
2003
Chromogenic (Type C) colour print
From *Why Mister Why?* 2004

During the Vietnam War, two books criticizing the United States' intervention in a culture the administration misunderstood were made by photographers David Douglas Duncan and Philip Jones Griffiths. Today, the rhetoric of both photographs and text in Geert van Kesteren's book on Iraq, *Why Mister Why?*, is uncannily similar to that of those earlier books.

Van Kesteren, a Dutch photojournalist, was 'embedded' with US troops for *Newsweek* magazine. He went to Iraq in 2003 with an open mind, but what he saw compelled him to make the book, with its questioning title. 'Why, mister? Why?' was apparently what so many Iraqi kids were asking the American troops.

Of course, the book raises questions, not only about US policy and its rights and wrongs, but about news photography itself. Van Kesteren has taken care to be as even-handed as possible – he shows victims of Saddam being exhumed, for instance – but his story is mainly one of a hopeless clash of cultures.

And yet even here we need to be careful. War is a brutal business, and any photographer embedded with troops is going to witness brutalities. The image here shows a line of bound, blindfolded Iraqis. It is easy to read mistreatment into this single picture. But we do not know the circumstances, although Van Kesteren amplifies the situation with other images. Still we cannot know all the facts, even though in the book's introduction senior *Newsweek* editor Michael Hirsh writes: '*American power went from being an accepted enforcer of last resort to an unrestrained force acting arbitrarily*.'

One thing seems clear. To get somewhere near the truth, we need responsible witnesses like Geert van Kesteren, and we need books like *Why Mister Why?*, which attempts to give us a credible picture of this unholy mess.

W. Eugene Smith (American, 1918–78)
The Walk to Paradise Garden 1946
Gelatin silver print

W. Eugene Smith's great picture of redemption, *The Walk to Paradise Garden*, was initially rejected by *Life* magazine because the children's faces could not be seen. But it became one of the signature images in Edward Steichen's 1955 exhibition, *The Family of Man*, chosen to be the last impression visitors would have as they left the show.

The image of the two children walking hand in hand up a dark woodland path towards the light clearly symbolized hope for the future. Indeed, the whole exhibition signalled that, for the United States at least, it was time to call closure on the Second World War, and that if the whole world adopted American values, then these children and others like them would have a better future than their parents.

For Smith too, the photograph – apart from being a snapshot of his children – had great personal significance. In May 1945, when covering the Okinawa campaign, Smith had been severely wounded, and had spent more than two painful years and several operations recovering. When he could finally bring himself to pick up a camera again, *The Walk to Paradise Garden* was allegedly the first picture he made, so it signifies for him a rebirth.

Named after the intermezzo in Frederick Delius's opera *A Village Romeo and Juliet*, the photograph is clearly on the sentimental side, as indeed was *The Family of Man* – and much criticized for it. But sometimes sentimentality has its place. And Smith's simple snapshot of his children, sentimental or not, regenerated his life and his distinguished career.

The concerned photographer

The cultural landscape of post-war Europe was dominated by two intellectual ideologies, largely but not wholly contrasting, which marked cultural life in general and could not fail to touch photography. In broad terms, they exemplified positive and negative reactions to the war. On the negative side, so to speak, was a philosophy that denied, or sought to redirect, our social impulse. We had made such a mess of things that the only sensible thing to do was to retreat inwards, into the self, and be responsible solely for one's own actions. That philosophy was existentialism, and its basic tenet of faith was that '*the individual defines everything*' – a precept which found a ready response amongst some photographers.

Magnum, however, exemplified the positive response to the war, and one rooted in the social. This was the humanist approach, and for a time it was even more prominent than existentialism in the arts and photography. The small-camera documentary photography style of pre-war days took on a new note of social concern, exemplified by Capa, Cartier-Bresson and their fellow Magnum photographers, and became known as the 'concerned photographer' approach. The hardness of 1930s social-documentary photography, with its surreal and voyeuristic edge, became softer, more lyrical and, above all, less cynical. As Jean-Claude Gautrand has written:

> *During the 1950s, the need to rediscover and celebrate human dignity was even more acute after five horrific years of war.*

This is not to say that the world's problems were ignored – the death, disaster and destruction hardly paused with V-J Day – but many photographers actively attempted to be more empathetic than intrusive, and recorded the banal and the routine rather than the overtly exotic. They actively promoted such values as hope and courage, and introduced a gentle humour into photography. It was very much a French mode, seen in films and novels dealing with the working and *petit-bourgeois* classes, and centred on the old working-class suburbs of Paris, which were undergoing rapid change. Photographers such as Robert Doisneau, Isiz, Willy Ronis, as well as Magnum members like Marc Riboud and, of course, Cartier-Bresson, define the essence of this approach, which became popular worldwide, partly because of its humanist positivism, and partly because the idea of the lone photographer roaming the city streets with a small camera, capturing life's small moments on the wing, was such a seductive one.

In the post-war period, one photographer came to epitomize the crusading wing of photojournalism, both in his independence and in his sense of the craft's moral imperative. W. Eugene Smith had been, like Robert Capa, a star war photographer with *Life* magazine. He was badly wounded in the Pacific, and after a long convalescence it is said that he restarted his photographic career by making a picture of his two young children, walking hand in hand up a wooded path towards a clearing suffused with light, a photograph he somewhat pretentiously called *The Walk to Paradise Garden*. The picture was hopelessly sentimental, but it expressed an element of hope following the defeat of fascism.

Smith went on to create a number of classic picture stories for *Life*. He was characterized by his intense, idiosyncratic style and by the rows he had with the magazine's editors. He walked out, or was fired, several times in his tempestuous *Life* career. For Smith,

photojournalism was an artform, and he was its primary artist. He would spend months rather than days or weeks on an assignment, ignoring budgetary constraints. He insisted on painstakingly making his own prints, which were usually very dark, full of Rembrandtesque *chiaroscuro,* and which he further exaggerated with chemical retouching. Then he would insist on laying out and designing his own stories – and that inevitably required twice the number of pages allocated. In short, as more than one editor at *Life* put it, he was '*a pain in the ass*'. And yet the results he produced seemed worth all the trouble.

From the perspective of 1950s America, they were. The country – or rather its suburban consensus – was enjoying unprecedented prosperity under Eisenhower, with the 1930s, for many people, just a bad memory. Smith's best-known *Life* stories – *Country Doctor* (1948), *Nurse Midwife* (1951), *Spanish Village* (1951) and *Man of Mercy* (1954), a look at medical missionary Dr Albert Schweitzer's work in Africa – were perfectly in accord with the times. They showed an empathy with their subjects, they were positive in outlook, and they were more than a little sentimental in tone. But Smith was a strange mixture. There was toughness as well as sentimentality, and his own contradictions seemed to exemplify the contradictions, not only of photography, but of photojournalism. Smith himself put it very well:

> *I am constantly torn between the attitude of the conscientious journalist who is a recorder and interpreter of the facts and of the creative artist who often is necessarily at poetic odds with the literal facts.*

In 1955, Smith and *Life* parted company yet again, and he joined Magnum. The agency secured him an assignment to photograph Pittsburgh, Pennsylvania, for a book by Stefan Lorant, a job that was expected to last a couple of weeks and produce a hundred or so photographs. Two years later, the Pittsburgh project totalled many thousands of negatives, and Magnum was out of business, having subsidized Smith while he turned down other assignments so he could complete the story as he saw it. Finally, when Magnum managed to sell the story to *Life* for a substantial sum, Smith turned it down because the magazine would run only half the number of pages he felt the essay deserved. The Pittsburgh story was never published to Smith's satisfaction, and it was no surprise when he left Magnum in 1958.

After this, his photojournalistic career lost focus somewhat, but then, in the early 1970s, he went to Japan and made the story which probably comes closest to realizing his aim of welding committed journalism and fine photography in a complex narrative. He photographed the fishing community of Minamata, affected drastically by mercury poisoning from the waste dumped into their bay by a nearby factory. Smith was badly beaten up by thugs employed by the factory's owners, but still completed the project, which became a *cause célèbre* in Japan when it was published in 1975 as a powerful book.

The highpoint of the humanist tendency is usually considered to be Edward Steichen's 1955 exhibition at MoMA – *The Family of Man*. The exhibition certainly lived up to its claim to be the 'biggest photographic exhibition of all time', and was one of the most widely seen, but it also highlighted the contradictions of the humanist tendency in photography. The exhibition's origins, it is frequently contended, lay with Magnum, and was one of the first

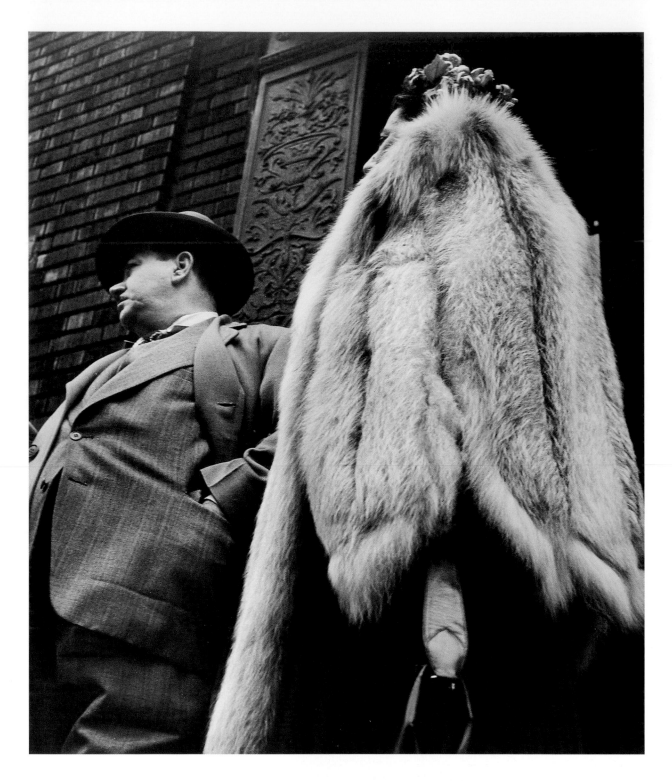

Leon Levinstein (American, 1910–88)
Untitled, New York City 1954
Gelatin silver print

For many years, Leon Levinstein had a 'day job'
as a draughtsman, but he was still an eminently
serious and assiduous hunter of photographs on
the streets of New York. He favoured a medium-
format, twin-lens reflex camera and a ground-
glass screen held at waist level so that he could
photograph unobserved.

Levinstein worked within the tradition of the
Photo League, so one could characterize him a
humanist, but, like Helen Levitt, it was humanism
with a New York face – dry eyed and even cynical

at times. As a hunter after images, there was
more than an echo of Weegee about him, and,
like Weegee, he had a taste for the grotesque,
for larger than life characters straight out of the
Damon Runyon school of hard knocks.

By keeping his camera low and close to his
subjects, so it looked up at them from an acute
angle, he made pictures in which the figures
tended to loom diagonally in the frame. That
meant they were not only grotesque but powerful.
This image is one of the best examples of his
method. The fur-coated woman towers over
the snub-nosed man. We do not see her face,
and can only guess at their relationship, but that,
of course, is the picture's point. Yet, short though

he seems, the man nevertheless exudes
confidence, and the whole aspect of the picture
suggests that the relationship, whatever it is –
a wise guy with his moll? a pimp with a
prostitute? – is about money and power.

But Levinstein gives only enough information
to allow us to guess, and such fanciful notions,
although suggested by the picture's composition,
could be completely wrong. It could just as easily
be a couple out for a Sunday afternoon stroll.

Of the many pictures Joan Colom made during the late 1950s and '60s in his documentation of the Raval – the Chinese quarter of Barcelona – the most evocative are of the area's prostitutes. The Raval is a dangerous place, and Colom usually shot with his Leica down by his side, without looking through the viewfinder, the low angle forcing a concentration upon bodies and bodily gestures.

Joan Colom (Spanish, b. 1921)
Raval, Barcelona c. 1958–61
Gelatin silver print

Colom was reportedly annoyed when only his shots of prostitutes were used in *Harlots, Whores and Strumpets* (1964) by the writer José Cela. But that was, after all, the book's subject, and they are both a unified group and brilliantly evocative of this old, raffish district of Barcelona. Comparable to Brassaï's photographs of prostitutes and their clients in the Paris of the 1930s, Colom's images, like those of Leon Levinstein, were often shot from a low level and have a peculiar air of having been taken on the sly, as if through a keyhole or window. They were basically portraits of the girls, shot singly or in pairs, sometimes interacting with clients. And it is bodily gesture that is the most startling feature of his work, the means whereby he could vividly evoke individuality and character.

Like Edgar Degas in his brothel pictures, Colom sometimes caricatured his subjects. But, whereas there seems always to be a hint of misogyny in Degas, there is none in Colom. His pictures were sharp, even funny, yet always sympathetic. They might not have worked so well as documentary – one might suppose Colom had a fetish for breasts and buttocks, so often did he photograph these features – but that, of course, is precisely what attracted the clients.

Looking at this particular picture, one cannot help but smile. The whole transaction is sketched in without sentimentality, yet with a sympathy for the woman that is as manifest as that of Bellocq.

big projects they attempted. John Morris, an early friend of Magnum and picture editor of the *Ladies' Home Journal*, had commissioned Capa, Seymour and Rodger to look at the daily lives of people worldwide. *People are People the World Over* was begun in 1947, and eventually ran for twelve months in the magazine, featuring individual stories like *This is the Way the World Washes*, or *This is the Way the World Shops*.

The theme of people are people the world over appealed to Steichen, and he decided to mount a blockbuster exhibition at MoMA on this topic. After much preparation, *The Family of Man* opened in 1955, featuring 503 photographs by 273 photographers, both professional and amateur, from 68 countries. As the title indicates, the primary aim of the show was to reinforce the notion that the human race is one vast family, not necessarily a happy family, but one in which individual members were the same under the skin, sharing the same hopes, fears, problems and joys.

Steichen was attempting to make a populist exhibition, with an upbeat message, and in this he certainly succeeded. Photographically, it focused primarily upon photojournalists of the humanist school, becoming the biggest photo-essay of all time, one might say. The show travelled worldwide (most notably to Moscow) under the auspices of the United States' Information Agency, and the book has been continuously in print ever since. It was an exhibition that was loved by the public but heavily criticized by intellectuals, for whom it made an easy target.

It was attacked for its sentimentality and its simplistic message, which was as schmaltzy as anything turned out by Hollywood. To run a picture story in *Ladies' Home Journal* on how people worldwide wash or shop is one thing – an interesting and pertinent exercise in sociological comparison. But when elevated to a single drumbeat as loud as *The Family of Man*, the message becomes so general as to be almost meaningless, appealing to the emotions of the broadest constituency and making no attempt at serious historical or political analysis. Steichen's 'universal' message ignored one vital fact. Although people on this planet do indeed have the same hopes and fears, history and politics ensure that we cannot all face those fears or realize those hopes with an equal measure of freedom, of economic power, of opportunity. As Phoebe-Lou Adams put it, in a biting review for the *Atlantic Monthly*:

> *If Mr. Steichen's well-intentioned spell doesn't work, it can only be because he has been so intent on the physical similarities that unite* The Family of Man *that he has neglected to conjure the intangible beliefs and preferences that divide men into countries and parties and clans. And he has utterly forgotten that a family quarrel can be as fierce as any other kind.*

The Family of Man removed partisan politics from its look at the world, but, like almost anything that adopts this strategy, there was a hidden political agenda. It was mounted at a time when the United States had not only emerged as the richest and most powerful country in the world, but was also engaged in a bitter struggle with the Soviet Union. The exhibition was, in fact, a projection of humanist positivist values, offering hope rather than despair, upholding the dignity of human beings certainly, yet denying so much else. And beneath the denial of politics and the lavish sugar coating, the real message was implicit. *The Family of Man* told the world that America had won the war, and that

American values were the world's pre-eminent ideology. For America itself, *The Family of Man* could be viewed simply as a statement of closure on the Second World War. Let's move on in hope, it urged. And, in spite of the sentimentality, for the whole world an exhibition of the kind was both timely and needed.

But what of the photography? The exhibition contained work by many fine individual photographers – not just most photojournalists of note, but high-art photographers like Ansel Adams and Wynn Bullock. And yet within the overall sermonizing tone of the concept, the work of many sharp, unsentimental, politically radical photographers was rendered as anonymous as any picture by an unknown vernacular photographer. Many were dismayed by this, but as John Szarkowski, who succeeded Steichen as director of MoMA's photography department, noted wryly: '*The exhibition's basic theme – that all people are fundamentally the same – required that all photographs seem fundamentally the same.*'

It has to be said that there were many wonderful individual images in the show, but the context into which they were incorporated was an unambiguous demonstration of one of photography's greatest bugbears. The fact that meaning is determined by context was driven home in spectacular fashion.

Imperatives of the self

I have talked earlier about existentialism – the negative reaction to the Second World War – and its place in 1950s' European cultural life. But existentialism had an American manifestation too. Beat – the 'beat generation' – quickly permeated the more rebellious sectors of American art. Indeed, existentialism's insistence upon the primacy of the self had political relevance in the America of the McCarthy era. With McCarthy suspicious of all those who had worked for the socially motivated federal arts programmes of the 1930s, many were being called upon to testify by the House Un-American Activities Committee. So documentary photographers and artists were adopting new strategies for expressing themselves in a political climate where dissent was frowned upon and conformity the rule.

The result was the first 'me' generation. American art turned inwards upon itself. Instead of addressing the world, it addressed the self. Art became about process – the act of making became the most important factor, as long as it expressed the spontaneous release of one's innermost thoughts. So painters flung paint onto canvas, writers scribbled down their 'stream-of-consciousness', actors used The Method and improvised to get in touch with their feelings. This is not to say that American artists were any less concerned with the state of the world, but in a repressive political era they expressed their concern first and foremost through their own direct experiences.

As writer Norman Mailer famously put it, '*On this bleak scene a phenomenon appeared: the American existentialist – the hipster.*' The hipster's answer to McCarthy, the Cold War and the dull Eisenhower years was '*to divorce oneself from society, to exist without roots, to set out on that uncharted journey into the rebellious imperatives of the self*'.

The most famous journey into the rebellious imperatives of the self was that taken by writer Jack Kerouac in his book *On the Road*, published in 1957. Written during a frantic three-week

Johan van der Keuken (Dutch, 1938–2001)
Paris Metro 1956–58
Gelatin silver print
From *Mortal Paris* 1963

Johan (Joan) van der Keuken published a renowned photonovel, *We are 17* (1955), when he actually was seventeen, photographing his teenage friends in one of the first examples of the 'snapshot' mode. In 1963, his book *Mortal Paris* became one of the monuments of European stream-of-consciousness photography, and a distinguished addition to the long line of photobooks about Paris.

Van der Keuken had studied filmmaking in Paris from 1956 to 1958, and the thousands of photographs he took on the streets at that time formed the basis for *Mortal Paris*. His view of the city was dark, though not as dark as that of Ilya

Ehrenburg, and gloomily romantic. Like Ed van der Elsken in *Love on the Left Bank*, Van der Keuken adopted a cinematic style, both in terms of the individual pictures and the book's layout and design. *Mortal Paris* is divided into six 'chapters', but one can also imagine them as scenes, dealing with various aspects of a city which, at the time he was photographing, was consumed by the Algerian question, changes of government and the rise of Charles de Gaulle.

Mortal Paris does not take the familiar 'day in the life' approach. The view here is much more personal and metaphysical, or, rather, existential, for existentialism was in the air when Van der Keuken made the pictures. So the book can be considered a mood piece, very much in a morbid existential vein, and the final sequence, in the cemetery of Père-Lachaise, makes its psychological tone quite clear.

The individual photographs are raw and spontaneous, influenced by William Klein and the 'new wave' cinema of Godard and Truffaut. This image of the Métro, taken with a hand-held camera in dim light, is typical. The grain and high contrast describe an energetic bleakness that underlines the essential alienation of Van der Keuken's jaundiced vision of Paris.

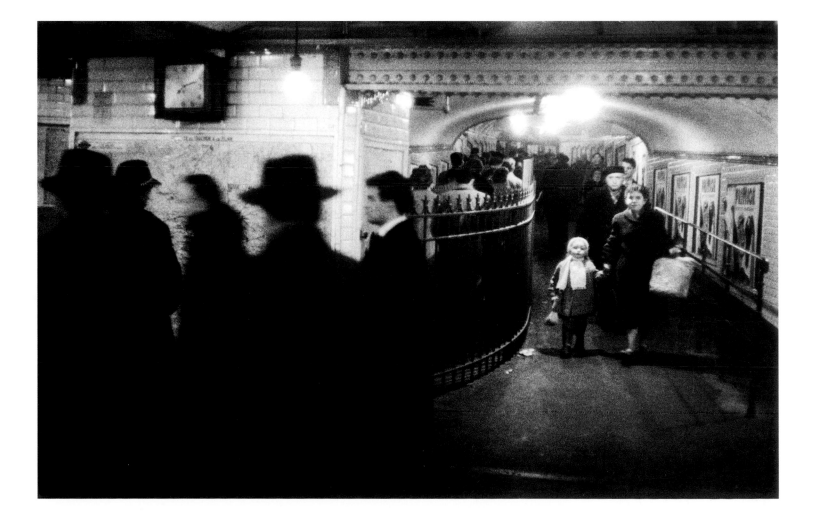

The 'photonovel' was developed by Dutch photographers in the 1950s. Using photography as a diaristic medium, this type of photobook often employed a stream-of-consciousness style.

And it defined a more personal, spontaneous kind of documentary photography, private rather than public in intention, focusing upon a photographer's own life, rather than on others.

period in 1951, the book became one of American art's enduring talismans, not only the most important stream-of-consciousness novel, but the most reliable guide to the thinking of the first 'youth' generation.

'Stream-of-consciousness' also describes the work of such photographers of the period as Robert Frank or William Klein in the United States, and Ed van der Elsken or Johan van der Keuken in Europe. Because of an insistence upon photographing either the immediately personal or mediating the world through the personal, this style also came to be known as the 'diaristic' mode.

127–28 In 1956, Klein published his book *New York*, a kaleidoscopic, exuberant mix of raw, random impressions of New York, put together like the rough-cut of a film. In 1958, Robert Frank's *Les Américains* was published in Paris, and then a year later in an American edition, *The Americans*, with an added introduction by Jack Kerouac. '*Anybody don't like these pitchers don't like potry,*' wrote the high priest of beat. Van der Keuken photographed his friends in his book *We Are 17* (1955), and Van der Elsken, in *Love on the Left Bank* (1956), photographed a group of friends living in St Germain-des-Prés, the home of existentialism, concentrating particularly upon their bohemian lives in café culture and their numerous love affairs.

Ed van der Elsken (Dutch, 1925–90)
Untitled 1950s
Gelatin silver prints
From *Love on the Left Bank* 1956

The most famous photonovel, Ed van der Elsken's *Love on the Left Bank*, told a loosely fictional story, based upon the photographer's snapshots of girlfriends and friends living in the St Germain-des-Prés quarter of Paris. When serialized as a photo-essay in *Picture Post*, two years before its publication as a book, Van der Elsken's pictures were accompanied by the explanation, '*This is not a film. This is a real life story about people who do EXIST.*' In other words, the story was so lightly fictionalized that it could have been published as a documentary photobook. No doubt making a filmic 'story' was the more commercial decision.

The chief protagonist in the series was one of Van der Elsken's girlfriends of the time, an Australian called Vali Meyers. *Love on the Left Bank* tells the story of a romance between Vali (re-named Ann in the book) and a Mexican student, Manuel. Everyone, however, acts as supporting cast to the striking Australian in this tale set in the bars, cafés, nightclubs and student bedrooms of the Left Bank. St Germain was the birthplace and centre of existentialism so Van der Elsken's story contains much discussion in cafés, and, as here, moody portraits of Vali looking soulfully beautiful, and no doubt thinking existential thoughts.

As photobooks go, *Love on the Left Bank* was successful, and both it and Van der Elsken's impressionistic style were widely influential, particularly in Europe and Japan.

This focus on the personal was accompanied by a radical method. Often, stream-of-consciousness photographers neglected to look through the viewfinder, shooting from the hip or holding the camera at arm's length and trusting serendipity. Their pictures as a result looked dynamic, but in a loose, off-kilter way. They cared little for technique, and their pictures were frequently grainy or ill-focused – or both. Their subject-matter was the everyday, the grimy everyday, but they weren't seeking to elevate it, or even describe it fully, just sense it in an offhand way. Their pictures seemed to be either fragmentary and elliptical or full of an angry, melancholic energy. They seemed to be aiming for not the decisive moment but the indecisive moment. *Rebel Without a Cause*, the title of James Dean's famous film, describes the mood exactly. The youth rebellion was finding expression in both the popular and serious arts.

When *The Americans* was published in the States, it split the photographic community down the middle. There was outrage at its technical roughness. And there was outrage at what Walker Evans called Frank's '*bracing, almost stinging manner*', his vision of an America most Americans preferred to ignore.

But for younger photographers in tune with its rebellious sensibilities, the book was a rallying call. They were transfixed, not just by the book's pictures, but by the way they were sequenced, in four 'chapters', each one prefaced by an image featuring the star-spangled banner. Frank introduced visual and metaphorical themes, playing them off and piling them against each other with energy and intelligence. There were numerous moods – sad, happy, bitter, defiant, angry, sorrowful – but the general tenor was decidedly pessimistic. As Tod Papageorge has written, '*A continent is spanned, but its life compressed in a single grief.*' Frank photographed jukeboxes that looked like altars, cars like coffins, and flags like shrouds. He photographed funerals, road accidents and crosses. *The Americans* was a profound, shattering *cri de cœur*, and at its heart was death. As Kerouac rightly said, it was '*a sad poem sucked out of America*'.

It was the opposite of *Family of Man* certainties or humanist optimism. The apparently artless transcription of undefined moments of direct experience seemed more related to the snapshot than serious photography. But this was the point. The mood was downbeat and nihilistic, and technique followed mood. During the 1960s, stream-of-consciousness photography was eagerly taken up by the first post-war generation of Japanese photographers. There, the bleak, alienated vision was taken to extremes by artists and phototographers whose country had experienced the apocalypse at first hand.

By the 1960s European photography had dealt with the Second World War, but it would take much longer to find closure in Japan.

The American occupiers had tried to control the distribution of images of Hiroshima and Nagasaki after the bombings. So it was not until the late '50s that the Japanese really began to deal with the war's troubled ending. Right through the '60s and '70s Japanese art and photography were largely defined by the country's post-war relationship with the United States.

Coda
Bye bye, photography

At the end of the war, the Japanese reaction to defeat was a mixture of shame, guilt and anger, a normal enough response for any defeated nation. But Japan had also to come to terms with American occupation and a psychologically shattering event – the nuclear bombing of the cities of Hiroshima and Nagasaki. Coupled with events which had quite literally burned themselves into the Japanese psyche was another pressing issue. Post-1945 the Japanese had experienced an economic reconstruction of unprecedented speed, a growth fuelled by American money and aid. But ever since the 19th century Japan had had a love/hate relationship with the United States, and this would climax in the 1960s as anger at the American occupation collided with a fascination with the culture the occupiers brought with them. The young and the artistic community were especially attracted to American youth culture of the '50s, such as the beat generation and, later, to rock'n'roll and pop art.

These tensions gave the arts in Japan something on which to bite, especially during the 1960s. French existentialism was also an influence, reflecting the alienation many Japanese experienced as a hybrid culture began to develop. Out of this unique crucible emerged a renaissance in Japanese photography, and several bodies of work, published as photobooks, that are the equal of any made in the medium's history. These books might stretch any definition of photography's ultimate mission to breaking point, but there is no doubt that they were an artistic response to a historical moment – the schizophrenic nature of post-war Japanese society.

Takuma Nakahira (Japanese, b. 1938)
Rotogravure reproductions
From *For a Language to Come* 1970

In 1961, Ken Domon and Shomei Tomatsu's *Hiroshima–Nagasaki Document*, published by the Japan Council Against the Atomic and Hydrogen Bombs, drew widespread international attention to Japanese photography. And in 1963, photographer Eikoh Hosoe published *Killed by Roses*, a collaboration with the ultra-nationalist writer Yukio Mishima (who would later commit public suicide in protest at America's continuing influence on Japan). The book made Hosoe's international reputation, and well-known Western photographers, such as William Klein and Ed van der Elsken, began to visit and work in Japan. The visits by Klein and Van der Elsken were particularly significant. Japanese photographers took readily to the gritty spontaneity and existential inflections of their stream-of-consciousness approach, and by the late '60s were ready to use it in their own, totally uninhibited way.

The year 1968 was a particularly tense one in Japan, with protests and riots about 'Americanization' and the Vietnam War a regular occurrence. On 21 October, there were pitched battles on an unprecedented scale between riot police and students in Tokyo. In November 1968, a small magazine was published – part literary, part photographic, part philosophical and political – called *Provoke*. It was founded by two writers with a keen interest in photography, Koji Taki and Takuma Nakahira. Nakahira, indeed, soon became a photographer, telling his photographer friend Daido Moriyama:

I have become a photographer. These are dreadful times.

The magazine's aim was basically to free photography from the 'tyranny' of words. Its adherents saw photography as the best way to express the turmoil of 1968 and all the unresolved issues of the war. Its photographic approach represented rebellion, youth, anger and despair in a style that was raw, visceral, unrestrained and unstructured, with all notions of good technique thrown away.

Provoke lasted for only three issues, but had an enormous influence upon later Japanese photography. Perhaps its finest legacy, some years after it ceased publication, was two books by two of its leading adherents. These were Takuma Nakahira's *For a Language to Come* (1970) and Daido Moriyama's *Bye Bye Photography* (1972). Both are difficult, intensely poetic books that push the stream-of-consciousness style to the point of incoherence. Both express a brooding concern with the past (the War, the Bomb), the present (the colonization of Japan by American consumerism), and an uncertain future. Both have a nightmarish, fantastic quality, bombarding the viewer with images that are grainy, streaked, scratched, out of focus, covered in dust and stained. They read like a photographic equivalent of surrealist automatic writing.

For a Language to Come is essentially a landscape book, and Nakahira uses metaphors of fire and water to signify the problems facing Japan. The book ends with several moody shots of a dark, menacing and even claustrophobic sea, an image that has punctuated the work at intervals. Fire is even more prominent, whether expressed indirectly in night pictures with swathes of burned-out lens flare, or directly in images of a burnt and shattered landscape, as in the pair of pictures shown opposite, which probably represent the book's key moment. Almost identical photographs, stained and scratched by Nakahira, they show tyre tracks leading to what may be bunkers.

The marks in the sky suggest a firework display, or a battle, or the burning fires of a post-nuclear-holocaust world. Like most of the book, everything is blurred and uncertain. Yet Nakahira's bleakness is not, and the new language would seem to be one of despair rather than hope.

If Nakahira's dreamscape can be described as a restless nightmare, punctuated by moments of calm, Moriyama's *Bye Bye Photography* is like a bad psychedelic trip. '*I wanted to go to the end of photography*', he said of probably the most extreme photobook ever made. If Atget gave us the French *flâneur*, leisurely strolling the streets of Paris, Moriyama gives us the lone outsider, speeding through the streets of a *Blade Runner*-type Tokyo. The face of American consumerism is seen everywhere – in the dazzling lights, the signs, advertising displays and ranks of consumer durables. The frantic pace of the book never lets up, with a barrage of stream-of-consciousness imagery taken from his own pictures, found photographs – such as images of car accidents – and images shot from television sets. Rather than a book with a clear narrative, it is a kaleidoscopic impression of an alienated and grossed-out urban experience, shot through with a desperate kind of exhilaration. But with the tone so uncertain, we never know whether we are experiencing an exciting dream or a nightmare – or both.

Despite being so intensely Japanese, and even given its jaundiced view of American influence, *Bye Bye* was itself heavily influenced by America – by William Klein and Andy Warhol, for instance – and is a thoroughly 'pop' book. Even Moriyama never pushed stream-of-consciousness photography that far again, and *Bye Bye Photography* drew a line under the Provoke era, though its influence lingered. It also finally drew a line in Japan under the photographic legacy of the war. Nevertheless, the somewhat ambiguous relationship with the United States has remained a potent and rewarding subject for Japanese photography.

Daido Moriyama (Japanese, b. 1938)
Rotogravure reproductions
From Bye Bye Photography 1972

Of all the post-war evocations of place in photography, few have had a greater resonance or more widespread influence than William Klein's book *New York*, published in 1956. *New York*, or to give it its full, beat-generation title *Life Is Good and Good for You in New York: Trance Witness Revels*, influenced not only a style of photography but the development of the photobook.

Prelude
The revels are the thing

New York, even more than Robert Frank's *The Americans*, can be regarded as the epitome of the beat photobook, and, as some commentators term it, the first 'pop' book. It has been particularly influential in Europe, generating a raft of imitators looking at various cities, and also in Japan, inspiring the rough-hewn but dynamic photobooks of the Provoke photographers. And in the United States, it clearly inspired the primary book to emerge from the full-blown pop art movement – *Andy Warhol's Index (Book)* of 1967.

Klein's dynamic, 'in yer face' style of photography also defines the stream-of-consciousness approach as much as Frank's very different work. As we have seen, it was a style appropriated by such Europeans as Ed van der Elsken and Johan van der Keuken, and Klein's disregard for technical niceties, his disregard, in fact, for almost anything except his pictures' energies, encouraged Japanese photographers like Daido Moriyama to take photography to extremes that even Klein dared not consider.

William Klein was a native New Yorker, a young abstract expressionist painter who moved to Europe, firstly to Milan and then to Paris. He had begun to take, as he put it, '*abstract expressionist photographs*', but then returned to New York in 1954 with his wife, a fashion model. She modelled, and he took fashion photographs for *Vogue* under the direction and mentorship of the magazine's art director, Alexander Lieberman.

Encouraged by Lieberman, Klein was also shooting pictures on the city's streets, supplied with copious amounts of film by *Vogue*. As often happens with returning natives, he saw a familiar city with fresh eyes and became excited by that, photographing in a raw, aggressive, totally uninhibited manner, shooting fast, often from the hip, and, above all, moving right in on his subjects. The excitement in the images was manifest. As he said of them:

> I would look at my contact sheets and my heart would be beating, you know. To see if I'd caught what I wanted. Sometimes, I'd take shots without aiming, just to see what happened. I'd rush into crowds – bang! bang! I liked the idea of luck and taking a chance. Other times I'd frame a composition I saw and plant myself somewhere, longing for some accident to happen.

As that statement indicates, Klein's style was about distilling the experience of being out on the street, confronting one's subject

and clicking the shutter. He did not stalk his subjects in the manner of a Cartier-Bresson. To be sure, he made candid pictures, but *New York* is as much about Klein's personal interaction with people on the streets as it is about the city itself.

The result was a confrontational view of New York, but one which reverberates with energy, and it catches perfectly the aggression and alienation of the city itself. As Alexander Lieberman remarked on first seeing his work:

> Those pictures had a violence I'd never experienced in anyone's work. The prints were harsh and uncompromising, yet Klein somehow made the everyday fit into a new aesthetic. The strong graphic aspect of the streets interested me very much. There was a wonderful iconoclastic talent, seizing what it saw.

Others, however, thought they were too aggressive. Klein once stated that most people in New York to whom he showed the pictures had the same reaction:

> This isn't New York – too ugly, too seedy, too one-sided. This isn't photography, this is shit.

Around the time Klein was photographing in New York, Robert Frank was preparing to make the journeys across the States that would result in his existential road trip of a photobook, *The Americans*, and it is instructive to compare the work of the two men. Frank presented a somewhat sour view of the world, Klein something else. Of course, Klein's New York is hardly tourist New York. It is tough and more than a little alienated. He photographs with a degree of world-weary cynicism, yet exhibits none of Frank's almost misanthropic pessimism.

The difference is one of personality. Both men give us indelible views of America in the 1950s, the unpalatable truths behind an era of optimism. It was a schizophrenic period in the country's history, when many people had never had it so good, but when those outside the suburban mainstream felt an increasing sense of rebellion and alienation. Both Klein's and Frank's views can be termed jaundiced, but the personal tends to outweigh the documentary aspect of their work, and any public meanings are largely subordinated by the private and the psychological. Thus Klein's imagery exudes a brittle cheerfulness, while Frank's is shot through with gloom. *The Americans*, to reiterate Jack Kerouac's memorable words, was '*a sad poem sucked out of America*'. Images and symbols of death abound in the book – we have to recognize that death is at its heart – whereas, for all its violence, cynicism and aggression, Klein's *New York* is brimful of energy and life.

Above all, Klein's work is about process. Firstly, it is about the process of making photographs on the wing, and then about the process of combining those photographs in a book. From the beginning, Klein had envisaged his New York photography as a book project, and this was where working for *Vogue* gave him another advantage. The magazine had newly acquired a state-of-the-art Photostat machine, so big, Klein recalled, that it occupied most of a room. With this machine, Klein was able to make copies of his workprints, at different sizes, and then cut and paste them together to make different page layouts, finally combining his preferred pages into a book maquette. It is because Klein was responsible for photography, layout, typography and design in *New York* that the book has greater 'totality' as a concept than *The Americans*. All four elements fuse to make not just a photographic statement, but a 'book' statement.

William Klein (American, b. 1928)
Gun 1, New York, 1955
Gelatin silver print
From *New York* 1956
© William Klein. Courtesy: Howard Greenberg Gallery, New York City

New York is also about energy in a collective sense. Klein took individual photographs overflowing with energy, but compounded their energies within the supercharged structure of the book, piling picture upon picture with an almost manic pace. It is how they were combined to form a kaleidoscopic impression of the city that made the book so fresh. He would follow a page of a dozen or so pictures crammed together with a single image as a double-page bleed, employing a style that owed as much to cinema as still photography. *New York* is one of the best examples of a photobook's layout and design mattering as much as the individual pictures, fine as they are. Even *The Americans* followed a conservative single picture to each double-page-spread layout.

Klein returned to Paris with his maquette, and, with the help of the French avant-garde artist and filmmaker Chris Marker, the book was published by Editions du Seuil. Ironically, both *New York* and *The Americans* were first published in Paris, though only Frank's book was later published in the States. Nevertheless, Klein's masterpiece has been at least as influential as Frank's, although perhaps in a less overt way. Whereas photographic

history once tended to laud Frank, slightly at the expense of Klein, anyone who knows anything about photographic history today would contend they are of equal importance as photographers and as bookmakers. Indeed, Max Kozloff suggests that it is impossible to consider *The Americans* without considering *New York*, and vice versa:

> *Frank though, and Klein, brought to the decade a feeling for its woes which, in retrospect, synthesizes it for us. There hovers in their work an oppressive sense of the odds against which people struggled, the dismal mood and chance of defeat that lowered the emotional horizon. This was all the more striking because of the general affluence of the period, underway shortly before the start of Frank's and Klein's major effort, in the great boom of 1955. These transplanted photographers found live and visual metaphors for the bleakness of this Cold War moment, and the deadness of the things in it. For those who remember the era, these photographic evocations of it have the keenest resonance; for those who came later,* The Americans *and* New York *offer a wondrous guide.*

William Klein (American, b. 1928)
Fifth Avenue, Graceline, New York, 1955
Gelatin silver print
From *New York* **1956**
© William Klein. Courtesy: Howard Greenberg Gallery, New York City

4

On the Road

Carleton Watkins (American, 1829–1916)
Cape Horn near Celilo 1867
Albumen silver print from wet-collodion negative

Of all the great 19th-century landscape photographs, Watkins's images would seem to be the most perfectly poised between document and art. Indeed, any distinction between art and science does not appear to have existed for him. He would seem never to have sought the picturesque, but he did not go out of his way to avoid it either. Always, his aim was to present his subject as clearly as possible. That, for him, was the 'art' of making a photograph. Lucidity was the keynote, veracity his aim.

Joel Snyder wrote the following about the 19th-century American photograph, but he might have been talking specifically about Watkins's work when he said:

Accuracy is identified with fine detail, objectivity with distance, art with craftsmanship,
documentation with transcription, and interest with the obligations of a good citizen and not with any intrinsic qualities of the picture.

This image, of a railway line near Cape Horn, Washington, taken from the Oregon side of the Columbia River, illustrates how perfectly and elegantly Watkins balanced the documentary with the formal when at his best. He set the camera looking straight down the railway tracks, giving the picture a fulcrum around which everything could revolve in perfect balance, from the brooding rock bluff on the right to the flat spaces which disappear off to the left. It is both an evocative image of the opening-up of the West, and a consummate example of how to compose a photograph.

Taking the viewer there

There are basically three photographic subjects – people, things and places. The American photographer Lee Friedlander once stated that he was interested in *'people and people things'*, but he tended to express those interests in the depiction of places. Friedlander is a notoriously reticent speaker. Once, when giving a lecture in Graz, Austria, the only information he would venture as he showed slide after slide of his work was where the picture was taken. Eventually, one member of the audience could stand it no longer, and asked why it was necessary to name where each image had been taken. The laconic Friedlander thought for a few seconds before replying that if he hadn't been in a particular place he wouldn't have been able to take that particular photograph.

A simple answer, probably intended to be sardonic, yet it states a fundamental truth about photography. A photograph is made by a photographer standing in a particular place at a particular time. All else follows, primarily the fact that the chief reason why photographers make photographs of places is to take the viewer there. That applies as much for a photographic artist like Friedlander as it does for a postcard photographer or an amateur snapshooter.

As we have seen, from photography's beginnings, the camera has been used to take a photograph's viewers to the next town or the ends of the earth. At first, photographers from Britain and France – the two countries where the medium was invented, countries that had colonized much of the world – trawled the countries they had colonized for images of people, things and places to send back home. Some of these photographs, especially those depicting the wonders of scenery and monuments, were for public consumption, but others were destined for the archives, and the attentions of the scholars and specialists who would pour over them, extracting whatever information they contained.

The beginnings of photography coincided with the beginnings of mass tourism – so much so that it is now difficult to tell which was the original stimulus. But wherever people travelled, they could purchase a photograph to remind them of the experience. In England, Francis Frith, who would eventually establish one of the most successful photographic businesses purveying topographical views and employing many photographers,

began in the mid-1850s by personally making three trips to Egypt and the Holy Land. And in 1865 Thomas Cook – a Derbyshire man like Frith – arranged the first of his renowned tours to the Middle East with a Nile cruise.

Four years before, the first war to be extensively documented by photography had begun – the American Civil War. In 1866, George Barnard published a book documenting Sherman's Unionist campaign of 1864 through Georgia and the Carolinas. Much of the book depicted places – the site of such-and-such a battle, the spot where General So-and-So fell. It was not so much a volume of war photographs as the first great book of landscape photography, and the land Barnard depicted is gouged and scarred not only by battle but the engineering works required to move men and materials.

When the war ended, some of the war photographers, such as Andrew Joseph Russell and Timothy O'Sullivan, either photographed the march of the railways to the Pacific Ocean, or joined expeditions sent to explore and map the largely uncharted territories west of the Missouri–Mississippi Basin. O'Sullivan photographed for several US War Department expeditions to the West, making photographic documents that would reveal how the land might be exploited for profit, yet at the same time investing them with a credible meditation upon nature and man's place in it. He had an eye, and his stark photographs are rightly regarded as amongst the most interesting of early landscape photography. They are both uncertain documents and beguiling pictures, and much more personal than their rather dry appearance suggests.

The dichotomy between art and science was always present in O'Sullivan's work, as it was in that of Carleton Watkins. Watkins can be considered the American equivalent of Roger Fenton or Gustave Le Gray, in that his work was conceived on a similarly grand scale, using large glass plates, and ran the gamut from art to commerce. He won medals at international photographic salons for his images of the Yosemite Valley made in 1861 – images that were instrumental in getting Yosemite named the United States' first national park in 1864. But the photographs he took for railway or mining companies were much more straightforward, without picturesque frills, and in general the photography of place in the 19th century was a practical affair.

Carleton Watkins is one of the great American landscape photographers of the 19th century, and also a near perfect example of photographic practice in the medium's first four decades. His work varies from medal-winning natural landscapes made for international photographic art exhibitions to documentary work for the agricultural, mining and railroad companies changing the face of the Western landscape.

George Barnard (American, 1819–1902)
Rebel Works in Front of Atlanta no. 1 1866
Albumen silver print from wet-collodion negative
From *Photographic Views of Sherman's Campaign*
(plate 39) 1866

George Barnard's book *Photographic Views of Sherman's Campaign* is not just one of the great early war photobooks. It is one of the great landscape books of the 19th century. Barnard photographed much of it after Sherman's brutal campaign was over, but it depicts an American countryside ravaged by battle and altered by the logistics of military advance.

The photographs fall into four categories – topographical views of the country over which Sherman's army marched, places where major engagements were fought, views of military engineering works, and war-devastated cities.

Some of the best-known images were made in and around Atlanta – pictures noted by the producers of the 1939 Hollywood epic *Gone with the Wind*. Barnard made a sequence of the 'rebel' fortifications which failed to defend the city, and this photograph precisely demonstrates the salient points of his vision. He was a superb organizer of complex scenes, always in what might be termed a photographic rather than a painterly manner, that is, with an acute regard for tonalities and texture.

However, he was also interested in the artistry of his photography, drawing upon common motifs in landscape art, such as water or clouds. In about a third of the album's pictures, Barnard added clouds in the manner of an art photographer like Gustave Le Gray, printing them in from another negative. Here they are somewhat unconvincing, but for Barnard it was important to marry the documentary with the artistic. It increased the saleability of his views.

As critic Keith Davis has written, Barnard's book '*was a work of art, history, and commerce*', a complex and profound meditation upon the documentary and the aesthetic, upon the landscape and the war.

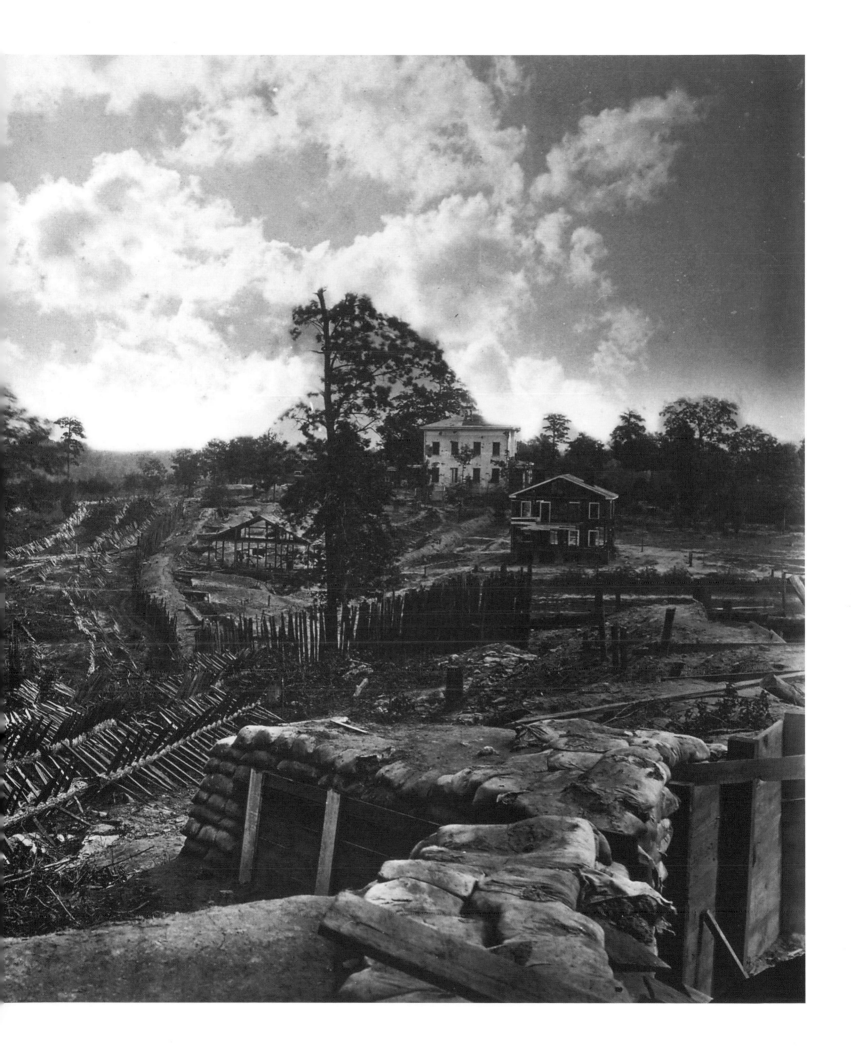

Landscape and the transcendental tradition

By the advent of modernism, however, photography of place had become landscape photography, a personal genre of self-expression in the hands of would-be art photographers. Alfred Stieglitz made photographs of specific places, most notably Lake George in New York State and New York City itself, but he also made pictures of dramatically clouded skies and called them 'Equivalents'. These were semi-abstract images, intended to provoke free-ranging associations on the part of the viewer, much as one experiences when staring at the flickering flames in a fire – photography as a kind of transcendental meditation.

Ansel Adams, a great admirer of Stieglitz, made lucid, though somewhat operatic photographs of the American West, particularly of Yosemite, maintaining the documentary clarity of Watkins. Unlike Watkins, Adams ruthlessly expunged any signs of the contemporary from his images, which were firmly in the transcendental tradition of Stieglitz, poetic meditations upon an apparently timeless Eden, but an Eden that was already lost when Watkins photographed it in the early 1860s. Like *The Family of Man*, however, Adams's shamelessly romantic photographs answered a need, and were – indeed are – extremely popular. And if there seemed little sign in his pictures of the issues that concerned landscape photographers of a more documentary bent, outside of them Adams was more politically active than most photographers. He was an indefatigable campaigner for the environment, for which he should be lauded.

The notion of 'equivalence' is an important one in American photography, for the transcendent principle, the idea that one can find some kind of epiphany through the depiction of objects and places, runs deep – not only in American photography, but American art. Walker Evans, somewhat miscast as a social-documentary photographer, looked for it in his photographs, although he was no lover of either Stieglitz or Ansel Adams. He said that he wanted his photographs to be '*literate, authoritative and transcendent*'. He simply found his 'Equivalents' in the places formed by man rather than mountains or the sky – on the city streets and in the small towns, with their profusion of poles, wires and signs.

87–88

And in the long run, the quiet Evans proved to be the most influential of American photographers, especially during the 1960s and '70s, precisely the time when photography was winning final acceptance as an artform in the American art museum. Stieglitz may have kicked it all off, Adams was certainly the most popular in the public's eyes, but for most photographers Evans was the one engaging with photography's fundamental subject – the modern – the here and now. And in the post-war period, following the examples of Evans, Frank and others, that meant the man-made rather than the natural landscape.

Ansel Adams (American, 1902–84)
Clearing Winter Storm, Yosemite National Park
1944
Gelatin silver print

Adams photographed only what was there, obtaining his heightened effect by a profound knowledge of photochemistry, which he used to create perfectly controlled negatives and prints. '*The negative is the score, the print is the performance*,' he said. And his approach to photography was to take the technical perfection demanded by classic American modernism to new heights.

His favourite stamping ground was Yosemite Valley in California, and he made many of his best pictures in and around the valley. He used a large-view camera for much of his career, a method that gives the ultimate quality but requires great deliberation and patience.

Clearing Winter Storm was taken from the viewpoint at which tourists can look down the valley. Millions of photographs have probably been taken from this spot. Adams himself must have taken dozens, and on two or three occasions he got everything breathtakingly right. The picture, of course, does not take in the accoutrements of the tourist industry, or the throngs of daytrippers themselves, despoilers both in his view. Adams photographed Yosemite as it might have been ten thousand or a million years ago. Just nature at her most magnificent. There perhaps should have been an embargo on wasting film here after he made this image, but of course there was not.

Ansel Adams was a tireless environmental campaigner and an advocate of straight photography, yet he believed both aims were best served by an idealistic rendition of the landscape. His Western landscapes are grand and operatic, presenting the land as we want it to be rather than as it is. That makes his pictures immensely popular but none the worse for it.

Roger Mayne (English, b. 1929)
Southam Street, North Kensington 1956–61
Gelatin silver print

Unlike the United States or Europe, Britain has no tradition of photographers photographing on the street. The place that could be said to be 'owned' by British photographers is the seaside. There have, however, been some conspicuous exceptions, and one of the most successful bodies of work exploring British street-life was made by Roger Mayne in London, in the 1950s.

Mayne's street photographs stand out in British photographic history, partly because of their vibrancy and originality, and partly because they were taken during a relatively fallow period for British photography, although they would be considered outstanding at any time.

The most renowned series of photographs made by Mayne was taken in and around one London street, Southam Street in North Kensington, in the area then known as Notting Dale, now Notting Hill. The area was even more raffish than it is now, a mixture of working class, immigrants from the Caribbean and elsewhere, and adventurous middle-class bohemians, such as Mayne and his writer friend Colin MacInnes, who set his celebrated novel *Absolute Beginners* (1959) there.

Mayne's photographs of Southam Street children, in particular, are completely fresh and uninhibited, a rare quality in British photography of the time. They may be compared to Helen Levitt's images of New York children, having that blend of unsentimental exuberance and energy.

In their lack of concern for fine technique, and what would seem to be an emphasis on 'process' – that is, capturing the experience of the street rather than external realities – they could also be related to stream-of-consciousness photography, not an inherently British mode. These images look casual and spontaneous, but it is worth noting that Mayne spent five years documenting Southam Street. Photographs as good as this do not come easily.

Towards a social landscape

The problem with photographing rocks is how to make work that expresses and evokes something more than woolly romanticism. It can be done – rocks as well as city streets have meanings, and important meanings for us – but any photographer looking to make 'modern' photographs, pictures that comment upon the here and now, finds both an easier and a richer vein of material in the metropolis. Since that first image by Daguerre of the Boulevard du Temple, the street has been a natural hunting ground for photographers, especially American photographers of the 1960s and '70s.

The key photographers at the end of the war to influence this trend were Walker Evans, Weegee and the members of the Photo League, and for them New York rather than Paris became the key city. Out of New York City came a photographic vision that was a deal rawer than the humanist street photography practised in Paris. And so, although it was never defined as such, street photography in the 1950s was very much a case of the 'New York School' and the 'School of Paris'. It would be too crude to say that they were in opposition, but cultural attitudes made for two very different approaches.

From Weegee and his book *Naked City* (1945) came the rawness, a willingness, even a gleeful desire, to confront the seamier side of life head on. From the Photo League and their social-documentary projects came an interest in every aspect of street life in New York. And from Walker Evans came a conceptual way of doing things, in which the camera works as if on automatic pilot. Evans made a series of portraits on the New York subway in the late 1930s and '40s, for which he hid his camera under his coat. With just a vague idea of what the camera was seeing, the only decision he had to make was when to press the shutter. He used the same technique on Chicago street corners and proved to photographers that it was not necessary to look through the viewfinder to make effective photographs.

A style gradually emerged from these various influences, probably without its practitioners realizing it. That style was raw, immediate, unfussy, rhythmically pacy and cinematic in tone. And, above all, the key was spontaneity. Its practitioners were street photographers to the core, figures such as Louis Faurer and Leon Levinstein.

Ironically, further influences had come from two 'outsiders' – the expatriate William Klein and Swiss-born Robert Frank. While Klein's influence was felt more in Europe and Japan, the great influence upon '60s American photography would come from Robert Frank. His acid view of America enraged the conservatives in the American photographic world, but became a touchstone for the next generation of young, radical photographers in New York, who took instantly to the ironic, stream-of-consciousness approach – photographers such as Garry Winogrand, Lee Friedlander, Danny Lyon, Bruce Davidson and Joel Meyerowitz. Unimpressed by what they viewed as the sanctimony of the humanist approach, they turned to the commonplace subject-matter photographed by Klein and Frank for much the same reasons – to distil their own experiences of life in the camera.

Their radicalization, it should be stressed, was not primarily political – though they tended to be somewhat rebellious and disaffected – but photographic. They were interested more in

84

78

173

116

127–28

147

Lee Friedlander (American, b. 1934)
Hillcrest, New York 1970
Gelatin silver print

By photographing what we hardly ever notice, the poles, wires, signs and other articles of street furniture that clutter our urban environment, Lee Friedlander created a new photography of the commonplace. And by including himself in frame from time to time, he declared that contemporary photography is a medium of personal expression, as much visual diary as document.

Lee Friedlander became widely known in the 1960s for his images of urban America, in which he took a laid-back and coolly affectionate look at the everyday streetscape of American towns and suburbs. Like Winogrand and others of his generation, it seemed he photographed not to document society, but for more personal reasons. On the surface, those reasons appeared to be primarily formal. Friedlander used street furniture to break up the pictorial space, creating strange juxtapositions of scale and a sense that we never know quite where we are. That state of visual confusion disturbs the initial geniality of these images, and has been described as an effective metaphor for our sense of alienation today.

Friedlander's streetscapes, with their oblique self-portraits, have become immensely influential. Telegraph poles dividing the frame are now a cliché, but Friedlander's early pictures, in which he more or less invented the device, still resonate strongly. Their visual wit and graphic whimsy touch a profound chord. And they can be read, as Martha Rosler wrote, as registering '*anywhere from photofunnies to metaphysical dismay*'.

Rosler also characterized Friedlander as a '*solitary guy in a crazy clockwork world*'. But that might explain the appeal of his pictures. The urban views and sly self-portraits brilliantly document, both visually and emotionally, our experience of the modern city.

Garry Winogrand (American, 1928–84)
American Legion Convention, Dallas, Texas 1964
Gelatin silver print

Although as great a virtuoso of the 35mm camera as Cartier-Bresson, Garry Winogrand's view of the world was hardly positive or humanistic. '*We have not loved life,*' he once wrote, and that reflected perfectly the pessimistic nature of his vision.

This photograph is typical, a perfect – though neither classical nor obvious – arrangement of forms within the frame. Our eye is, of course, drawn to the disabled man, apparently stranded in an uncaring world oblivious to his plight, and it would seem that Winogrand was also oblivious, an uncaring, even merciless photographer. His humour – and there is a lot of humour in his pictures – tended to be of the bitter, even cynical kind, but he was not regarded as possibly the key photographer of his generation for nothing, and his work was a lot more complex than its brittle, somewhat satirical surface at first suggests. He was interested in anything and everything on the street, but although he tended to turn whatever he saw into a personal reflection we still have a document – a brilliant document of a troubled and fascinating period in recent American history.

It was said of Winogrand, as it is said of Martin Parr, that he did not care much for the people he photographed, often holding them up to ridicule. Certainly, his vision was sharp to the point of biting, but like Parr he could be tender as well as cruel, although his pessimism usually won out. In truth, his vast, sprawling body of work is ebullient and morose by turns. But at the top of his game he was the best street photographer around.

distilling personal experience rather than in projecting a socio-political viewpoint. In 1966, the leaders of this generation of American photographers were featured in an important exhibition organized by the teacher and curator Nathan Lyons at the George Eastman House in Rochester. Entitled *Towards a Social Landscape*, the pictures exhibited depicted an American social landscape influenced by the Frank point of view, but, as Nathan Lyons pointed out in a catalogue essay, the private meanings of these photographs mattered as much, if not more than, their public meanings. In other words, they were not so much a report upon the state of America as upon the feelings of the photographers involved, and the social landscape described in the pictures was a constructed one, put together in the camera and in the photographers' minds – and, therefore, a pictorial landscape as much as an actual landscape.

Another key supporter of the 'Social Landscapists' was John Szarkowski at MoMA, not because he wanted to do the opposite of his predecessor Edward Steichen but because he recognized this was the coming thing. Their aims appeared to be the antithesis of the photojournalism sponsored by Steichen, and conceptually that was the case, but they were, in fact, just trying to do what serious photographers had always done – make sense of the world on their own terms.

In 1967, Szarkowski featured Winogrand, Friedlander and Diane Arbus in another of the decade's key photographic exhibitions – effectively anointing the trio as the leading photographers of their generation. In his wall-label introduction to *New Documents*, Szarkowski explained this crucial change in photographic expression in a few eloquent paragraphs:

Most of those who were called documentary photographers a generation ago, when the label was new, made their pictures in the service of a social cause. It was their aim to show what was wrong with the world, and to persuade their fellows to take action and make it right.

In the past decade a new generation … has directed the documentary approach towards more personal ends. Their aim has been not to reform life, but to know it. Their work betrays a sympathy – almost an affection – for the imperfections and frailties of society. They like the real world, in spite of its terrors, as a source of all wonder and fascination and value – no less precious for being irrational.

… What they hold in common is the belief that the commonplace is really worth looking at, and the courage to look at it with the minimum of theorising.

Garry Winogrand, for example, was a garrulous, pessimistic man, who found that within the rectangle of his viewfinder he could freeze vignettes of life as he saw it or, rather, as his camera saw it. It might sound like Cartier-Bresson, but in truth his aims were very different:

I photograph to find out what the world looks like in a photograph.

As with much American art of that time, as with Frank and Klein, for Winogrand the act of photographing became more important than what he was photographing. 'I photograph, therefore I am', one might say. The American art museums' interest in photography was increasing tenfold in the 1960s, and so the photographers of Winogrand's generation, even those nominally in the documentary mode, had a new forum for their work, the gallery wall. This emboldened them to make totally personal work, for no one's satisfaction except their own – and maybe a curator or two. It was a significant step, for it freed photographers like Winogrand and Friedlander from the drudgery of commercial assignments.

It also freed them, some might argue, from any meaningful content, except the graceful disposition of forms within the picture-frame, or obscure private musings, and this has been a major criticism of the street photographers of the 1960s and '70s, that they were all form and no content, essentially uninterested in the social realities of what they were photographing. This is true to an extent, but only an extent, for even a photographer like Winogrand, who adopted a machine-gun approach to taking photographs – at his death he left 2,500 rolls of undeveloped film, 90,000 unseen images – had a view of the world which came across strongly in his work. He might be characterized as a Cartier-Bresson with a sour face. He certainly was as great a virtuoso with the 35mm camera as the French master, but he was an aggressive, sometimes cruel photographer, his pictures always teetering on the brink of misanthropy, though they seldom crossed the line. As fellow street-photographer Joel Meyerowitz has said of him, he '*performed a type of open heart surgery on the street. He would rip up flesh and break bones to get at the heart, but once it was exposed he would act with the utmost restraint.*'

Any kind of public gathering was Winogrand's hunting ground, yet, although that might imply a concern with only the surface of things, his camera cut with the keenness of a scalpel and he had the analytical mind of a Balzac. His human comedy of the '60s and '70s remains one of the most astute photographic records we have of that period in America.

Tony Ray-Jones (English, 1941–72)
Derby Day 1967
Gelatin silver print

Ray-Jones's subject-matter was the seaside and English customs, in part because it was when they were at the seaside or partying that the English dropped their innate reserve and revealed themselves most fully. To this potentially rich line of enquiry, he brought an eye that was not only humorous but tinged with a surreal edge he had learned from the films of Jean Vigo and the photographs of Bill Brandt. It was also an eye honed with a formal virtuosity garnered from the best American street photographers, like Garry Winogrand and Robert Frank. And, infusing his new subject-matter with the subjective documentary approach of his American masters, Ray-Jones breathed new life into photography in Britain, along with such figures as David Hurn, Ian Berry and John Benton Harris.

The result, as in this photograph of Derby Day, is an image of formal complexity exhibiting the foibles that make up the English. A horse walks into a telephone box while a man concentrates on eating an ice cream. It is, of course, a fiction, and Ray-Jones was concocting a fictional vision of the English, founded on clichés. He showed the British a picture of themselves at which they could laugh, but also appreciate. It was somewhat lacking in political edge, but it was a vision that contained a degree of truth.

When Tony Ray-Jones returned to England in the mid-1960s after studying photography in the United States, he thought Britain a photographic desert. Looking at his native land as if for the first time, he was inspired to document the English in ways that had far-reaching consequences for British photography.

Stephen Shore (American, b. 1947)
*Merced River, Yosemite National Park,
California, August 13, 1979*
Chromogenic colour (Type C) colour print
From the series *Uncommon Places*

During the 1970s, Stephen Shore produced two important bodies of work from trans-American trips, work that helped to establish colour photography as a serious medium. His first trips, in 1972 and '73, resulted in *American Surfaces*, in which, shooting in 35mm, he looked closely at the everyday world around him – the buildings and streetscapes of the small towns he passed through, and the motels in which he stayed.

For his next forays into America's hinterland, Shore switched to a large-view camera. The mode of seeing with this camera is contemplative and precise. The large negative renders an enormous amount of detail so Shore was able to step back and take a wider view of things. Indeed, the negative was able to render information the eye could not see at a distance, and this kind of panoramic view was an influence upon the School of Düsseldorf and their large-scale colour views of the 1990s.

For much of *Uncommon Places*, Shore was photographing urban and smalltown America. But in this view of Yosemite he encroaches upon territory made famous by Ansel Adams. However, whereas Adams tried to make believe that Yosemite remained an unsullied wilderness, Shore photographs a family picnicking by the Merced River. He has accepted that where nature is, man is also, but that does not prevent him from making his own version of the American Sublime, for if he can find it in a suburban gas station or motel he can surely find it in Yosemite, albeit tinged with gentle irony. The 920-metre cliffs are cut down to size, and the picture-postcard perfection derives from Shore's immaculate composition, not the realities of the daily traffic jam to get into this natural wonderland.

Richard Misrach (American, b. 1949)
Bomb Crater and Destroyed Convoy,
Bravo 20 Bombing Range, Nevada 1986
Chromogenic colour (Type C) colour print
From *Desert Canto V*

Begun in 1979, Richard Misrach's *Desert Cantos* is one of the most ambitious photographic explorations of place in recent years. A *canto* is a song, so Misrach's project can be considered a song cycle on the American desert. The form has given him the freedom to treat each canto separately, yet as part of the larger structure.

His approach has varied widely, from cantos simply delineating the desert's beauty to others where he documents the region's despoliation. Some of the most political cantos deal with areas controlled by the US military,

where weapons testing has done untold damage. One canto, *The Pit*, features graphic images of a burial ground for cattle that have been killed by contaminated water where radioactivity from nuclear testing has leached into the soil.

Misrach has been criticized for mixing politics and aesthetics, for even the most horrifying pictures from *The Pit* have a terrible beauty. But he is adamant that a 'bad' subject does not need a bad photograph to do it justice. *Canto V*, entitled *The War (Bravo 20),* is a case in point. At some personal risk, Misrach photographed public land near Fallon, Nevada, that for many years had been used by the US Navy airforce as a bombing range. On a broad plain, an 80-metre peak known as Lone Rock had been reduced to two-thirds of its original

height by repeated bombing, and scattered about it lay tons of unexploded ordnance.

Here, Misrach photographs a bomb crater full of rusty water, military debris littered all around. The red of the water makes the obvious but effective metaphor of the wounded earth bleeding, but more affecting is the ironic contrast between the beauties of a ravaged nature and the ugliness of some of mankind's baser impulses.

Joel Meyerowitz (American, b. 1938)
Fifth Avenue, New York City 1975
Dye-transfer print

Joel Meyerowitz's New York street pictures of the late 1960s and early '70s were in the familiar genre of the so-called New York School. There was, however, one major and crucial difference. His vibrant, complex views of the crowded New York sidewalks were shot in colour.

Meyerowitz was a leading member of the post-Frank generation of photographers and included in the 1966 exhibition at George Eastman House, *Towards a Social Landscape*, which introduced this new generation to the photographic world. His series of New York street pictures in colour might be seen as a transition in his work, but it was nevertheless an extremely successful transition.

One would not guess, looking at these pictures, that Meyerowitz had to overcome some quite severe technical problems. He was shooting in 35mm using Kodachrome film, an extremely good but slow colour-transparency film, which as well as making 'slice of life' street photographs difficult was also very contrasty. To get the kind of print that satisfied him from a colour slide, he had to resort to the costly dye-transfer method. These difficulties, plus a desire to move on to a more contemplative subject-matter, clearly influenced his decision to change to a large-view format camera, and he used it initially to make a series featuring the Empire State Building.

The New York street scenes shot in 35mm, however, reveal that when a photographer fights against technical difficulties and overcomes them, the results can be very stimulating indeed. Meyerowitz must have had a lot of failures for each successful image, but those that worked, like this one of an improbable leaping tiger in a showroom on Fifth Avenue, are not only important images in the history of colour photography, but significant additions to New York's iconography.

'I am at war with the obvious,' William Eggleston has said, and he set out to prove it by showing the everyday and the ordinary in a startling new light. More than almost any other photographer in recent years, Eggleston has expanded the medium's vocabulary to accept colour and include subjects disregarded by most photographers.

William Eggleston (American, b. 1939)
Tallahatchie County, Mississippi c. 1972
Dye-transfer print
From the portfolio *14 Pictures*

Probably only Lee Friedlander and Robert Adams have matched Eggleston in defining the ways both we and other photographers have come to view the everyday and the ordinary. But since Friedlander and Adams work in black-and-white and Eggleston in colour, it is the latter who has been an almost ubiquitous influence upon contemporary photography.

Although he is said to work in the 'snapshot' style and 'diaristic' mode, he neither takes snapshots nor photographs his life. But his work supports his view of his own life, and he has tended to work best in his native Southland. However, it would be too crude to say that his work is 'about' the South. Indeed, so successful has he been in waging war against the obvious, it is difficult to say with certainty what his work *is* about. No photographer is harder to interpret in words than Eggleston. To look at the images and marvel is enough.

This image of a gas station in Tallahatchie County is typical. He might be unobvious, but he does not scorn the virtues of simplicity – the kind of mysterious simplicity that tantalizes and draws in the viewer. No one before Eggleston thought much of photographing shoes under a bed, the contents of a fridge, a red light bulb. Or a white tin industrial building (though the flash of red is so important). And to reiterate once more, Eggleston's work is not about colour, it is colour. Just think of this image in black-and-white. It might work, but it is unlikely.

Robert Adams (American, b. 1937)
Colorado Springs, Colorado 1968–70
Gelatin silver print

Robert Adams succeeded Ansel Adams in the 1970s as the most assiduous chronicler of the American West, but his view of nature was very different. Employing a cool but beautifully lucid style, Robert concentrated not upon the unspoiled wilderness – like Ansel – but upon the ubiquitous 'man-altered' landscape. If it is possible to find beauty in despoliation, yet also be passionately angry about it, that describes the approach of Robert Adams. He has documented many aspects of the landscape, ranging from tract development, clear-cutting and industrial blight to his own

garden and walks in the country, always with the dual aim, like Lewis Hine, of showing what should be changed and what should be appreciated. He is a political photographer and an artist, and sees no contradiction in marrying indictment with beauty.

As a leading light in the influential New Topographics movement, his photographs are marked by directness and clarity, and he has a particular affinity with the clear light of the West. He is one of those rare photographers, like Eggleston, who seem to find photographing as natural as breathing, making apparently simple images that always seem completely fresh.

Here, from a series taken around Denver, he photographs a suburban tract house,

the elegant structure of his framing belying its tackiness. His camera has captured the silhouette of a woman inside, caught, or trapped, in a square of light. He might be saying her life is circumscribed, but he is not judging her, only the endless suburbia in which she is compelled or has chosen to live. His judgments are reserved for those who make the big decisions regarding our environment. Adams's pictures are quiet, but beneath their elegant reserve, which requires a close reading to penetrate, he is one of the most deeply passionate of photographers.

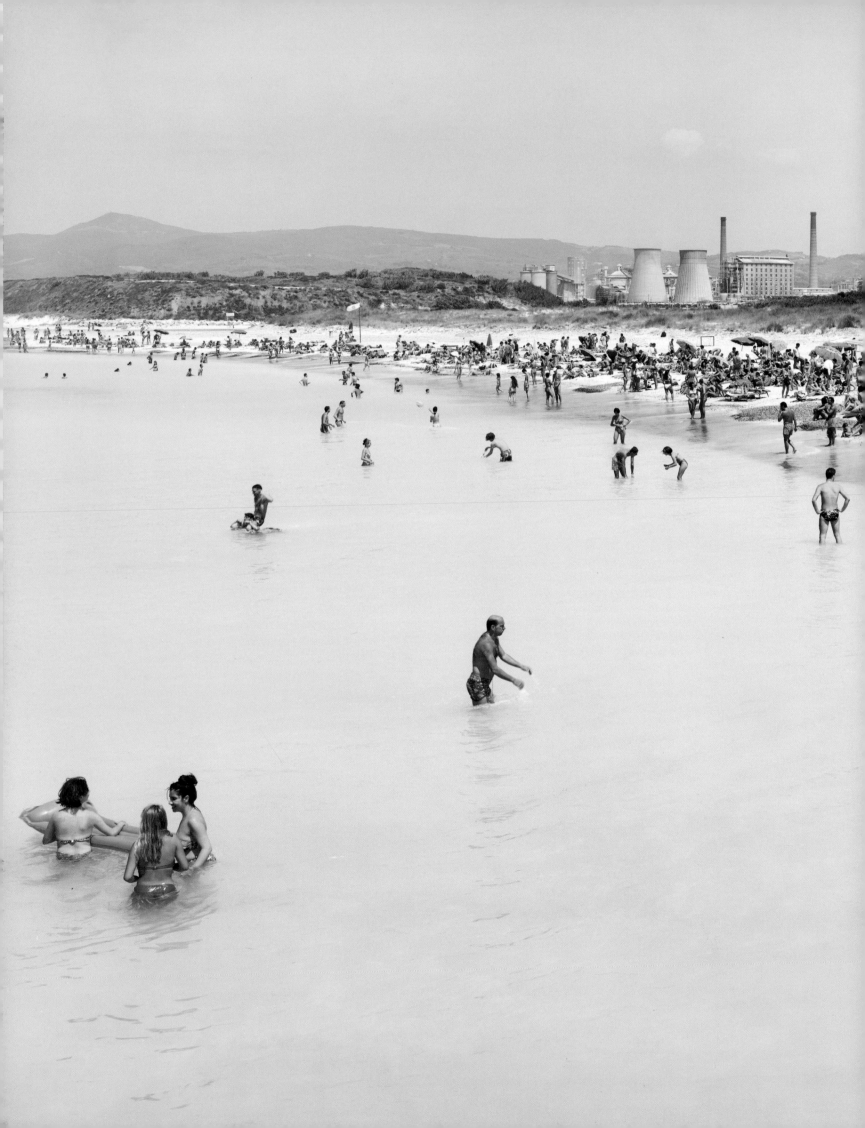

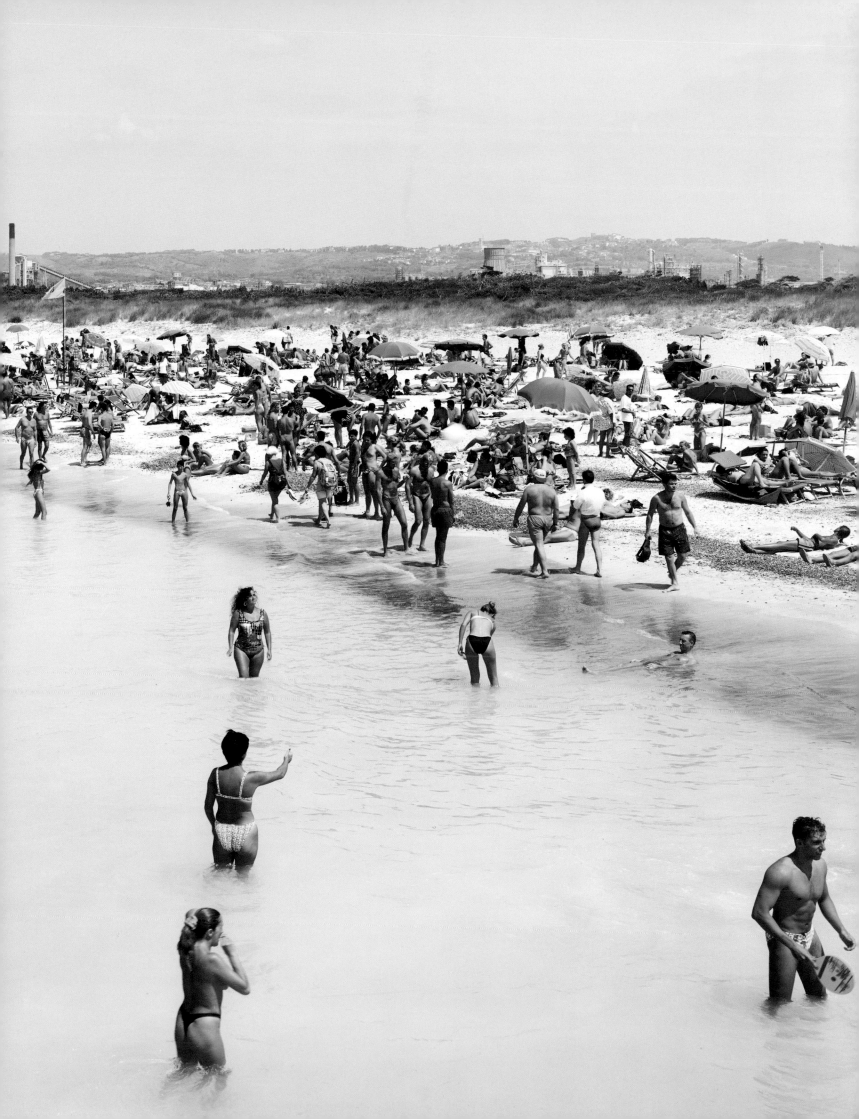

objective, or that Robert Adams is not sometimes extremely personal, but the two approaches are quite distinctive, and both have characterized photography in recent decades.

The links that the *New Topographics* exhibition forged between art and photography, that is, between the photography world and the artworld, were highly significant. So were those forged between American and European photography. The New Topographical style was perhaps even more influential in Europe, and the decade following the exhibition saw art photography in Europe, which had lagged behind American developments in the 1960s, begin to catch up, as art institutions in Europe took a belated interest in the medium, and began to collect it and promote it in much the same way as in the United States.

American photographers came to Europe to exhibit and teach. Some, like John Gossage, returned repeatedly and made work. Gossage photographed Berlin and the Berlin Wall for over ten years. Others, like Lewis Baltz, moved to Europe to live and work. By the mid-1980s, there was regular contact between American and European photographers, and the Europeans began to influence the Americans who once influenced them.

Landscape becomes text

During the 1980s and '90s, the New Topographical approach was widespread, as seen, for example, in the work of the School of Düsseldorf. But the other approaches to photography of place discussed earlier in this chapter were evident too. The street, of course, retained its particular fascination for photographers, but the area which has begun to rival it in popularity is the suburb or, more broadly, the interface between mankind and nature, the places where we impose ourselves upon nature. That is to say, almost everywhere.

Photography of place was also influenced by postmodernism, an art movement highly critical of what was perceived as late modernism's 'art for art's sake' elitist creed. Postmodernism preached that any work of art was a 'text' rather than an act of creative genius. It was an ethos that seemed particularly relevant to photography, both because of its mechanical nature and because photographic representations were so ambiguous and yet so influential. Photography gave postmodernists the 'intertextuality' they looked for in any work of art.

Robert Adams may not have been inclined to talk about 'intertextuality' – he is an avowed sceptic on the subject of postmodernism – but when he talked about the levels at which the best landscape photography (indeed any photography) might work, he was expressing the complexities that contemporary photography looks for in plain terms:

> Landscape can offer us, I think, three verities – geography, autobiography, and metaphor. Geography is, if taken alone, sometimes boring, autobiography is frequently trivial, and metaphor can be dubious. But taken together ... the three kinds of representation strengthen each other and reinforce what we all work to keep intact – an affection for life.

Adams might have added history or psychology to his list of verities, but the point he was making is that the photography of place has a complex tradition, and today the best landscape photographers employ a wide variety of strategies in a multifaceted discipline.

The most pressing issue in the photography of place is a site's history, how it has been affected by time, by climate and by mankind. Landscape photography has become political, not necessarily in terms of environmental causes – although many photographers are directly concerned with such issues – but in terms of the meanings it asks us to consider. Since the 1970s, the best photography of place does not simply expect the viewer to inhabit the depicted space. It asks that the viewer think more deeply about how a place came into being, how environmental and social pressures may change it, and the way people use it. Landscape photography still takes us 'there', but the contemporary photographer also recognizes that a place, and its depiction, is a complicated matter – every site is acted upon by both nature and mankind. In photographing place, we are never just photographing nature. We are always photographing culture.

'Landscape can offer us, I think, three verities – geography, autobiography and metaphor. Geography is, if taken alone, sometimes boring, autobiography is frequently trivial, and metaphor can be dubious. But taken together ... the three kinds of representation strengthen each other and reinforce what we all work to keep intact – an affection for life.' Robert Adams

Osamu Kanemura (Japanese, b. 1964)
Untitled 1995
Gelatin silver print

To support himself while making photographs of Tokyo, Osamu Kanemura worked as a newspaper delivery boy. Doing his round helped him experience the city with the kind of intensity required for this project. The result is an almost nightmarish, undeniably exuberant vision of a city swamped by a jungle of signs, posters, poles and electrical cables.

Kanemura uses this profusion to make formally dense photographs, the frame filled to overflowing with jumbled visual elements that he has forced into largely coherent compositions.

His complicated patterns rival those of a Jackson Pollock in their overall spatial complexity, with no object dominating any other. They are like the fractured landscapes and wirescapes of Lee Friedlander taken to another level, collages of the contemporary metropolis. Yet these 'visual collages' are not artificial constructions, but simple records of what was in front of his eyes.

Essentially documentary photographs, they record the visual aspect of Tokyo – albeit an aspect filtered through Kanemura – but they also, in a tradition that dates back to Friedlander and William Klein, document the city experience. Here is the pace and confusion of an environment that is the product of unchecked commercial imperatives rather than design.

And yet, although one can recognize the dehumanized quality and loneliness of life in the contemporary metropolis, Kanemura's pictures have visual excitement as well as chaos. The psychological tenor of his images might be as dark as the tonalities in his prints. They might be uncertain – we can read into them whatever we want – but overall there is as much exhilaration as despair or alienation. However we react to his vision, it cannot be denied that Osamu Kanemura has fashioned a visually exciting and persuasive picture of contemporary Tokyo.

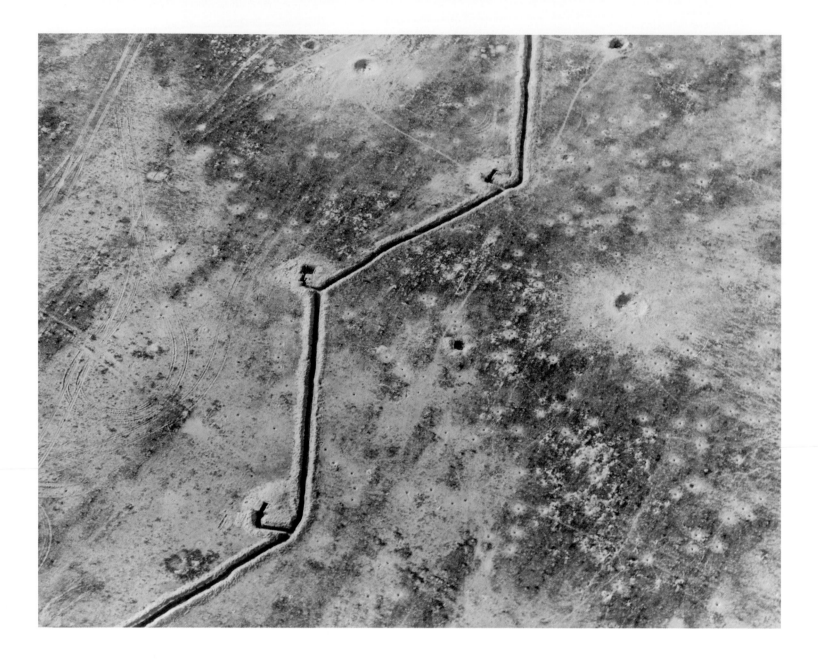

The landscape photography of Sophie Ristelhueber explores how the land is shaped by physical, political and cultural forces.

Sophie Ristelhueber (French, b. 1949)
Untitled 1992
Chromogenic (Type C) colour print
From *Fait: Kueait 1991*

Sophie Ristelhueber's project *Fait* ostensibly looks at the landscape, and takes a conceptual artist's approach. Yet it is arguably the most telling document to emerge from the 1991 Gulf War. '*We must abandon the territory of reality and collective emotion to reporters, editors, and photographers*', Ristelhueber has said, but with *Fait* she is staking a claim, like her compatriot Christian Boltanski, for photographic artists to involve themselves with history.

Fait is presented without captions, in a gallery installation or in an exquisite little artist's book. It is a suite of colour photographs, taken from the air or on the ground, of the land over which the first Western conflict with Saddam Hussein was fought. The ground photographs tend to be close-ups but, like the aerial photographs taken from a great distance, they are confusing in scale. We often do not know whether we are looking at a large or a small piece of territory.

Ristelhueber's images have the dry, objective look of, say, an insurance assessor's report. That is, they seem like evidence. But they are art, and Ristelhueber asks rather different things of them. She asks us to view them culturally as well as

factually, and to use our imagination as well as our eyes. She is fascinated, artistically, by scarred bodies, by scarred territories, and, as writer Marc Mayer has said, '*by the more impenetrable scars that events and texts leave on our cultures and personalities*'.

In this picture, we have a set of Nazca Lines for our times, a mysterious conglomeration of marks on the desert floor, which, if we draw parallels with those ancient Inca patterns, might suggest that religion and war are synonymous.

Shirana Shahbazi (Iranian, b. 1974)
From the series *Goftare Nik [Tehran-02-2000]*
Chromogenic (Type C) colour print

In *Goftare Nik (Good Words)*, the Iranian artist Shirana Shahbazi set out to counter the West's generally demonized view of her homeland. She sought to widen the impression we have had of Iran since the Islamic Revolution of 1979, as a country almost mediaeval in outlook, ruled tyrannically by bloodthirsty, anti-Western and backward-looking ayatollahs.

Shahbazi shows that behind this notion of a fundamentalist Islam – which of course has its adherents – many Iranians, young and old, have similar ideas and aspirations to their Western counterparts, and contends that a certain degree of modernization has been permitted by the regime. This photograph, of the outskirts of Tehran, is typical of the forward-looking Iran, and Shahbazi depicts in this, and other landscape images, a country of construction sites, highways and power lines.

In her pictures of people, she demonstrates how popular culture, imported from the West, has affected young Iranians. Shahbazi also counters the view the West tends to have of the position of women in Iranian society – repressed by the doctrine of full-body covering and confined strictly to the home. She shows women in responsible jobs, even in politics, taking a full part in building the modern Islamic state.

Shahbazi is not claiming to paint a full picture of Iranian society, but rather to deconstruct any view which is prejudiced, blinkered and simplistic. There are backward elements in Iran, and some terrible abuses of human rights. But reforms are also taking place – albeit cautiously – and in her photographs she seeks to reinstate the balance that is lost in any one-sided, tendentious view of a society.

Shirana Shahbazi depicts an Iran where traditional and modern cultures both clash and integrate.

Roni Horn (American, b. 1955)
Untitled 2000
Chromogenic (Type C) colour print and text
From the series *Still Water*

The American artist Roni Horn has dealt with two
particular places in her work – Iceland and the
River Thames. Her photographs and texts about
the Thames form one of the most complex artistic
meditations made in recent years about the
nature of place and the meanings we attach
to places. Simple photographs of the water's
surface are accompanied by multi-layered texts
detailing cultural associations that the river has
generated – among them, the work of Charles
Dickens, the *Marchioness* riverboat disaster,
Weil's disease, murder and suicide.

Horn photographed the surface of the water
close-up, from trips taken on riverboats. She
caught its changing colours in different lights,
freezing its flow and making it look impenetrable,
observing that the river's murky '*appearance
negates any of the typical associations historically
brought to water: for example, the pastoral,
sublime, romantic and picturesque*'.

The grimly factual details of river deaths
culled from police reports certainly rule out
romantic connotations, and the physical character
of the water in each image could variously be
described as solid, oily, viscous, metallic, slimy,
grimy, luminous, dark and polluted. Most of those
associations are negative, and it would seem that
only a suicide would want to venture into these
decidedly unwholesome depths.

Although the photographs by themselves
suggest certain readings, Horn adds further
layers of complexity with her accompanying texts.
As well as the police reports and anecdotes
by river workers, the artist sets up a continual
dialogue with the viewer, about the nature
of water and how we might regard the surface
of a river as a reflection of ourselves and our
collective psyches. This is certainly a profound
and thought-provoking work, and might be
regarded at one level as a more intellectually
determined, non-romantic and thoroughly
postmodern version of Alfred Stieglitz's
'Equivalents', where we are invited to read into
semi-abstract photographs as into the flickering
flames of a fire.

Coda
Spirit of place

Photographers naturally love to make 'on the road' pictures. But some of the best photographs of place have been made by photographers who have worked in a specific location over a long period of time. It's a question of getting to know something intimately. Like fly-fishing, knowing a stretch of river and the pools where the fish are, it's a matter of skilfully casting for images.

This coda looks at two photographers of place who made important bodies of work in the 1980s. One focused upon a great European capital with a troubled past, the other upon a small seaside resort in the north of England that had seen better days. The bodies of work are John Gossage's *Berlin in the Time of the Wall* (1982–93) and Martin Parr's *The Last Resort* (1982–85). One project was shot in black-and-white, the other in colour, at a time when photographers were beginning to favour colour rather than black-and-white.

More significantly, although Gossage is American, both projects represent a point in time when photography in Europe, having suffered something of an artistic decline, was undergoing a rapid revival. Gossage did the Berlin work after he, like other leading American photographers such as Lewis Baltz and William Eggleston, had been invited over to Berlin to exhibit and conduct workshops. Regular contact between American and European photographers was of mutual benefit, beginning the shift towards the global village that is photography today.

On his first visit to Berlin in 1982, Gossage, like many visitors of the period, was overwhelmed by the Berlin Wall. Built in 1961, it had kept the city locked into a kind of time warp – a constant replaying of the moment in 1945 when the four occupying Allies divided the city between East and West. Gossage had been feeling his way in his previous work towards, as he put it, a way of '*photographing the*

John Gossage
(American, b. 1946)
Gelatin silver prints
From the series *Berlin in the Time of the Wall*

clockwise, from top left
Gröbenufer 1982
Stallschreiberstrasse 1982
Bernauerstrasse 1982
Monumentenbrücke 1985

past as present', a reversal of what photographers usually do. He was discovering how many ways he could encourage history to enter his pictures. He was exploring the different means by which photography informs the discourse of history. And he was trying to make visible the psychological effects of history.

For an artist with such concerns, Berlin was a gift, the equivalent of the archaeological photographer faced with the unviolated tomb of Tutankhamun. The wounds of recent history were laid out in superabundance within the landscape. The layers – pre-war, wartime, post-war, Cold War – lay clearly exposed. Little had been rebuilt in the vicinity of the Wall, and the open ground and ruins were like the strata of history on an archaeological site, ready to tell their stories to the sensitive photographer.

Gossage immediately set to work, paying many visits to Berlin over a period of eleven years. He was encouraged to discover that local photographers paid little attention to the Wall – at least when he began – so he had a great subject very much to himself.

The *terrains vagues* – the 'non places', empty lots, ruins and wasteground around the Wall – form the core of the book, land left untouched since the war, piled high with rubble and shrouded in weeds. But Gossage extended his exploration outwards, always photographing the city as it was shaped by this history. He was focusing on a landscape that had been acted upon by mankind *in extremis* – in war and in political strife.

In photographing what one might term 'the landscape of power', Gossage began to employ the photographic techniques of power. To reach over the Wall, he photographed at night with a telephoto lens and 'surveillance' film, extremely high-speed film used by security forces on both sides of the Wall. These night shots form the 'heart of darkness' at the centre of the book. They reinforce the unease that permeates the work, and are clearly a metaphor, as photo-historian Laura Katzmann says, '*for an occupied city burdened by the dark forces of fascism and totalitarianism*'.

Gossage had always believed in the power of the photobook, and parts of the Berlin work were published variously before he released his *magnum opus* in 2004. The book contains 464 photographs, divided into seven chapters, a dense, poetic meditation on the nature of landscape, on politics and culture, on history and the aesthetics of power. It is an epic statement, rich and allusive, and so grand in scope that the only body of work with which it can be compared is Atget's exploration of Paris. 55–56

Another passionate advocate of the photobook is Martin Parr, and, although single images in *The Last Resort* (1986) have become contemporary classics, Parr would argue that it is in the context of the book that they flourish to their fullest extent. *The Last Resort* was his first book in colour and represents a significant moment in both British and European photography – a major body of documentary photography in colour rather than monochrome.

The 'resort' in question is New Brighton in the Wirral, across the Mersey estuary from Liverpool, once the No. 1 holiday resort in the north-west of England and famous for its lengthy promenade. It was in decline when Parr began photographing it, but was still a popular day-out destination on weekends and bank holidays for the Merseyside conurbation. However, if the town was crowded, as it often was when Parr photographed it, people left a lot of litter, and it was this, plus his rather clear-eyed, unsentimental view and sharp, lucid colour, that ensured a mixed reaction to the work.

Photographs of screaming babies, children with ice cream on their faces, in a litter-strewn environment, led to Parr, a middle-class boy from Surrey, being accused of cynicism.

But young photographers approved and *The Last Resort* was immensely influential. In retrospect, and in view of Parr's later work, the initial negative reaction was somewhat hysterical. While it is true that the combination of biting colour and flash in Parr's vision can be merciless, there is also a great deal of gentle humour and affection in his view of New Brighton. Children do get ice cream on their faces, bank holiday crowds do litter seaside resorts, but Parr's project was about a great deal more than that. It was about an industry and a community in decline, a way of life threatened by cheap air travel. Above all, it was about Britishness, about how the British muddle through, how they make the best of things despite crowds, bad weather and litter-strewn promenades.

Since New Brighton, Parr has taken a similar unsentimental yet ultimately affectionate view of the British middle classes, of tourists, of the fashion world, and of the eccentricities and foibles of many other groups, so his view of the Merseyside working-classes at leisure is by no means unique. It should be remembered that he is a documentary photographer, that is to say, he has a personal vision, but his view of any individual is not personal. He is not simply saying something about people, but about society and cultural mores. If his work is harsh at times, it is also empathetic at times, and any critique is directed at the culture, not the individual.

Gossage and Parr are just two of the thousands of photographers who have contributed seriously to the photography of place in the last twenty-five years or so. Embracing a fundamental part of what photography does best – take us there – both have found a way to contemplate our present and our past.

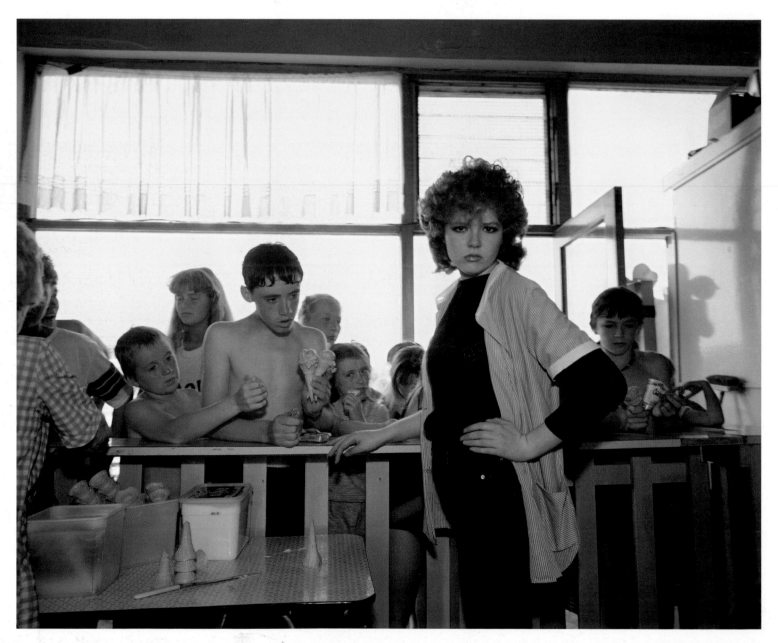

Martin Parr (English, b. 1952)
New Brighton 1985
Chromogenic (Type C) colour print
From the series *The Last Resort*

One of the most important early postmodernist works was a suite of photographs by a young American artist called Cindy Sherman. It had the decidedly prosaic title of *Untitled Film Stills*, but was spearhead to the whole postmodern revolution in photography.

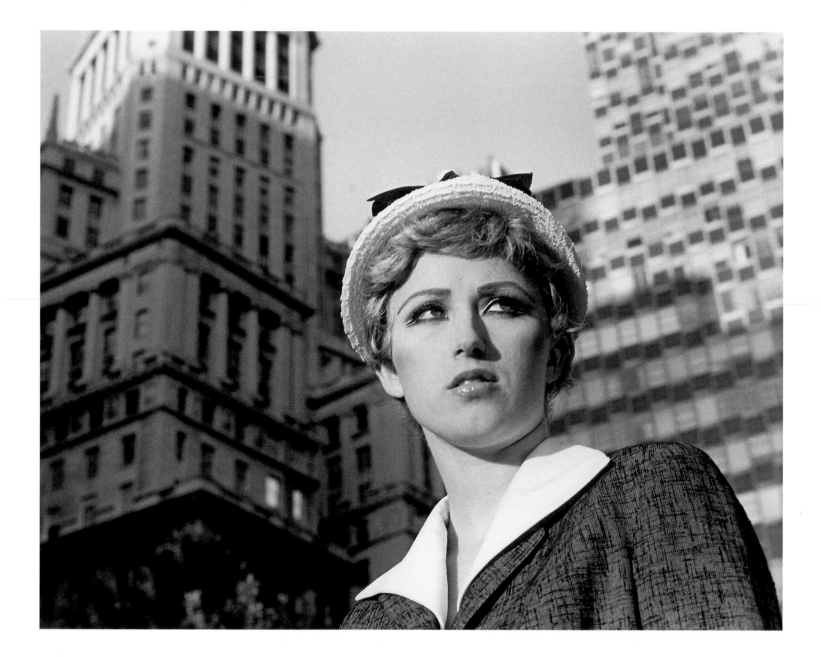

An expression of this new way of thinking about art – as a system of signs whose meaning is determined by reference to other signs – Sherman's photographs challenge our perception of, and interaction with, the images that surround us as we live our lives.

Prelude
Material girl

At first sight, *Untitled Film Stills* (1977–80) consisted of sixty-nine small black-and-white photographs – not particularly seductive photographs in a technical sense – that appeared to be self-portraits of the artist, dressing up and acting out a number of fictional roles. In fact, they were not self-portraits, but Sherman was her own model, and has continued to be so in the two-and-a-half decades since *Untitled Film Stills* was finished. The role playing, however, was precisely the point of the work. Sherman, wearing different costumes and wigs, photographed herself playing scenarios she had devised, little psychodramas involving feminine stereotypes or archetypes, depending upon your point of view.

Each image in the series shows a single woman engaged in a situation which evokes a moment, a frequently banal yet charged moment that might be a still from a film. The work's reference was Hollywood or more especially, according to Sherman, European films of the 1950s or '60s, the period when she was growing up and becoming aware of the movies and television. It requires that the viewer is aware of at least some of the stories, strategies and conventions of both media, although Sherman did not create stills from specific films. Genres like *film noir* and French 'new wave' are evoked, so are directors like Alfred Hitchcock and Michelangelo Antonioni, and stars like Brigitte Bardot and Simone Signoret.

But Sherman's interest was generic. That is a vital part of the suite's postmodernist credentials. We are not required here simply to recognize a film and a scene. We are being asked to look at, to appreciate and to 'decode' Sherman's work through our inherited and shared knowledge of movies, of film stills, and of the other kinds of photographic material – such as pictures of stars in the press – that make up our individual and collective interaction with all the images (still or moving) that enter our lives.

Cindy Sherman (American, b. 1954)
Untitled Film Still #14 1978
Gelatin silver print
From the series *Untitled Film Stills*

Postmodern photography does not simply represent things – film stills that depict certain incidents in women's lives, in this case – it re-presents them. That is to say, it actively comments upon the making of those representations, and refers to other representations from which they may have been derived – in other words, to the genre of the movie still. Of course, no art emanates from thin air. Most art is influenced by other art, even when it apparently takes a leap forward into the unknown. Postmodernism simply acknowledges this debt, and offers a way to examine the complex relationships between all kinds of imagery in this image-saturated, especially photograph-saturated world.

We are asked to decode Sherman's stills, and they require a lot of decoding. The first level of interpretation, as it were, is the 'films' that the 'stills' are illustrating. Each scene shows a woman, a character we recognize from popular culture. In his introduction to the original publication of *Untitled Film Stills* (1990), the critic Arthur C. Danto calls her 'the Girl', but the girl is Woman, and each manifestation of her in Sherman is one we can name. There is the slatternly housewife, the shy but sexy librarian, the tart with the heart of gold, the woman in jeopardy from a stalker, the day-time lush, and so on. Familiar characters from countless films, so real to us that we generally do not realize that they are constructions, fictions – fictions that nevertheless colour our view of the world.

Many of the women portrayed by Sherman in this series might be regarded as 'bad girls', or in situations that are, to say the least, uneasy. But these imagined situations are set before the viewer so that each of us may concoct our own notion of how things might develop. The frame of reference, however, is films of the 1950s and '60s, a time when women portrayed in films tended to conform to the virgin/whore dichotomy. And the whore – the bad girl – tended to reap the wages of sin, while the virgin – the good girl – ended up with the man and everything else. Only films from Europe confounded this stereotype, and that may be why Sherman was attracted to European films, and the 'strong, independent woman' more often found in continental movies.

The sense of unease and uncertainty depicted in so many of the scenes suggests, however, that Sherman's aim is to subvert all the stereotypes about women fed to us, even today. And some of the strongest, most immediate and positive reactions to the work came from feminists, who saw *Untitled Film Stills* as 'critiquing' stereotypical views of women and modes of representation largely dictated by men.

The feminist movement of the 1970s saw many women artists in the United States take up photography and begin to make work that either portrayed women as women would want to see themselves, or critiqued male views of women. One of the key tenets of postmodern cultural theory was that of the 'male gaze'. This was the realization that most of the images of women throughout history were fabricated by men to be gazed at by other men. Such images, therefore, revealed not only the prejudices men entertained in relation to women, but also the underlying hatred many men felt for women. In a word, the history of art – according to the most rigorous feminist theory – was basically misogynous, and it was the duty of women artists to counter this distorted view.

A raft of women photographers – among them Judith Golden, Jo Ann Callis, Eileen Cowan and Joyce Neimanas – made work relating to the representation of women, but most have been in part eclipsed

by *Untitled Film Stills*, which has become a touchstone not only for postmodern photography but feminist photography in general.

One of the primary reasons for Sherman's success, however, is the fact that *Untitled Film Stills* can be enjoyed as much by men as women. As the curator Charlotte Cotton has remarked:

> Much of Sherman's work examining identity and image is reached through the route of visual pleasure. The satisfaction and enjoyment of developing narratives for the Untitled Film Stills, *for example, is a part of the viewer's experience. The enjoyment Sherman must have derived from developing narratives for the suite is transmitted to the viewer as he or she seeks to decode the imagery and establishes his or her own narrative. In short,* Untitled Film Stills *beguiles and engages the senses, it is as much visceral as intellectual.*

Sherman's work as a whole has been a crucial component of the feminist influence upon women's photography, yet it seems clear that she came to it by examining personal concerns – a love of movies, a penchant for dressing-up. She claims that she had never heard of the 'male gaze' theory when she began *Untitled Film Stills*. Yet, through this exploration of the personal, she instinctively created a body of work that touched upon wider issues concerning the representation of women. As Arthur C. Danto has written:

> I can think of no body of work so timeless and yet so much of its own time as Cindy Sherman's stills, no œuvre which addresses us in our common humanity and at the same time induces the most advanced speculations on Post-Modernism, no images which say something profound about the feminine condition and yet touch us at a level beyond sexual difference. They are wry, arch, clever works, smart, sharp, and cool. But they are among the rare works of recent decades that rise to the demand on great art, that it embody the transformative metaphors for the meaning of human reality.

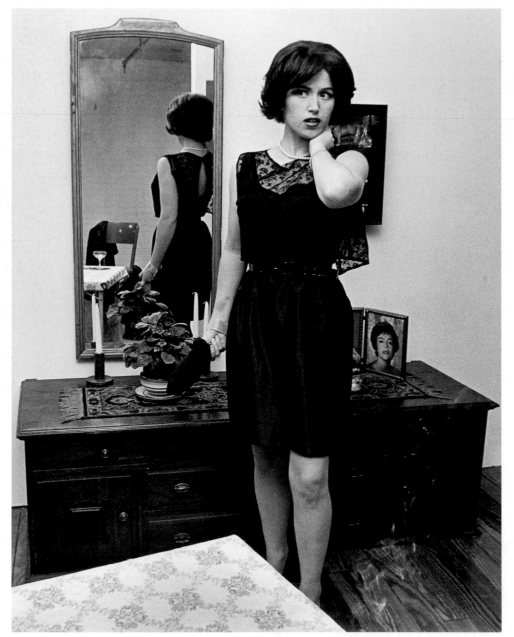

Cindy Sherman (American, b. 1954)
Untitled Film Still #21 **1978**
Gelatin silver print
From the series *Untitled Film Stills*

5

The photo-based artworks, installations and artist's books of Christian Boltanski generally have as their basis the 'found' anonymous photograph.

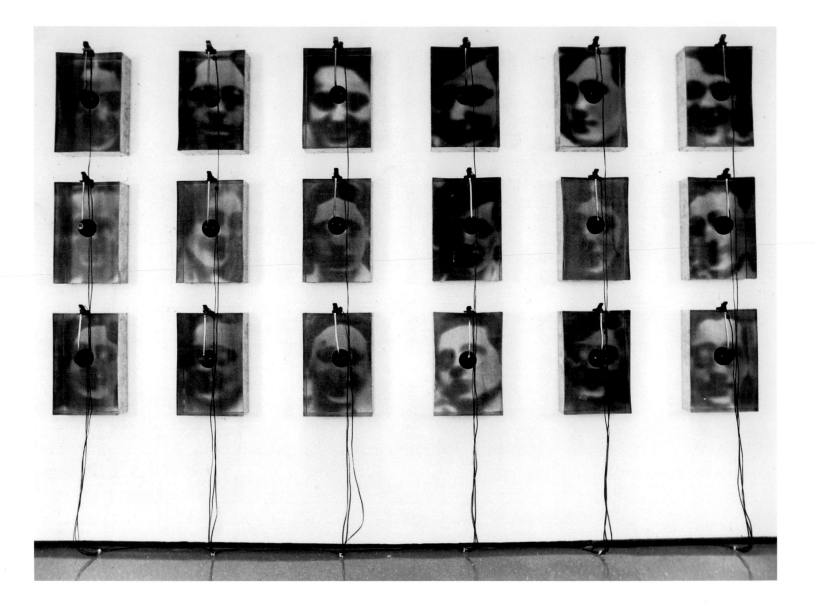

And his art deals with two of photography's primary uses in our contemporary culture – as a vessel for memory and as a means of social control.

Christian Boltanski (French, b. 1944)
Chases High School 1991
Mounted photogravure prints, lamps and
display stand

A typical Boltanski work consists of grids of
anonymous portraits, sometimes deliberately
blurred, as here, sometimes presented in
a more orthodox manner. These portraits might
be snapshots; they might be identity-card or
passport photographs. The distinction between
the two – one, a private function of photography,
the other, a public function – is left unspecified,
for Boltanski's aim is to mediate between the
two, thereby examining the politics of identity
bound up in the photograph.

He frequently uses these grids or rows of
photographs to make an installation resembling
a reliquary or shrine, a memorial to those who
have died. Boltanski is Jewish, and his works'
titles often refer to the Holocaust, but the artist
has stated that, while this may be the obvious
reading, they are not necessarily Holocaust
specific. They certainly are about the way a
portrait photograph marks and individualizes
a life, makes it particular. Yet political systems,
particularly totalitarian systems, use the medium
to strip us of our individuality, and that, as in the
case of Nazism, can be a step towards genocide.

The images in Boltanski's 1991 installation
piece *Chases High School* show the 1931
graduation-class photographs from a Jewish high
school in Vienna. Taken two years before Hitler
came to power, we are left to speculate what
became of the young men and women shown in
this ghostly out-of-focus manner, in a profound
demonstration of photography's elegiac qualities.

Identity and immortality

Of all the genres of photography, the most charismatic, and
therefore the most difficult to resolve successfully, is the portrait.
A portrait photograph immediately grabs the viewer's attention
and triggers profoundly personal responses – emotional,
paradoxical and not always rational. The issues raised are
complex, challenging, even treacherous, revolving around the
self and its representation, identity and immortality. In a very real
sense, the photographic portrait conforms to the hoary legend
that it steals something of the sitter's soul. Certainly, the chemical
imprint of a fellow human being's physiognomy has a potent
talismanic quality. It is capable of immortalizing and creating
myth. It can confer acknowledgment and bestow dignity. It can
also stereotype, debase and dehumanize.

Portraitists, therefore, should have a clear moral obligation,
for their powers to misrepresent are wide. They have been
entrusted with a sitter's identity, no less. And the act of portrait
making is inherently perilous. It involves, as one of the great
photo-portraitists Richard Avedon notes, '*manipulations,
submissions*'. But if the moral obligation is recognized, and
accepted, then the photographic portrait at best can reinforce
our positive sense of collective and individual humanity. So the
best portrait photographers invariably have been humanists.
And if they themselves have not been moralists, their work
nevertheless has had its own internal morality.

The other characteristic of the photographic portrait, another
reason for its potency, is also distinctly two edged. Nowhere is the
sweet and sour nature of photography more apparent.
Compare any 19th-century portrait photograph and a portrait
painting of the same period. For all their haunting presence,
the faces in paintings are fictions. Whether painted by anonymous
craftsmen, or Ingres or Sargent, they are filtered through the veil
of another intelligence – be it adroit or maladroit, perceptive or
imperceptive, stunningly masterful or boringly mediocre. But no
matter how technically inept, how lacking in considered formal
qualities, a photograph must always stop us short. For it brings
us into direct communication with time past, and it transcends
geographical boundaries. It puts us into immediate touch with
the long ago and far away. It establishes a connection between
the quick and the dead.

And any person whose face the light of the 1840s, '50s, or '60s
traced – Lady Elizabeth Eastlake, by Hill and Adamson, Thomas
Carlyle, by Julia Margaret Cameron – has been '*dust and bones for
more than a century*', as the filmmaker Peter Greenaway observed
of Hippolyte Bayard in an essay on the photographer's marvellous
self-portrait of 1839. Bayard, of course, photographed himself
playing 'dead'. Now he is actually dead, but his portrait lives on,
conferred by the camera with a kind of immortality.

30
31

Combat or collaboration?

The act of photographic portraiture – with its ability to play fast and loose with identity – can certainly be considered an aggressive act. We speak of the 'capture' of the image or 'snatching' a 'shot'. The metaphors are revealing, and hardly accidental.

At the most extreme levels, as in hardest core pornography or in political surveillance photography, the aggression is manifest. Taking a photograph becomes an exercise of control, and, for much of its history, a particular tool of the dominant gender. Even in the relatively uncharged situation of the portrait studio, a subtle form of combat is enacted, because sitter and photographer tend to have different views of the end game.

These differences might be those of viewpoint or of emphasis. They might be marginal, of no matter, or they might be wide, and have serious consequences. But, in general, the sitter can be said to regard the construction of the self-image as the primary object of the exercise. On the other hand, the photographer, if ambitious enough, will seek to objectify, to puncture the subjectiveness of the self-image, to 'deconstruct' the self-regarding external mask. His or her intention is to 'reflect the soul'.

The portrait process might be compared to a tennis game in which the photographer has benefit of service. He or she tries inevitably to win each point with a swift volley or, failing that, to wear the opponent down with a grinding baseline rally. Irving Penn, for example, is considered a baseline specialist. His studio sessions are said to last until his subject drops the defensive mask out of sheer fatigue, subjugated by the insistent probing of Penn's camera. But the sitter, even if confronted by a nervous neophyte, is nearly always committed to the defensive, confined to deflecting the assault, to gaining points by stealth. Ultimately, the subject can only limit the margin of the photographer's success, for the game is rigged. The photographer must win, unless the result be declared null and void – that is, unless no image of worth or insight emerges from the encounter. As Richard Avedon has said of one of his sitters:

My concerns are not his. We have separate ambitions for the image. His need to plead his case probably goes as deep as my need to plead mine, but the control is with me.

That is a refreshingly honest statement by a photographer, free of the usual piety and hypocrisy – and yet chilling in its implication and application.

Of course, sometimes the making of a photographic portrait is an act of collaboration, although even a loving mother photographing her child has a vested interest in the outcome she desires. Nadar, the great French portraitist of the 1850s, knew that he was obliged to present his sitters in a positive light, but he did so without overt flattery. In his portraits, there is an ease and a degree of empathy with his subjects that derives in part from the fact that his sitters knew they were persons of some consequence, the cream of Second Empire intellectual society. One of Nadar's sitters, a seventeen- or eighteen-year-old aspiring actress named Sarah Bernhardt, seems to have grasped instantly that the camera 'loved' her, and that the new medium could further her career. That she became the most famous actress of the century was due, of course, to her electrifying performances, but she used photography throughout her career to project an image of the irresistible combination of beauty and talent.

Nadar (Gaspard Félix Tournachon)
(French, 1820–1910)
Sarah Bernhardt 1863
Albumen silver print from wet-collodion negative

Commercial portrait photographers like Nadar always realize the value of a 'hook' in their images – something to engage the viewer's attention. When photographing a young aspiring actress named Sarah Bernhardt in 1863, he suddenly had the idea of throwing a piece of studio drapery around her bare shoulders.

The resulting portrait is a perfect publicity image, an irresistible combination of the soulful and the sexy. The serious expression reflects the artist, and Bernhardt's beauty – by no means a conventional beauty by the standards of the period – adds the requisite sexiness, especially in an era when a stage career for a woman was regarded as little short of prostitution. A further twist is added by the fact that Bernhardt was Jewish, lending a note of orientalist exoticism to the imagistic cocktail, and this may have inspired Nadar to drape the curtain around her.

An instant success, Nadar's portrait was instrumental in launching Bernhardt's glittering career. And she used photography both for publicity portraits and 'stills' of her many roles throughout her career. *Cartes de visite* of Bernhardt were among the best selling, and she can be regarded as one of the first women to become a famous 'face' and to further both her celebrity and her career using photography.

Nadar is known for his portrait gallery of the eminent figures in Second Empire Paris, bringing to the business of celebrity portraiture an ideal approach, producing exactly what was expected, with just enough of the unexpected to make his pictures lively and interesting. Most of his best portraits were of prominent men – such was the nature of celebrity then – but he never made a better photograph than the several negatives he took of the 'Divine Sarah'.

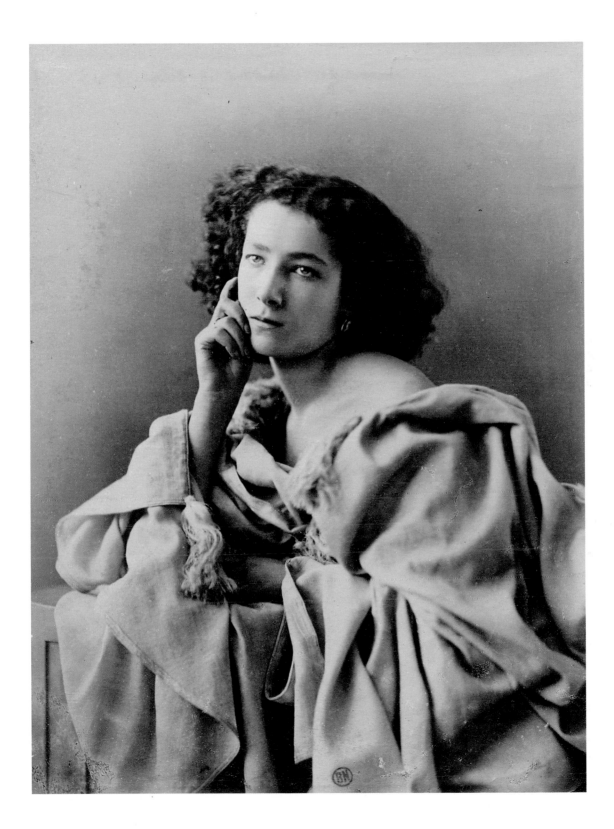

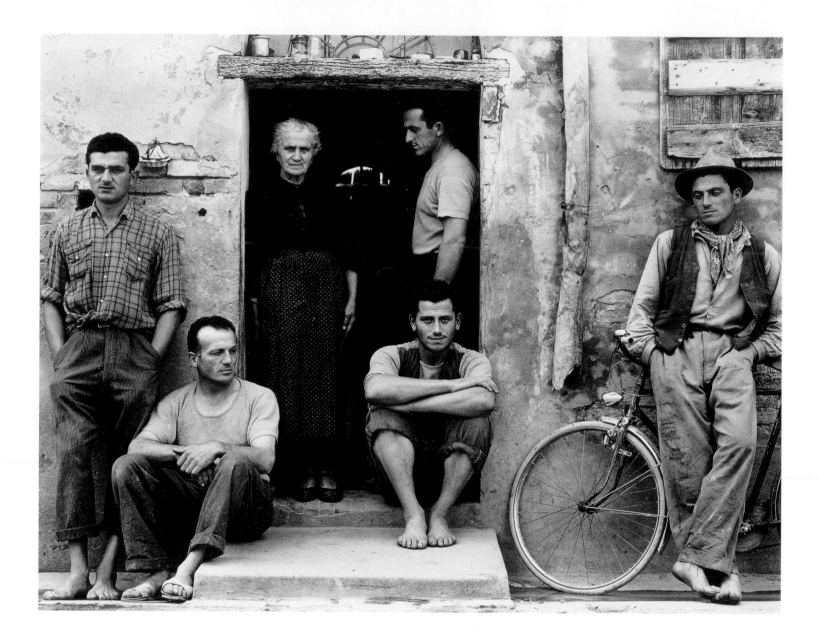

'I like to photograph people who have strength and dignity in their faces. Whatever life has done to them, it hasn't destroyed them.' Paul Strand

Paul Strand (American, 1886–1976)
Family, Luzzara 1954
Gelatin silver print

Strand declared that the kind of social pessimism which often passed for 'concerned' political art was too defeatist in spirit, offering no remedy except violence. The socialist artist should be concerned with the struggle of people to better themselves. But, in the subdued intensity of his portraits, a bleak undertow pulls at Strand's nominally positive message. His sitters seem stern rather than dignified, and his classical compositions do not simply freeze his subjects in temporal space, but lock them tonally into a harmonious whole. In an act of isolation, his subjects are moved from society, from the world, into a space that is 'other', the picture frame.

This famous family group from Luzzara bears all the solemnity characteristic of his work. Each individual within the group is spectacularly alone, suspended within his or her own existence. Separateness is the keynote. There is, as Reynold Price noted, '*no common physical feature, no common psychic moulding in their solemnity.*' Price even asked, '*Is there in fact a way to read them as a family?*' Crucially, it was Strand himself who posed the group in this psychologically telling fashion.

The sense of existential unease which runs through all of Strand's work does not necessarily negate his social programme. He still celebrated the proletariat, but in terms of a rich, voluptuous despondency. The political signs are certainly there to be read, though the intoxicating gloom tended to undercut the polemic. But if it limited his imagery in one direction, it surely enriched in another, for his portraits are amongst the most moving and complex in all photography – quite magnificent in their dourness.

Walker Evans (American, 1903–75)
Subway passengers, New York City, 1938
Gelatin silver print

In the late 1930s and early '40s, Walker Evans became interested in photographing 'types' in a way that was both candid and minimized the control he had over the result. He began to ride the New York subway, taking surveillance-type portraits with a camera under his overcoat.

His aim was to take absolutely candid images and also to filter out his own expressive voice as much as possible. He looked at his subjects directly – not through the camera – deciding when to press the shutter, but having only a vague idea of how they were placed in the frame. He was attempting the photographic equivalent of the surrealists' automatic writing, photographs with the deadpan, but fascinating look of the automatic photobooth portrait.

He was not entirely successful, of course. The images are totally candid, but also totally expressive, and quite different from other, similar exercises. Certainly, Evans's own preferences for types come through strongly. While he did not focus upon the ugly, he did not photograph the particularly handsome. Nor did he tend to concentrate upon the very young or old. As for his subjects' expressions, he inclined towards the slightly sour, though any expression the camera depicts as sour may not be so a moment later.

The work might be interpreted as an accurate depiction of the daily ride to and from work, where mankind is hardly putting its best face forward. In that regard, it might be viewed as a brisk antidote to the sentimental humanist photography that he hated, and as a forerunner to the rather more negative – some would say realistic – tone taken by Frank, Klein, Winogrand, Arbus and those who followed them.

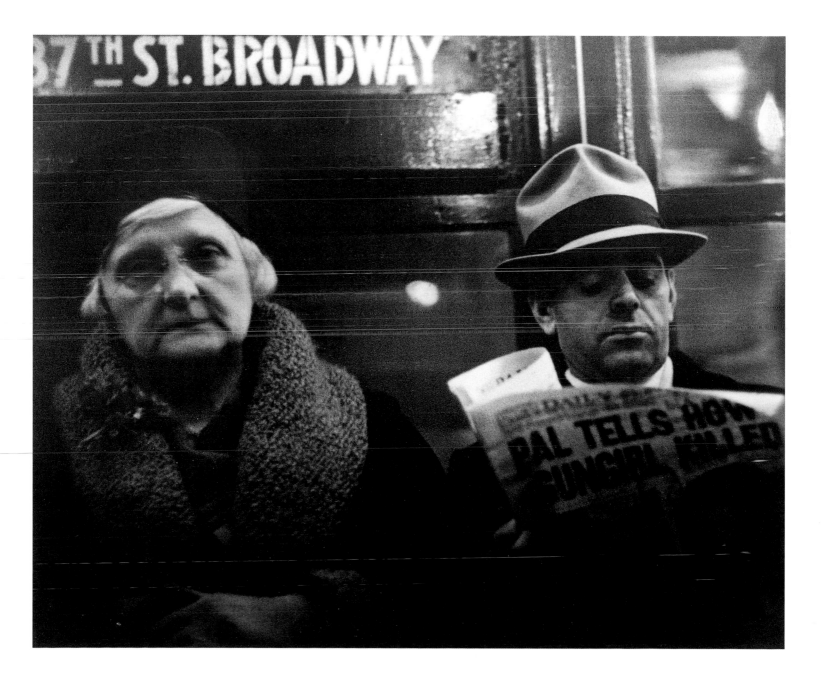

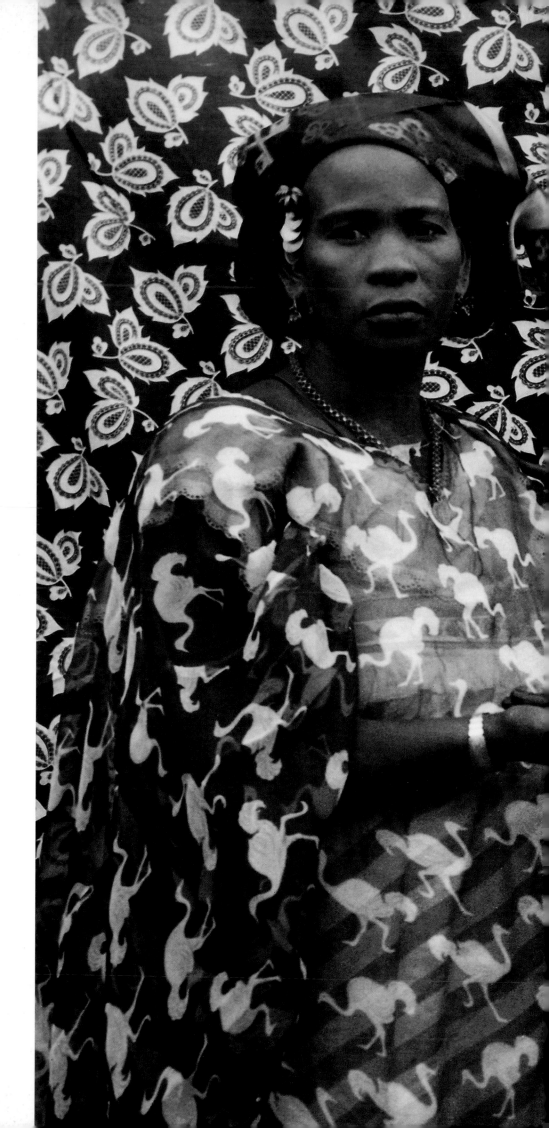

Seydou Keïta (Malian, 1923–2001)
Untitled 1958
Gelatin silver print

Photography began as an expression of the cultural values of its inventors, France and Britain, the two great colonial powers of the 19th century. In the 20th century, photographers worldwide used the medium to reflect the world around them and picture their own cultures from within.

A fine example of this is the work of the Malian photographer Seydou Keïta, who opened a portrait studio in Mali in 1948, close to the city's railway station and post office. Its business was commercial portraiture, yet Keïta's inherent talent and ambition ensured that, during his two-and-a-half-decade career, he and his fellow Malian Malik Sidibé put Malian photography on the map by building up bodies of portraiture that form a fascinating and valuable chronicle of life in Mali in the late 20th century.

Keïta developed an instantly recognizable style, which derived directly from the country's indigenous culture. Malian women wear brightly coloured and boldly patterned textiles, and Keïta used these in his studio backdrops, so that often, as in this picture, he was photographing complex pattern against complex pattern, breaking 'rules' in a successful and highly diverting way. Yet he always retained his subjects' individuality amongst the riot of formal design. He made many images in this vein, and might be described as a formulaic photographer, but his work belies that description. He captured both a subject's character and also nuances of life in Mali and neighbouring Senegal, and his meticulous and wholly objective scrutiny displays many of the virtues of Bellocq's Storyville portraits.

The work of Keïta and Sidibé has now been brought to the attention of the West, but it is certain that there are other, equally fine photographers in ex-colonial nations worldwide who await a wider audience for their work.

Hannah Starkey (Irish, b. 1971)
The Dentist, 2003
Chromogenic colour (Type C) print

Making documentary photographs in public places is hard work, with no guarantee of success, and with sometimes dubious control over what one wants one's photographs to say. But what if photographers 'cast' and set up their own images, controlling every aspect of the process? Does that somehow make them less valid as photographs?

Like Gregory Crewdson, Hannah Starkey casts and directs her photographs. But, far from the heightened, fictive reality he depicts, she is seeking to record ordinary, everyday events in the most unobtrusive manner possible, so they could be mistaken for documentary photographs.

The subjects in her carefully thought-out and staged scenarios are usually young women, and her theme is generally the lives of these women within contemporary urban culture. It's an important theme – modern life, one of the primary themes of photography – but these are not dramatic tableaux. The figures in her images don't do much. They generally sit around or, as here in a dentist's waiting room, they wait in some alien environment, isolated in their own thoughts.

That is not to say that nothing happens in a Starkey picture. There is always an implied narrative in the stillness. They contain all the measured tensions of those lonely women in Edward Hopper paintings. They are documentary fictions that encompass the small joys and inherent fears of city life. However, to the Hopperesque inflections Starkey adds layers

of cultural reference that locate her imagery in the convoluted maw of contemporary representation, especially popular representations of women.

Starkey may construct her photographs, but they are rich and complex documents of modern life. They are delightful visually but also intellectually stimulating, reinforcing the fact that images and identity are culturally determined in complicated, profound and mysterious ways.

Katy Grannan (American, b. 1969)
Mike, private property, New Paltz, NY 2002
Chromogenic (Type C) colour print
From the series *Sugar Camp Road*

One of the more interesting artists from Yale, where environmental portraiture in the 'directorial' mode has been a feature of the photography programme, Grannan has been called 'the new Diane Arbus'. But the tag is superficial, though Arbus might be the obvious frame of reference. Both their intentions and the final effect of each woman's imagery would seem quite different.

Although Grannan often makes portraits where her subjects are either nude or partially nude, and although there is a strong sense of psychological, even psycho-sexual disclosure in her pictures – as there is in Arbus – Grannan's work seems much more conceptual in nature. Arbus was a phenomenologist, rooted in the documentary tradition and open to all the contingencies of the moment. Grannan certainly improvises, but her approach is much more controlled and prepared – more artificial – and she deliberately draws inspiration from art history and the European traditions of portrait painting.

Grannan frequently places her naked or semi-naked figures in apparently arcadian landscapes – as if Cézanne's bathers have been translocated from the earthly paradise of Provence to the here-and-now of an American setting where the mall or suburb looms just behind the trees.

Her subjects are treated with a studied neutrality. Grannan neither idealizes nor takes the opposite tack. She does not actively seek the overtly damaged (unlike Arbus), but looks for the ordinary. Nevertheless, there is still some sense that everything in Grannan's world is not quite as American as apple pie, of something slightly suspicious emanating from the suburban woodshed. After all, Cézanne notwithstanding, lounging about nude in the countryside is not the kind of thing supposedly nice boys and girls do.

**'Artist/photographer female: seeks people for portraits: no experience necessary: leave msge.'
Katy Grannan places this request in local suburban newspapers to find subjects for her portraits.**

about her subjects, even those who have beaten her up, and this aspect of her work makes *The Ballad* one of the most generous and open-minded examinations of the thorny relationship between the sexes. Her imagery deals with issues of gender representation quite as well as any of the more theoretical postmodernists, and it resonates more than most because it has the authentic ring of lived experience. '*You can only speak with true empathy about what you have experienced*,' she has written.

Unlike some photographers working in the 'diaristic' mode and using the 'snapshot aesthetic' she does not deny its origins, and clearly has a great ambition for it.

> *My work originally came out of the snapshot aesthetic. …*
> *Snapshots are taken out of love and to remember people,*
> *places, and shared times. They're about creating a history*
> *by recording a history.*

That last sentence is a good definition of photographs generally.

Although Goldin has said that *The Ballad* is '*my family, my history*', it soars beyond that circumscribed horizon, unlike many of the imitations it has spawned. But her work – like that of Diane Arbus, with whom she can be usefully compared – does not revolve simply around personal relationships. It continually demonstrates how personal relationships determine social relationships and then societal relationships. Like Arbus, Nan Goldin surefootedly negotiates the tightrope between the personal and the public, confession and art, the snapshot and the documentary. That is the true value and potential of the 'diaristic' mode at its best. Like the best photography, it holds up a mirror to its time.

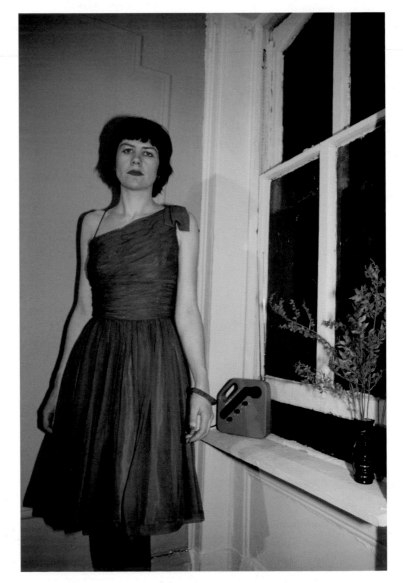

Nan Goldin (American, b. 1953)
Vivienne in the Green Dress, New York City **1980**
Cibachrome
From the series *The Ballad of Sexual Dependency*

In the 1980s, photographers began to make huge prints – some of them up to four metres wide. Photography had traditionally suffered in comparison with painting because photographic prints were so much smaller. Now, finally, they were competing in terms of scale.

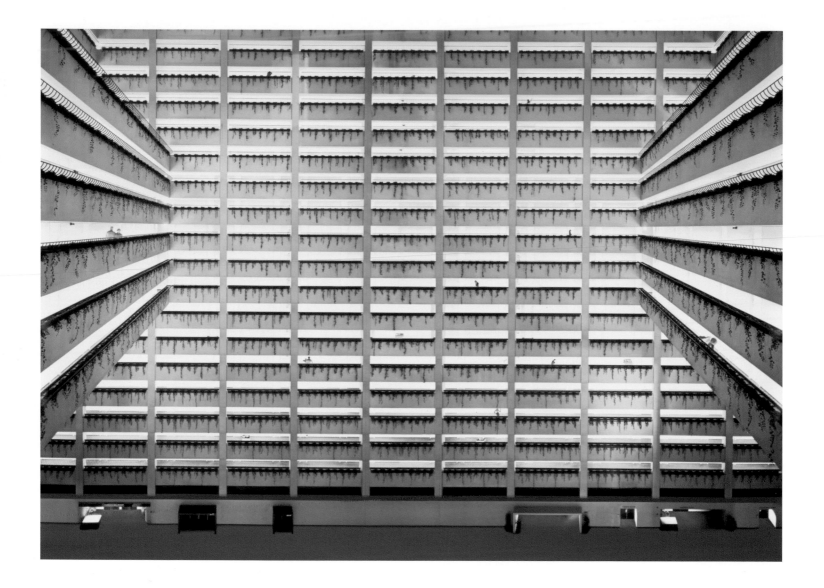

It was, in part, a consequence of the wide-spread acceptance of colour, which enlarges better than black-and-white, but more importantly it was a consequence of postmoderism and photography's colonization of the art gallery.

Prelude
Towards a bigger picture

Figurative painting staged a strong comeback in the 1980s, especially in Germany, with such artists as Gerhard Richter and Anselm Kiefer. Postmodernism was in full swing, and the subject of most of the new figurative painting was representation itself, particularly the representation of history. And photography was never far away. Kiefer made photographic works or incorporated photographs into his paintings. Richter made large paintings derived from snapshots – painted photographs, in other words.

Into the art gallery, alongside these postmodern painters, came a new breed of postmodern photographer. And not only their subject-matter but their conceptual approach was almost exactly the same. Indeed, the new photographers could be said to be making photographed paintings. Their prints were much larger, and, helped by their computers and the wonders of Photoshop, they had as much freedom as painters to construct and control their imagery.

Two leaders of this significant and far-reaching trend have been the German Andreas Gursky and the Canadian Jeff Wall. Both have remained photographers, in the sense that their subject has been modern life, the history of our times, but both approach it with such control over their imagery and awareness of art history that some commentators term them the 'new history painters'. And both borrow imagery not only from art history and the world but from photography's own past, from the cinema and from advertising.

Andreas Gursky is a leading member of the Düsseldorf School, the hugely successful group of German art photographers who 70 studied with Bernd and Hilla Becher at the Düsseldorf School of Art. At first, Gursky's work was perceived to be in the mould of his teachers, another example of the new New Objectivity, in which the world is regarded with a dispassionate and somewhat distanced eye, and the viewer is left to interpret an image very much as he or she would look at the scene itself. And his imagery still carries the stamp of this origin.

Andreas Gursky (German, b. 1955)
Times Square 1977
Chromogenic (Type C) colour print

He began by making photographs of subjects such as weekend leisure and tourism, but expanded his field of vision (and the size of his pictures) to take in an international itinerary as he became interested in the oppressive and monolithic nature of contemporary institutional architecture. Although he is essentially a landscape photographer, many of his images show the interior landscapes found in building types such as large industrial plants (the Becher influence again), apartment blocks, office buildings, hotels and the trading floors of international stock-exchanges. The atrium, a monumental interior space made specifically to impress, and maybe ten, fifteen, twenty or more stories high, might be said to be the archetypal Gursky subject.

The Gursky view is an expansive one. If a hotel atrium is, say, not quite expansive enough for him, he will use Photoshop to add a few more floors, even mirror it and double it, or take out intrusive figures. His view is clearly not – although we might be fooled into thinking so – a documentary one, but that of an artist. Gursky's work, like Jeff Wall's, is about constructing 'pictures' on a grand scale. And, like Wall, he tackles the problem of making 'painterly' statements while dealing photographically with the contemporary world. He seems to be concerned with generating mood pieces, impassive mood pieces, to be sure, but mood pieces that reflect the alienation of modern life. It is an alienation to which he seems to contribute, by forcing the world into the formal structures of his preordained vision:

A visual structure appears to dominate the real events shown in my pictures. I subjugate the real situation to my artistic conception of the picture.

Wall's work is probably the more varied of the two, and makes the more overt references to art history. He presents his large (up to four metres wide) pictures not as prints but as transparencies in backlit light-boxes, a method taken directly from advertising display techniques, such as the backlit boxes seen in subways or neon-lit buildings at night. His work is complex, being both about making pictures in a traditional painterly sense and also about commenting on modern life. Of course, this could be said of all photographers, but Wall makes those dual aims not only clear but absolutely manifest with the whole form of his images, including their titles. *Diagonal Composition* (1993), for example, features a nondescript interior – a filthy sink, some dirty shelving and a mangy bar of soap. It is totally naturalistic (one can almost smell the sink), but it is also a perfect abstract 'painting', especially at the scale at which Wall presents it.

He employs both actors and the computer to control the outcome of his imagery, and his two most renowned and ambitious works derive from this complex methodology. *A Sudden Gust of Wind (after Hokusai)* (1993) was inspired by one of the 19th-century Japanese artist's series of woodcuts, *Thirty-Six Views of Mount Fuji* (1830–33). Here, Japan's iconic mountain is replaced by a high-rise building, and windswept peasants by builders and surveyor, while the landscape is a bleak wasteland, actually a cranberry farm on the outskirts of Vancouver. Although the image appears to capture a complex 'decisive moment', it was staged using actors and synthesized in the computer, being assembled from many negatives taken over a five-month period.

Dead Troops Talk (A vision after an ambush of a Red Army patrol, near Moqor, Afghanistan, Winter 1986) (1992) is another complex tableau using actors and digital manipulation, but this

time Wall shot in a studio, building an elaborate set to simulate a desert in Afghanistan. The picture represents the aftermath of an ambush by Afghan rebels, taking the form almost of a museum diorama. Although the scene looks authentic, and the actors are made up gruesomely, realism is not the aim. The actors play several parts, and the scenario is that the dead come to life and talk to each other. The whole is a meditation upon what is real and what is not, upon traditional history painting and contemporary photographic war reportage. However, such is the degree of verisimilitude we demand of photography that, even knowing the picture to be a 'fake' (and it is fairly obvious), its realism is still rather spooky.

Jeff Wall is one of the most intellectually wide-ranging and original of contemporary art photographers, despite sometimes basing his work on other pictures. But he is an absolute believer in the power of the pictorial tradition – of pictures whether painted, photographed or made in any other way. His work attempts to mitigate photography's inherent weakness in dealing with narrative by introducing the strategies of the advertising hoarding, the cinema, the diorama and the history painting. The result is a synthesis that is both classical and modern, a concerted exploration of painting and photography. As he has said, using Velásquez's great tableau of the Infanta with her entourage, *Las Meninas,* as an example:

> The pictorial is par excellence, *non-conceptual and non-cognitive. The experience you may have of a picture has no purpose and cannot be used in any capacity. It forms us, it alters our feelings, and it transforms us: this is why, according to Kant, we need art.*

In the work of both Andreas Gursky and Jeff Wall, and others using the new computerized art photography, images of contemporary reality are set out for our contemplation. Depending upon the artistry and honesty of their vision, we can either accept or reject these fictions as an authentic view of 21st-century civilization.

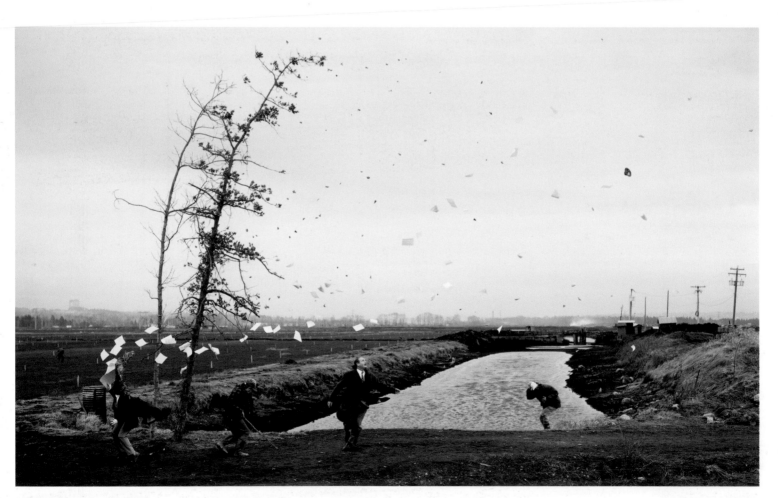

Jeff Wall (Canadian, b. 1946)
A Sudden Gust of Wind (after Hokusai) 1993
Colour transparency in lightbox

On 14 February 2006, at Sotheby's New York, Edward Steichen's 1904 photograph *The Pond – Moonlight* sold for $2,928,000, easily breaking the world record for a photograph selling at auction.

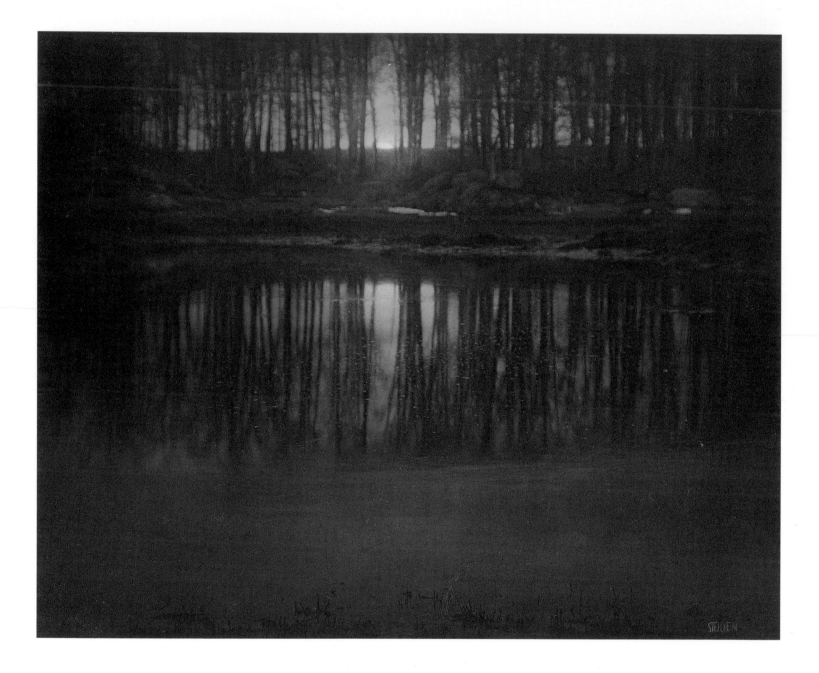

Market constructions

I began this book by examining the long struggle waged by photographers to gain acceptance for photography as a fine art. Chapter One concludes with the end of pictorialism and the beginning of high modernist photography, as practised by such figures as Edward Steichen, Alfred Stieglitz and Edward Weston. Now, almost as these words are written, comes the startling news that someone has actually paid over $1 million for a photograph by Steichen. *The Pond – Moonlight,* made in 1904, was sold at Sotheby's New York on 14 February 2006. It was expected that this rare print (one of only three) would be the first vintage print to exceed $1 million at auction. A contemporary artwork using photography by Richard Prince, *Untitled (Cowboy)* (1989), had already cleared that barrier at auction in 2005, as had a Man Ray image, *Glass Tears* (1936), in a private sale. But the Steichen didn't just scrape past. It flew over to fetch the astonishing sum of $2.9 million. A new world record by a comfortable margin.

Astonishing as this is, and it is difficult to comprehend in a medium which thrives upon the virtue of reproducibility, the Steichen print was made by the same process, gum bichromate over platinum, that he used for his image of the Flatiron. It is a process that requires hand work, with a brush, so the three prints of *The Pond* will contain enough differences in interpretation to allow us to consider each one unique.

And this is the point about the vintage photographs that sell for such sums, the $100,000 plus photographs. They are rare. Although a photographer can make innumerable prints from a negative, very few actually do. Printing can be a laborious business. Most photographers make maybe two or three prints of a subject during a session, and then, unless there is reason to print again, move on to the next negative. A photographer might revisit a negative over the years (maybe for an exhibition), making a few more prints, but few photographs have been printed more than twenty-five times.

The market has two strategies for creating rarity value. Firstly, only 'vintage' prints, that is to say prints created within five years of the negative are considered 'serious' by the well-heeled collector and by museums. 'Printed laters', as they are called, come way down the scale of values, even though the photographer may have learned to print much better. Secondly, in the contemporary photographic print market, prints are made in editions, strictly limited to no more than a few examples. With contemporary photographic artists fetching $10,000, $20,000 and more per print, and the market leaders, like Cindy Sherman, Richard Prince, Andreas Gursky and Thomas Struth, capable of making well over $300,000, people shelling out that kind of money want to be reassured that their precious and prestigious purchase doesn't keep company with too many others.

In many ways, the photographic art market is a ludicrous edifice, built on snobbery and sand. Note the use of the word 'vintage', adding the right kind of connotation to justify the higher price. Everything must be done to indicate that the 'fine' print is a matter for connoisseurship. Everything must be presented in a way that denies William Henry Fox Talbot ever invented a medium in which potentially unlimited reproducibility was the keynote. The designation 'vintage' is meant to signal that the print is the first and freshest manifestation of a photographer's thoughts, but that conveniently ignores the fact that many photographers did not make their own prints. The cult of the fine print was by no means universal among photographers.

However, Marxist cultural critic Walter Benjamin was mistaken when he contested in the 1930s that the photograph – being a work of mechanical reproduction – does not have the 'aura', the talismanic power, one may ascribe to a hand-crafted work of art like a painting. Photographs as objects may exude a remarkable amount of aura, and a portrait of a person from the 19th or early 20th century has a troubling fascination for us – firstly as an object that has survived the person it traces, and secondly as a demonstration of photography's potency as a surrogate reality. If, in addition, the photographer has a distinctly individual 'voice', you have an art object for which many collectors will be prepared to pay a lot of money.

Edward Steichen (American, born Luxembourg, 1879–1973)
The Pond – Moonrise 1904
Gum bichromate over platinum print

What makes this photograph so desirable? Firstly, it is rare. There are only three known prints, two were held by the Metropolitan Museum of Art, New York, the other by MoMA.

It was a sale by the Met of duplicate prints that gave a private collector the opportunity to acquire *Moonlight*, which (like the other two) measures 40.6 x 50.8cm, and is among the most sumptuous photographs ever made. As he did for his Flatiron picture, Steichen used the complicated gum bichromate over platinum technique, a method that requires brush work, making each print different in tone and therefore essentially unique – another plus in the rarity stakes. The image shown here is the one the Met retained, its slightly different title confirming that each print is slightly different.

The photograph depicts a woodland pond with light filtering through the trees and being reflected in the water. Shot probably at dusk, the moonlight effect is created by printing 'down' to make the image darker than it actually is.

Like *The Flatiron*, this is one of the great pictorialist prints. Considering what was happening in painting in 1904 – even American painting – it is quite conservative, and Steichen would reinvent himself after the First World War as a straight modernist photographer. But one of the problems with photography in the eyes of many collectors is that it does not compete with painting in terms of its presence as a framed object. This photograph, which could be termed unkindly a pseudo-painting, certainly does. And although pictorialism might not be to every collector's taste, both the sheer richness of Steichen's early masterpiece and its place in photographic history, plus the rarity value, made a record price a certainty.

Richard Prince (American, b. 1949)
Untitled (Cowboy) 1989
Chromogenic colour (Type C) print

Before the Sotheby's Steichen sale, which saw several other photographs exceed the magic $1 million dollar mark, the previous record for a photograph sold at auction had been set in November 2005 by a very different kind of photographic image. Richard Prince's *Untitled (Cowboy)* was sold in a contemporary art sale at Christie's East in New York for $1,248,000, and demonstrates a quite contrary side to the photographic art market.

This was a controversial sale. The problem for some is that Prince is one of the United States' leading conceptual photographers, known for 'appropriating' images. When a young aspiring artist, Prince worked for Time-Life, cutting out articles for staff writers. Left simply with the advertisements, he became so fascinated by the imagery that he began to re-photograph these tokens of society's desires. In particular, Prince made a series based around the Marlboro Cowboy and the adverts the cigarette company created featuring that icon. He re-photographed billboards and adverts, or parts of them, altered them by cropping or blurring, and then enlarged them to painting-sized proportions.

Prince's work is regarded as a pillar of postmodern art, and his re-photographing and 're-presenting' of the Marlboro ads is a classic of postmodern practice in its 'deconstruction' of a cherished American icon, with issues revolving around rugged individuality, freedom, manliness, homoeroticism and, of course, copyright and artistic originality. Prince's photograph is a copy of an image based upon illusion and myth, and meditates upon both the creation of images and their consumption within our society. Of course, for a minority of commentators Prince has merely taken someone else's hard work and made a million. Either way, his work certainly reflects the American Dream.

You have to be an artist

In many ways, the high end of the photographic art market has nothing to do with anything except those collectors involved in it. But it does indicate that, finally, photography – or at least some photography – has achieved the lofty status that was sought by the pictorialists and then the fine-art photography lobby in the United States. However, in another of the paradoxes in which the medium abounds, this was achieved in the main by photographers who did not care a fig for photography or photographic history, and who were part of an art movement which denigrated (nominally at least) art as an aesthetic experience and the notion of the artist as a creative genius.

Postmodernism evolved from various theoretical positions held by artists and critics in the 1960s, and from the artistic contributions of many individuals, but two influential early manifestations – especially in relation to photography – came from artists who were initially part of the pop art phenomenon – Ed Ruscha and Andy Warhol. I have already discussed the little artist's books that Ruscha made in the 1960s and '70s. Small, square books with 'bad' photographs cheaply reproduced and laconic titles like *Twenty Six Gasoline Stations* (1962) or *Various Small Fires* (1964), they were almost anti-photographic. Photography, as writer and artist John Stathatos puts it, had become an image book of '*inchoate raw material*' to be used as artists thought fit.

And that is exactly how Andy Warhol treated it. Whereas Ruscha at least took his own photographs, Warhol appropriated them, from books or the press. His assistants re-photographed and silk-screened them, even chose the colours in which they were printed. All Warhol did was consider the results and sign those which he approved. A 'genuine' Warhol is a signed Warhol (there are many unsigned ones) or, today, one that is approved by a committee set up to authenticate the artist's work. Authentication, of course, means thousands, even hundreds of thousands, of dollars on the art market, but what is 'authentic' in the case of Warhol? He was responsible for the 'concept' of the work, choosing the photograph and supervising its transformation into a silk-screened painting or print. Sometimes he would add touches by hand, sometimes not. But a Warhol photograph or, to be more precise, a work of art utilizing photography is a genuine Warhol not because he made it, but because he conceived it as an idea and caused it to be made.

This was a quantum leap in the way art was made and consumed. Art was art because it was deemed to be art, and shown in art galleries. Not a new idea – Marcel Duchamp first expressed it in 1907/8, when he exhibited a urinal as a piece of sculpture. But towards the end of the 1980s 'conceptual' art became one of the dominant art modes, a primary plank in the postmodern 'reaction' against the formal hermeticism of abstract modernism.

In this context, photography, an anti-elitist, mechanical, mimetic medium, replete with aesthetic paradoxes and innumerable functions, was perceived as an ideal tool. Never seen as an artform in its own right by the conceptual postmodernists, it assumed for them various roles – perhaps to document art activities, perhaps as an area of cultural enquiry, perhaps as an image bank to feed into other activities.

In the 1970s, a photographic art market was established, with galleries devoted to exhibiting and selling photographs, but this

Ed Ruscha (American, b. 1937)
Untitled
Gelatin silver prints
From *Twenty Six Gasoline Stations* 1962

When artist Ed Ruscha drove from Los Angeles to his home state of Oklahoma in the early 1960s, he took some apparently artless photographs of the gasoline stations he encountered on his journey. Published in 1962 as *Twenty Six Gasoline Stations*, in a roughly produced paperback, these 'bad' photographs revolutionized both the art of photography and the photographic book.

Twenty Six Gasoline Stations inaugurated the genre of the 'artist's book', a form which has become an extremely important and widespread mode of production for artists, particularly conceptual artists. Here the process of making the work outweighs the end product. In the artist's book, the artist's thought processes can be gathered together and disseminated in a hand-held, multiple form, and the book as object becomes the artwork.

As an object, *Twenty Six Gasoline Stations* was small and cheap, costing about three dollars when first published. It seemed so ephemeral that in a review the critic Phillip Leider described it as '*so curious, and so doomed to oblivion, that there is an obligation of sorts, to document its existence*'. Leider needn't have worried. The book, and the other little artist's books Ruscha made in the 1960s and '70s, have endured. They sell for well over a thousand dollars today.

And what is its appeal? Partly, it does what it says on the cover. Twenty-six gasoline stations is what you get, no more, no less. You don't get art, or great photography, just twenty-six gasoline stations. And that makes an important statement about photography – what you see is what you get. But in the best photography, including those gas stations, what you get might be both as plain as a pikestaff and as mysterious as a dream.

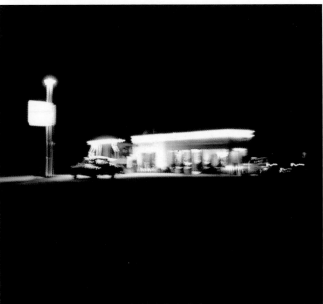

CHAMBRE 28

Mardi 3 mars 1981. J'entre au 28. Les lits jumeaux sont défaits. A gauche on dort avec deux oreillers, à droite, sans. Je remarque le pyjama d'homme en soie rouge et noire, posé sur la chaise et les babouches brodées (pointure 38). Ce sont les seuls éléments d'occupation visibles avec la valise et le sac de voyage, tous deux fermés à clé. Les armoires sont vides hormis trois sous-vêtements blancs (deux culottes et un tricot de corps) dans le tiroir supérieur de la commode, quelques affaires de toilette (rasoir, blaireau, dentifrice et brosse à dents...) et des médicaments dans le bidet de la salle de bains. Il n'y a rien d'autre à voir. Je fais le ménage et quitte la chambre.

Mercredi 4. Les valises sont toujours fermées à clé. Les babouches et le pyjama à leurs places respectives. Aujourd'hui, l'occupant du lit de droite s'est confectionné un petit oreiller avec un coussin du sofa protégé par une serviette. A gauche, maintenant un seul oreiller. Je remarque que la table adossée au lit a été tournée en sens inverse de façon à bloquer le tiroir contre le lit. Je la remets à l'endroit. En fait, le tiroir est vide.

Jeudi 5. Deux paires de bottes (pointures 38 et 42) ont fait leur apparition. Les valises sont toujours fermées à clé. Les trois sous-vêtements n'ont pas bougé. Et toujours au même endroit, le pyjama et les babouches.

Pour une fois les oreillers sont restés tels que je les avais disposés. Ils n'ont pas touché à la table.

Vendredi 6. La situation est la même (pyjama, babouches, valises, salle de bains, table, sous-vêtements, bottes). C'est mon dernier jour de service à l'hôtel C. Je laisse à ma remplaçante le soin d'observer les variations des oreillers du 28. Aujourd'hui celui de gauche, qui tombe légèrement du lit, garde l'empreinte arrondie d'une présence. J'y vois comme un signe d'adieu.

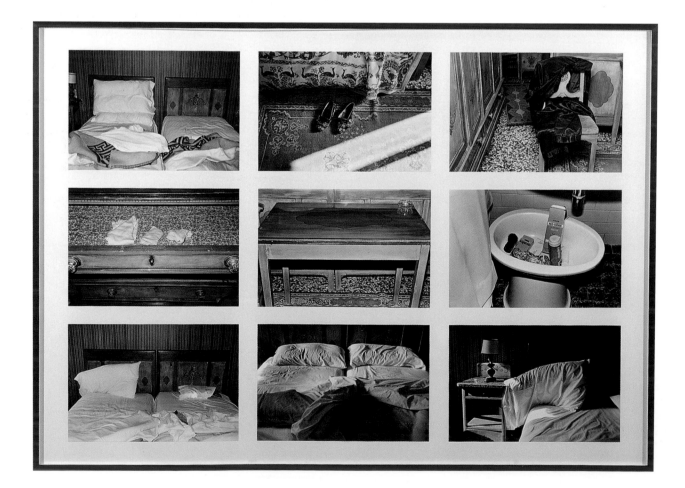

Sophie Calle is a performance artist who uses photography as an integral part of her work. Photography records her performances, but also frequently drives them. She has followed and photographed people, like a detective, but also had her mother hire a private eye to follow and photograph her daughter's activities.

Sophie Calle (French, b. 1953)
The Hotel: Room 28, 1986
Chromogenic (Type C) colour print, gelatin silver prints and text

In 1980, in her series *Venetian Suite*, Calle tracked a man from Paris to Venice, and continued to follow and photograph him for two weeks. Later, she got a temporary job as a chambermaid in a Venetian hotel and secretly photographed what she found in the rooms she was assigned to clean, making photographic pieces about her reconstructions of the guests' lives, based on their personal belongings:

For each room there was a photograph of the bed undone, of other objects in the room, and a description day by day of what I found there.

Calle's work, like that of Christian Boltanski, is about photography's reflection of memories and desires, and how we use the medium to construct our identity. It is also about a darker aspect of the medium – its use as a surveillance and spying tool. She utilizes photography to create different personal narratives in each piece, sometimes being the photographer, sometimes being the photographed – that is to say, sometimes acting as the author, sometimes as a character.

Sophie Calle's use of photography is imaginative, complex and wide ranging. She is interested not in photography *per se*, but in its cultural implications, and raises intriguing, often disturbing questions about how photographs intersect within our lives in various ways. Her work declares eloquently that we are both in control of photography and controlled by it.

was a niche market within the larger art market. Art galleries – spaces devoted to showing mainly painting or sculpture – did not show photography, and photographic galleries did not show painting or sculpture. As pop art or conceptual art became fashionable, some art galleries began to exhibit photographic 'pieces', but only if made by 'artists', not photographers. Often there would be little apparent difference between photographs made by photographers and those made by 'artists', but the perceived differences in approach led to a kind of gallery apartheid system, which had one crucial practical effect. Photographs by 'artists' received much more widespread attention in the wider artworld than those by mere photographers, and consequently sold for much more money.

The conceptual differences were often merely a matter of perception and snobbery. But photographers were deemed to be either making simple, mimetic transcriptions of the world or dealing with issues arising from the photographic tradition. Artists, on the other hand, were seen as a much more intellectual breed, concerned with either exploring the cultural implications of the medium, or taking up a theoretical position in relation to artworld issues. In a nutshell, photographers' photography tended to be generated by issues of practice, artists' photography by issues of theory.

A (hopefully) simple example might serve to explain this. Some photographs of gas stations by Robert Adams, photographer, can look very similar to those of the same subject by Ed Ruscha, artist. They share the same kind of precise, objective vision. But, in the case of Adams, it could be said that his work is 'about' gas stations, whereas, in the case of Ruscha, it is about the notion of objectivity, and is therefore part of an artistic discourse. Adams's work is about life. Ruscha's is about art. This is not to say that Adams is any less of an artist than Ruscha – although the artworld in the 1970s tended to say he was – or that Ruscha is uninterested in the gas stations he was photographing, but that the primary, the initial concerns of each photographer came from different traditions.

In 1982, Alan Bowness, then director of London's Tate Gallery, put the matter with absolute brevity in a now notorious interview with the magazine *Creative Camera*:

You have to be an artist and not only a photographer to have your work in the Tate.

And yet, as critic and artist John Stathatos has pointed out, the distinction is largely a matter of positioning and how the artist is presented, a matter of public relations:

… a surprisingly large part of the argument can be reduced to context: different ways of presenting, studying, analysing, promoting and marketing determine whether a photograph is regarded as part of the photographic or of the artistic discourse.

Peter Fraser (Welsh, b. 1953)
Untitled (Paper Aeroplane) 2001–4
Chromogenic (Type C) colour print

In his latest body of work, Peter Fraser explores symbolic connections between the materiality of objects to reflect upon the metaphysical nature of things – a modern Renger-Patzsch with a philosophical bent. Fraser, however, is not simply saying 'the world is beautiful', but that everything in the world, from the humblest to the grandest object, from an atom to an asteroid, is connected – in an immensely complex, almost infinite matrix of visible and invisible relationships.

Even before he became a photographer, Fraser had been profoundly influenced by Charles and Ray Eames's famous film *Powers of Ten* (1968), which stressed the interconnectedness of everything in the universe across time, space and materiality. But how could he express such philosophically dense ideas in a photograph? By throwing up imaginative associations and letting the mind engage with them, rather in the manner of Alfred Stieglitz's 'Equivalents'.

Here, Fraser has photographed a paper aeroplane he found on the floor of an abandoned school in Liverpool. The immediate connotations are obvious – a fragile object that is earthbound,

about to disappear. But the floor is inky grey, scattered with dust and glinting glass fragments, and rather than photographing a piece of folded paper on a rubbish-strewn floor, perhaps Fraser has photographed Concorde, zooming through the night sky, or a space shuttle, gliding silently through outer space. Of course, we know full well what he has actually photographed, but this simple, yet profoundly poetic and effective metaphor connects the detritus on a school floor with the stars – the universe contained in a handful of dust and a few shards of broken glass.

Peter Fraser is one of the contemporary photographic artists who exploit the potential of the ordinary, everyday, even discarded object, testing the poet William Hazlitt's contention that 'all things by their nature are equally fit subjects for poetry'.

Boris Mikhailov (Ukrainian, b. 1938)
Untitled 1997–98
Chromogenic (Type C) colour print
From the series *Case History*

Mikhailov frequently uses the nude, including his own body, to make a political point. His darkest work, *Case History* (1997–98), certainly shocks. It looks at the destitute, drunken underclass created by *perestroika*, when even rudimentary social support was withdrawn, and there was an increase in the homeless people (*bonzhes*), subsisting however they could. This included posing nude and performing sexual acts for a photographer willing to pay for the doubtful privilege of photographing emaciated, diseased bodies. Mikhailov does not deny the inevitable charge of exploitation, but justifies it in political and metaphysical terms.

In this image, a couple of uncertain age display their bodies. It's deliberately unseemly. We are not being asked to look for beauty in an unlikely place, but to ponder the process of making the picture. Mikhailov is playing a game of truth or dare, working upon our responses to this desperate exhibitionism, courting our outrage, making us wonder about the degrees of coercion which led his subjects to bare their flesh in the biting Ukrainian cold.

It is difficult to think of many other images of the nude or the poor in which the photographer challenges us so aggressively to think about the circumstances of their making, and causes us to feel uncomfortable for even daring to look at what are truly obscene photographs. But, says Mikhailov, the obscenity does not lie with the photographed, or even the photographer. He might be accredited a moral pornographer, yet his pornography is not so much the pornography of voyeurism, but of politics and of extreme poverty.

Boris Mikhailov's approach to photography is Rabelaisian to say the least. He moves effortlessly between fabricated and documentary modes to make some point about the human condition, shocking those who prefer their documentary to be 'pure', untainted by stage direction.

Thomas Demand (German, b. 1964)
Zimmer/Room, 1996
Chromogenic (Type C) colour print/diasec

Thomas Demand is a photographic artist who
stages his own photographs, illustrating events
from our common cultural past in an oblique and
diverting way. Using photographs from history
books, magazines and periodicals – usually of
buildings or interiors – as his guide, he constructs
meticulous models of the chosen scenarios in his
studio. He then carefully lights and photographs
them with a large-format camera, presenting
the result as a large-scale colour photograph.

The photographs are clinically objective,
yet nevertheless evocative. We are unsettled,
as Demand intends, by the tension in each image
between the real and the artificial. He heightens
this tension – and it exists in any photograph –
until it becomes the picture's primary point.

There always seems to be something 'wrong'
with Demand's photographs, although we cannot
quite articulate what. Even when we know that he
works with models, they are so well constructed
that the illusion is almost complete. That 'almost'
is the key word. It is in the tiny gap between an
almost perfect illusion and the completely perfect
one that Demand's pictures operate, forcing us to
consider whether we are looking at photographed
reality, a hard-edged realist painting or a
photograph of a surrogate reality.

Over that are laid the cultural nuances in his
work. This particular image is of the hotel room
in which the controversial founder of Scientology,
L. Ron Hubbard, wrote much of his polemical
tract *Dianetics*, in 1950 – '*a milestone for man
comparable to his discovery of fire and superior
to his inventions of the wheel and arch*', as
Hubbard modestly put it. This, at least, was the
starting point for *Zimmer/Room*, but the work can
be appreciated without that knowledge.

Nobuyoshi Araki is Japan's most famous, prolific and controversial photographer. His whole output can be considered a diary of his life – his 'I Novel', as he calls it.

Nobuyoshi Araki (Japanese, b. 1940)
Untitled 1993
Gelatin silver print
From the series *Erotos*

A large part of Araki's life seems to revolve around naked women, sex clubs and bondage so opinion about his work is sharply divided, and – interestingly – not simply along gender lines. Some commentators regard him as an out and out pornographer, yet Japanese mothers offer him their daughters as models. He subjects women to fairly extreme bondage, tying them up in positions that are indecorous at the very least, yet some Japanese feminists have said that his work empowers women, and he has been the mentor to a number of young Japanese women photographers.

This image is typical of Araki, although it comes from one of his less extreme series, where the pornography, so to speak, is more in the eye of the beholder. *Erotos* was made in 1993, following the death of his wife Yoko from cancer, in 1990. Yoko was the primary inspiration for his work and fully complicit in its sexual nature. The series explores, among other things, the close-up, for which he employs a favourite technique, ring-flash, which imparts a forensic and rather creepy aspect to his imagery of plants and parts of the body. Frequently, the plant forms, photographed deliberately to resemble human sexual organs, are more 'obscene' than the actual body parts and a long way from Karl Blossfeldt.

In *Erotos*, Araki is saying that sexuality is at the heart of life, and, as these forensically detailed images also indicate, death. Everything is sexual. But a man who has claimed that when he emerged from his mother's womb he wished he could turn round and photograph it would say that, wouldn't he?

Joining the big game

The gulf between photographers and artists was probably at its widest in the early 1980s, but since then it has gradually narrowed and now virtually, though not entirely, disappeared. Certain 'artists' who make photographs still command a premium over photographers but that seems related more to astute marketing than to what they actually do.

There seem to be two primary reasons why photography has stormed the bastions of the art market and bridged the great gulf between art and photography. One is Cindy Sherman, and the other is the so-called School of Düsseldorf – or, to be more accurate, the Düsseldorf Tendency, for the phenomenal success of objective colour photographs as large as paintings has not been confined solely to the work of Bernd and Hilla Becher and their students at the School of Art in Düsseldorf. Nevertheless, both the Bechers and students such as Thomas Struth, Thomas Ruff and Andreas Gursky have been among the highest profile photographers of recent years. 201

The Bechers themselves, as already mentioned in Chapter Four, can be credited with blurring the boundaries between art and photography. Their systematic documentary project comparing 19th-century industrial building types had begun during the 1960s. Crucially, however, they presented the results in art galleries, in grids of photographs, so that eight, ten, twelve or so 51 × 61cm prints took up a whole wall, and had art critics drooling about seriality, presentational rigour, minimalism, comparative typologies and other artspeak phrases that diverted attention away from the fact that these were elegant, beautiful architectural photographs, shot with head-on austerity and marketed brilliantly. 70

The international success of the Bechers gave German photography a confidence it had lacked since the days of August Sander and Karl Blossfeldt. The scale and cool, ironic detachment of the School of Düsseldorf's view of the modern world earned them the soubriquet of 'new history painters', and their work displayed every quality designed to appeal to the new international breed of contemporary art collector. It was large, hyper-real, colourful, with an easily readable surface yet promising hidden depths, apparently dealing with issues out there in the world rather than in the somewhat hermetic and – to use a favourite critical term – 'self-referential' world of aesthetic theory. German painting too, finding in Germany's troubled recent history a complex subject that outshone American art's increasing self-absorption, contributed to the vigour of German art in the 1980s. 68, 67

Following the success of German photography, a response was required from New York and American art photography, which could not rely solely upon the laurels of the New Topographical approach or Cindy Sherman. This duly came from a generation of photographers based around the photography course at Yale University. The School of Düsseldorf, in the main, had favoured a 'documentary' look to their imagery, although Gursky in particular became known for 'cleaning up' his pictures on the computer. One notable and notorious example was the excision of a whole factory from a scene along the River Rhine. The Yale School, however, have taken the potential artifice offered by the computer a deal further.

Gregory Crewdson is a latter-day Henry Peach Robinson or Oscar Rejlander. He directs his creepy scenes of American suburbia – Desperate Housewives on Prozac or crack cocaine – like 35 32

The unreliable witness

Following the advent of computers and Photoshop software, along with advertisements boasting that reality can be altered at the touch of a button, most people realize what photographers and media professionals have always known – the camera can lie. And often does. We now know that alternate heads can be grafted onto bodies, and, while a 'photograph' of a celebrity in a compromising position might not seriously fool anyone, we are rightly suspicious of news photographs that could have been more subtly altered. But the related belief that there is an immutable truth out there waiting to be revealed has also been undermined in two distinct ways, both of them fuelled by our increasing scepticism about television pictures in particular.

Firstly, many people are no longer blind to the fact that much of the product, especially 'reality' programming, is peddling entertainment rather than documentary truth. Television since the 1990s has become so bound up with 'selling' us something, whether a political ideology, a product or some notion of an ideal lifestyle, where we all have our place in the sun. It may be popular, but it is clearly ersatz and manufactured.

Secondly, and in a more serious vein, the advent of cable and satellite television has meant that alternative points of view can be beamed right into our living rooms. American and other Western views on the Middle East and Iraq, for instance, are countered by various Arab and 'Third World' television stations. The best known of these alternative voices is al-Jazeera, an organization that is pro-Arab but tailors its reports with a eye both on its natural constituency in the Arab world and the West. Al-Jazeera, indeed, has been so successful in putting the Arab point of view that at one point President Bush's advisors were reported to have considered bombing the company's headquarters in Qatar.

Of course, any television station is only 'reporting' facts, and I would not suggest for a moment that reporters and film crews from al-Jazeera, CBS or the BBC are not professionals, all of them dedicated to uncovering and telling the truth about events in Iraq and elsewhere round the world. Indeed, in many cases, all the television companies reporting Iraq will be sharing the same piece of film, but the resulting stories, the way that film is edited, and the words that accompany it might be vastly different. In a very real sense, television images are nothing without words to interpret them. Clearly, a young man with a pack of explosives round his waist is a 'terrorist' or 'suicide bomber' from one point of view, a 'freedom fighter' or a 'martyr' from another. An Arab television station, no matter how fair it is trying to be, naturally pitches its stories from an Arab point of view, and an American one from an American point of view, even if critical of the policies of its own side. As Howard Jacobson has written about photography and the reporting of news events:

> I hate the camera. It lies. Not in the sense of showing what did not happen – I have no doubt, in the instance of the British soldiers kicking Iraqi civilians, that what we see, whatever it is we see, took place – but because it is ahistorical, because it is not in its nature to render what it is like to be on the inside of an evolving deed.

Jacobson, a writer, is clearly suspicious of images, although similar remarks might be made about the written word, but he goes on to conclude:

> So what can we expect of a photograph? The confirmation of a political belief, that's all. The proof that we are right in what we always thought. An image, still or moving – but still even when it's moving.

The belief that the camera does not lie has been a strong and enduring one. We want to believe it still, yet more and more people are taking the Jacobson view, recognizing that photography does not present a wholly transparent view of the world. It is a mediated view, shaped first by the photographer and then by the context in which the photograph is presented – where it is shown, and the other pictures and words which might sit alongside it.

Paul Graham (English, b. 1956)
Untitled, Belfast (wire on post) 1988
Chromogenic (Type C) colour print

The work of Paul Graham has generally been concerned with pushing the boundaries of the documentary approach to photography, by investing apparently documentary photographs with metaphorical and symbolic meanings. In his key project of the late 1980s, *New Europe*, he used colour and associative objects to investigate how the 'New Europe' has been shaped out of the continent's troubled past.

From his beginnings as one of Britain's 'New Colour' photographers of the 1980s, Graham's work has gradually become more intellectually complex. An early project, such as *Beyond Caring* (1986), shows Britain's unemployment benefit offices in a straightforward documentary manner, its main feature being that the images were taken clandestinely. His next project, however, *Troubled Land* (1987), an investigation of the landscape of the Ulster 'Troubles', employed the symbols of Republican and Orange factions as he found ways of overlaying the documentary with the poetic.

Following *Troubled Land*, he took this a stage further, and his pictures became much more oblique and enigmatic, treading a fine line between description and suggestion as he asked questions without necessarily supplying answers. Many of these images were shot at night, in nondescript places such as shopping centres or bars, reflecting the unease he felt in a society apparently freed from a problematic past.

This photograph, of a masonry post wrapped with barbed wire, is typical of his method. The barbed wire can be read as connoting strife and loss of freedom, a reference to war and to prison camps. Or as an image relating to religion. The wire might connote a crown of thorns, thus representing the religious conflict which has, and still does, dog both Europe and the world.

So what of documentary photography? Of the photographer who seeks to document the world, who wishes to deal in some way with history? And, despite the problems and the paradoxes enumerated throughout this book, history – in the broad sense – surely remains the fundamental subject for most photographers. However tricky it might be, photography's uniqueness, the source of its fascination for us, and also its usefulness, comes from the camera's particular relationship with reality. And to reiterate an extremely pertinent observation by John Stathatos, already quoted in the Introduction, that relationship *has little to do with "truth", visual or otherwise, but everything to do with the emotional charge generated by the photograph's operation as a memory trace'*.

Photography is a complex medium, intersecting with history and memory in many different ways and at many different levels. In today's climate of suspicion about its veracity and the photographer's value as a reliable witness, photographers have to find new ways of positioning their photographic practice to deal with the medium's inherent slipperiness as a recorder of facts.

In Chapter Three, we looked at the beginnings of the Magnum agency and its leading role in the photojournalism of the 1950s and '60s, a time when photography was deemed to have a primary role in reporting the world and the photographer was regarded as a reliable, if not undisputed, witness. So it is revealing to consider some of the debates that now take place within Magnum as it prepares to celebrate its sixtieth anniversary in 2007.

In spite of the apparent problems with photojournalism today – declining markets, the incessant questioning of photography's role – photographers still apply to join the agency. But it is a very different organization now, housing four or so generations of photographers. And, as the markets for 'traditional' reportage photography have shrunk, the older members talk of remaining true to the founding principles. There is often lively debate between them and younger members who have found different markets and often have very different approaches.

Broadly speaking, the debate within Magnum is now between journalism and art. Magnum traditionally covered wars and other news events – and still does – but many younger members eschew such subjects and consider themselves artists rather than photojournalists. They work in very different ways from the traditional idea of the photojournalist, the roving reporter with the Leica. Some are using large-format cameras for their work and making pictures to be exhibited in art galleries as well as, or rather than, being published in magazines.

Nevertheless, although the debates at Magnum annual general meetings can be extremely lively, with older members talking about 'selling out', from the outside it would seem that, like the dichotomy in the artworld about 'photographers' and 'artists using photography', the distinction between documentary and art is more a matter of positioning and style than actual substance. Some younger Magnum photographers, like Alec Soth, might use a large-view camera and exhibit in one of New York's most prestigious art galleries, but at the root of his work is still that old desire to record the world and make some sense of what is going

96 on. And he does it with as much passion as Robert Capa 109 photographing the Spanish Civil War or Philip Jones Griffiths 113 photographing Vietnam. Indeed, Geert van Kesteren, a new Magnum nominee, has made the best photobook yet to come out

of Iraq in *Why Mister Why?* (2004). In the spirit of Capa, it makes no bones about its political stance, while endeavouring to be even handed in its coverage.

That has always been the tricky balancing act for reportage and documentary photography – to reconcile objectivity with subjectivity. If the tendency in the past was to stress objectivity, today it is to stress a photographer's subjectivity. And, while it is healthy to have punctured the pretence that cameras tell a wholly objective truth, one should not assume that every photograph is so tainted that it has no value at all as a record of history. The camera as witness still has a valuable role to play. If cameras were not there to witness history, much in this world would go unrecorded.

The question is not whether it is done, but how. Art is one way. Luc Delahaye, a former Magnum member, is making a series 98 called *History* (begun 2001), in which he photographs conflict situations such as Afghanistan and Iraq with a large-format panoramic camera and presents his pictures as 120 × 240cm colour prints on gallery walls, in the tradition of history painting. Here, Delahaye is using a different form, the art photograph, but photographing the subjects of reportage, making 'documentary' photographs. He confounds our expectations about what constitutes documentary by simultaneously drawing attention to the picture form and how the photograph was made.

That ability to realize, and somehow incorporate in the work, something of the dynamic that causes documentary photographs to come into being is a crucial aspect of contemporary documentary photography. It sounds difficult, but in her 'mask' portrait the Comtesse de Castiglione was already doing it in the 177 1860s. Similarly, in his book *Tour of Duty* (2001), Australian photographer Matthew Sleeth looked critically at the Australian peacekeeping intervention in East Timor in the late 1990s. People were being killed, but Sleeth shows that in only one image. The rest of the book details the media circus that accompanied the whole exercise – press conferences by the Australian and various warring factions, Kylie Minogue entertaining troops, and so on. The book is, therefore, a work of reportage and a commentary upon the whole business of news reporting, and how that itself affects the nature of events.

Of course, it is not just in news reportage or photojournalism that photographs deal with history. Every photograph is a memory trace. Much of the work in the so-called 'diaristic' mode, as well as genuine snapshots, might well be classified as both photographic and social history. Photography and history collide in so many different ways that the most valuable photographs for future generations will, perhaps, not always be those that photographers intended as such. It is frequently the information that 'drops off' a photograph, more or less by chance, which proves the most pertinent for later historians.

Traditional photojournalism predicated a particular way of witnessing history, using small cameras and black-and-white film, but all orthodoxy has gone in the last two decades. Magnum photographer Donovan Wylie has photographed the Northern Ireland conflict in a number of ways. Commissioned to photograph the Maze prison, he began with a 35mm camera but soon turned to a larger format.

Donovan Wylie (Irish, b. 1971)
Inertias, Stages 1–26 2003
Chromogenic (Type C) colour print
From the series *The Maze*

Wylie chose a large-view plate camera and a conceptual approach for his Maze commission in 2003, borrowing the typological methodology of the Bechers, and systematically photographing the interior and exterior of the infamous H-Blocks in a rigorously frontal and sequential way. One of his pictures seemed very much like another, but that was deliberate, as one part of the prison – also quite deliberately – looked like another. That is a feature of the architecture of 'correction'.

Buildings are designed to confuse, intimidate and disorientate. The prison's name, The Maze, was no accident.

'*I wanted to show how mind-numbingly boring it must have been to be incarcerated here,*' stated Wylie. So he photographed a sequence of cell interiors from exactly the same viewpoint, each picture differentiated only by a slight change of curtain, or a blanket. Outside, Wylie made elevational photographs of each side of the numerous identical courtyards, and then photographed sequences leading us through each of the many barriers and gates, just as we would experience the place as a prisoner.

Using flat, grey light (like the Bechers), muted colours and a tone of understatement and studied neutrality, these determinedly unflamboyant pictures would seem to be totally objective. But, although the single images may appear so, when Wylie builds them into sequences, the cumulative effect becomes so much more than the sum of their parts, and what starts out as neutrality ends up being highly analytical and political.

Carl de Keyzer (Belgian, b. 1958)
Siberia 2001
Chromogenic (Type C) colour print
From the series *Zona*

The traditional approach to photojournalism is
alive and well, although such labels have become
too limiting in today's diverse photographic world.
The Belgian photographer Carl de Keyzer's series
Zona (2000–2) could be considered a journalistic
essay in the grand manner, or a documentary
report on modern life.

When De Keyzer visited Siberia, he found that
the notorious gulags used for political prisoners
during the Stalin era were still very much in use
after the dissolution of the Soviet Union, albeit for

standard civil rather than political crimes. Around
the city of Krasnoyarsk, he discovered that no
fewer than 130 prisons and prison camps housed
a large criminal population.

It is absolutely certain that twenty years ago
De Keyser would not have known of these camps,
still less been given permission to photograph
them. But times have changed and, after a lot of
bureaucratic wrangling, he was able to make a
fascinating and detailed record of Siberian prison
life. He found a relatively open regime, in which
wives and families can live with the prisoners,
and, while inmates are made to work, we seem
far from the conventional view of Siberian gulags.

De Keyzer's images are colourful and
choreographed into complex compositions, and

it may be this that contributes to the 'not as bad
as one supposes' air. Nevertheless, to the
authorities' consternation, De Keyzer reveals that
these are no holiday camps – harsh punishments
are carried out, although he never witnessed any.

Like any photographer's work, these pictures
clearly represent a partial view, and their value
as evidence is at least open to some question.
Yet that partiality should not be overstressed.
Carl de Keyzer offers a vibrant and persuasive
view of a rarely glimpsed world – and represents
photojournalism at its contemporary best.

The photobook and the future

It is important to consider the intrinsic value of photography as we contemplate the dawn of the digital photography age. Since the medium's beginnings, critical arguments have raged around the photograph, and the 'half art, half science' dichotomy has played out in different forms at different periods throughout its history. At the moment, art seems triumphant and science (documentary) in a certain amount of difficulty, but there is one arena where such dichotomies do not matter a jot.

At a time when there are more photographs than ever gracing gallery walls, another area of photographic endeavour is enjoying unprecedented prestige. That is the photobook. Photography always was, and still is, essentially a publishing medium, and it is arguably in the field of the photobook, where photographers of every persuasion can put together sequenced narratives of photographic images, that the true value of the medium lies.

With work between the covers of a book, a photographer – whether an artist, a documentarian or whatever – is simply an author, or an *auteur* in the French sense. What matters in that context is how well the book works as a whole. Individual photographs, though they are important, do not matter so much. Photography is, as I have said before, a collective medium at root, and when a photographer takes a group of related photographs, brings in the talents of a designer, typographer and writer, if need be, and sequences the images so each one resonates with its fellows, then this, more and more photographers are coming to believe, is where photographs sing their song to the fullest. And photography becomes not just a fascinating medium based on the excitement of spontaneous sight impressions but as complex, as thoughtful and as challenging as any good film or novel.

In a 2004 review, the art critic Adrian Searle had this to say about the worth of photography, in sentiments not a million miles from those expressed by Lady Elizabeth Eastlake in the 1850s:

> *The living moments fixed by the photograph are gone in the blink of the shutter. But photographs also catch the smoke before it clears, the textures of a time and place. Photographs do something painting can't do – or shouldn't try to do.*

And what is it photography can do? Well, hiding between covers rather than brashly displayed – four metres wide – on a gallery wall might seem a overly modest ambition. But the best photography has generally been an unshowy breed, difficult and diffident, unused to the limelight, and by that token a stubborn and obdurate creature. As Lincoln Kirstein – the man who encouraged the great Walker Evans in his early career – wrote over sixty years ago, good photography has modest yet enduring standards. Fashions in photography and stylistic exaggerations come and go, excess and superficial profundity have their seasons, but the basic root of the photographic endeavour must continue to exert its fascination, heralded or not:

> *Always, however, certain photographers with a creative attitude and a clean eye have continued to catalogue the facts of their epoch ... A large quality of eye and a grand openness of vision are the only signature of great photography and make much of it seem, whatever its date or authorship, the work of the same man done at the same time, or even, perhaps, the creation of the unaided machine.*

<div style="float:right">30</div>

Martin Parr
(English, b. 1952)
Laser copier colour prints
From the series *Common Sense*

clockwise, from top left
Venice Beach, California (Poodle) 1998
Dhaka, Bangladesh (Brush) 1998
Benidorm (Blue Lady) 1998
Benidorm (Price Tag) 1997

After making several ground-breaking series documenting Britain in colour during the 1980s, Martin Parr spread his net ever wider in the '90s. *Common Sense* (1995–99) is his 'global project'. He began looking at consumerism and, to use Friedlander's phrase, '*people and people things*'.

Parr was also interested in, as he put it, '*cultural clichés*' – like the great British cup of tea – the things by which we immediately stereotype a country or its peoples. He was exploring contemporary culture to determine whether these clichés are justified – there is, of course, always a grain of truth in them – and whether they still hold true in today's global markets.

The investigation also encompassed national identity, especially the tourism, restaurant and souvenir industries, which have a vested interest in perpetuating the little myths we have about ourselves and others, even though the cultural and social map of nationhood changes constantly.

This is one of the most 'conceptual' of Parr's projects. But the conceptual approach has been a constant and conspicuous part of his work, as has a desire to find the best formal framework in which to present his imagery. A devotee of the photobook, Parr always features the book in his strategy, but *Common Sense* was also shown in a noteworthy way. The exhibition, consisting of 350 high-quality laser photocopier prints, opened more or less simultaneously in forty-three locations worldwide.

Aesthetically, *Common Sense* is also a determined exploration of the close-up, which has become something of a signature form for Parr. He discovered the use of ring-flash, normally used to give even illumination in close-up medical photography, from the books of Nobuyoshi Araki, but put the technique to effective and typically idiosyncratic use both in this project and others.

number of copies made of their work if they held the negative. Now the 'negative' is a computer file, which can be easily copied. Generally, photographers send out low-resolution files, but at some point a photographer might entrust a file to someone from which exhibition-quality prints could be made, and that file could be copied. At the moment, it is not a problem, but in time there could be implications for the photographic art market and issues of originality, authorship and provenance.

But, despite these concerns, the prognosis is not at all bleak. So what are the positive aspects of digitalization? Clearly, the digital camera and the computer have virtually eliminated certain arcane craft aspects of photography which were a barrier for some people and had contributed to a degree of elitism. Now, anyone can do it, provided he or she is computer literate. With a modest digital camera, a printer and a basic imaging program, anyone can capture images, store and manipulate them, print them out and email them to their friends. And by sending a file to a printing house, a large, professional-quality print costing far less than one made by traditional methods can be posted back in a day or two.

The photographic art market is still suspicious of digital prints, citing impermanence as a drawback in comparison with chemical prints, but here some of the leading art photographers are taking the initiative. Digital prints can be made chemically, or with dye and pigment inks, and there is every indication that they can be made more permanent than, say, traditional chromogenic colour prints. Digital prints can also be made on a vast range of papers, so a greater variety of printing techniques will be available to the digital photographer of the future, some of them capable of producing very beautiful results which approach the lustrous prints of the pictorialists. It looks as if the art market's objections are based on feelings rather than facts, and the suspicions of collectors.

One area which has benefited greatly from the digital revolution, paradoxically, is the photobook. The advent of screen technology has reinforced the fact that the book is not only the most effective way of presenting photography, it has also reminded us how desirable the illustrated book is as a physical object. Computer technology makes the production of books so easy, not just for publishers but for photographers themselves. Superb 'dummies' can be made, and there are companies who will take your layout files and send back a printed and bound book a week later. Small publishers using digital methods can offer books that are 'printed on demand'. In a real sense, we are back where the medium began, when photographers did everything themselves and produced their own handmade books or albums.

Digital photography has led, and will lead, to a vast increase in the number of photographs being made. With a unit cost of almost nothing per image, that is inevitable. Digital cameras encourage all photographers – amateur or professional – to overshoot. Whether that will in time improve photography is dubious. Really good photographers were always thin on the ground and will continue to be so. What will happen to this vast archive of photography which is being created is also open to conjecture. Future generations will decide what is important, and what should be kept. What seems obvious is that the potential opened up by digital photography is enormous – in the taking, storage, retrieval and dissemination of photographs – but the problems and abuses that could accompany this development are also clear to see.

In one sense, photography never changes. It is still about pointing a camera at the world and getting this miraculous image of it back. It is how we perceive photography that is subject to constant and fascinating change. Perhaps the most important thing that the digital revolution has done is to confirm the prophetic words of László Moholy-Nagy back in the 1920s:

The illiterate of the future will be the man who does not understand photography.

Photographer unknown
Untitled (Abu Ghraib) c. 2004
From salon.com

Timeline

<table>
<tr><td>1807–08</td><td>Beethoven composes his Fifth Symphony.</td></tr>
<tr><td>1812</td><td>Napoleon invades Russia in June. His armies enter Moscow but are forced to retreat in November as winter sets in.</td></tr>
<tr><td>1827</td><td>Franz Schubert writes his most renowned song-cycle Winterreise. The tale of a desolate winter journey through the depths of the soul is seen as a masterpiece of a new art movement – romanticism.</td></tr>
<tr><td>1831–32</td><td>Michael Faraday conducts a series of experiments which demonstrate the principle of electromagnetic induction and lead directly to the first electric generator, transformer and motor.</td></tr>
<tr><td>1831–36</td><td>Naturalist Charles Darwin travels aboard HMS Beagle on a scientific expedition to South America. His observations lead to his controversial theory of evolution, published in 1859 in his book On The Origin of Species.</td></tr>
<tr><td>1833</td><td>The American Anti-Slavery Society is founded in Boston, Massachusetts, dedicated to abolition throughout the United States. Slavery had been banned north of the Ohio River since 1787 and importation prohibited since 1807.

The Slavery Abolition Act is passed in Britain, outlawing slavery throughout the British colonies.</td></tr>
<tr><td>1838</td><td>Printing of John James Audubon's seminal work Birds of America is completed in London. The first prints had been made in Edinburgh in 1826. The work comprised 435 dramatic aquatint engravings – life-size portraits of North America's birds.</td></tr>
</table>

1500–1800 The *camera obscura* – a box with a lens at one end and a ground-glass screen at the other, upon which an image is projected (the basic optical principle of photography) – is widely used as an aid to drawing and painting. In 1558, the Neapolitan nobleman Giovanni Battista della Porta is the first to describe its use in a publication, his *Magia Naturalis* (book 3). Among those known to utilize the device are Vermeer, Caravaggio and Canaletto.

1725 The German physicist Johann Heinrich Schulze discovers the basic chemical principle of photography by noting that silver salts darken when exposed to light.

1802 Humphrey Davy reports to colleagues at a scientific society on the results of Thomas Wedgwood's experiments with silhouettes of leaves and other objects placed on paper sensitized with silver nitrate. Unfortunately, neither Wedgwood nor Davy is able to 'fix' the results permanently.

c. 1826 Joseph Nicéphore Niépce makes the world's first surviving 'photograph', using a *camera obscura* and a polished pewter plate coated with light-sensitive bitumen of Judea. An eight-hour exposure produces a dim image of a courtyard from the upstairs window of an outbuilding at his country estate. This is about a year after he obtains a photographic impression – literally a 'photocopy' – of a Dutch drawing by placing it in contact with a sensitized sheet of paper.

1829 Niépce enters into a partnership with Louis-Jacques-Mandé Daguerre to make further photographic experiments.

1833 Joseph Niépce dies, and his son Isidore assumes the partnership with Daguerre, who continues with his experiments.

1834–35 William Henry Fox Talbot experiments with photographic processes, using paper sensitized with silver chloride in the *camera obscura*, and also making 'photogenic drawings' in the manner of Wedgwood. In 1835, using his tiny 'mousetrap camera', Talbot exposes *Latticed Window, Lacock Abbey*, the earliest surviving photographic negative. The basis for all modern photography before the digital revolution is established: a negative is exposed, and from it any number of prints can be made.

1837 Daguerre perfects the first practical photographic process – the daguerreotype. The image is formed on a silvered copper plate sensitized with iodine, and is incapable of being reproduced, except by re-photographing it, with an inevitable loss of quality.

1839 On 7 January Daguerre's sponsor, Count François Arago, announces the birth of photography to the French Academy of Sciences, and brokers an arrangement with the French government, whereby Daguerre and Niépce would receive lifelong pensions in return for the rights to the process.

Talbot claims that he is the true inventor of photography.

Hippolyte Bayard produces direct-positive photographs on paper, but is persuaded by Count Arago to withhold publication of his process, leaving Daguerre to reap both the plaudits and financial rewards for inventing photography.

Sir John Herschel, applying to photography his 1819 discovery that sodium hyposulphate (hypo) dissolves silver, realizes that a photographic image can be permanently 'fixed' by bathing it in a hypo bath. He is one of the first to use the term 'photographic', and also initiates common use of the terms 'negative' and 'positive'.

In a joint session of the Academies of Fine Arts and Sciences on 19 August, Arago demonstrates the daguerreotype method to the assembled members. The French government announces that this great French invention will be given free to all the world (except England).

1841–43 Talbot works to improve his process, which he terms the 'calotype'. This term enters into general use, though Talbot later tries to introduce the term 'talbotype'.

1843 Albert S. Southworth and Josiah J. Hawes open a daguerreotype portrait studio in Boston, Massachusetts, and take what are generally agreed to be the finest portraits in that medium.

Mrs Anna Atkins produces the first volume of her three-volume *Photographs of British Algae: Cyanotype Impressions* (1843–53), a privately printed album of cyanotype plant impressions, which many consider the first photobook, although others award the palm to *The Pencil of Nature*.

William Henry Fox Talbot opens the Manufacturing Establishment at Reading, a factory for the commercial-scale production of photographic prints and publications.

1843–48 The painter David Octavius Hill forms a partnership with the photographer Robert Adamson to produce calotype portraits of Edinburgh notables. From their studio on Calton Hill, they make many of the finest portraits of the 1840s.

1844 *The first inter-city electromagnetic telegraph line is inaugurated with a message sent from Washington DC to Baltimore by its inventor, Samuel Morse. It read, 'What hath God wrought'.*

1844–46 *The Pencil of Nature*, the first commercially produced, photographically illustrated book, is published by the Reading factory in six parts over two years. Consisting of twenty-four calotypes by Talbot in total, the first part, containing five calotypes, is published at a price of 12 shillings on 29 June 1844, and sells 274 copies. By the time the sixth part is published on 23 April 1846 there are only 73 subscribers.

1845 Talbot publishes *Sun Pictures in Scotland* in one volume with a subscription price of one guinea, containing twenty-three calotypes of places associated with the popular romantic novelist Sir Walter Scott. The book is not a success.

1848 *The revolution of February 1848 deposes King Louis-Philippe and establishes the Second French Republic, with Louis-Napoléon Bonaparte elected as president.*

Karl Marx and Frederich Engels publish the Communist Manifesto, *a critique of the capitalist system and a demand for an equitable distribution of wealth in society.*

1849 Sir David Brewster perfects a stereoscopic viewer. When a matching pair of photographs is placed in the viewer, a three-dimensional effect is produced. Stereographs become extremely popular in the 1850s and '60s.

Gustave Le Gray, the most technically accomplished French photographer of his generation, experiments with his waxed-paper negative method. Impregnating paper with melted beeswax makes it more transparent and capable of resolving finer detail.

1851 *Suggested by Prince Albert and inspired by the French Industrial Exposition of 1844, the Great Exhibition is a celebration of the British Empire and industry, held in the 65 030m² Crystal Palace, designed by Joseph Paxton.*

1851 What is, in effect, the world's first open photographic exhibition is mounted at the Great Exhibition in the Crystal Palace in London's Hyde Park, attracting seven hundred entries from six nations, including Britain, France and the United States.

The Missions Héliographiques, under the auspices of the Commission des Monuments Historiques, commissions five photographers – Hippolyte Bayard, Henri Le Secq, Gustave Le Gray, Edouard Baldus and O. Mestral – to photograph historic buildings and ancient monuments in the French regions.

The waxed-paper process is trumped by the introduction of Frederick Scott Archer's collodion on glass (or wet-plate) system. Using glass as the support medium for photographic chemicals means that the negative to positive process can yield details as fine as those of the daguerreotype. Despite the system's drawbacks – the glass plate must be coated immediately before exposure, exposed slightly damp, and developed on the spot in the dark – the wet-plate method becomes the standard for much of the 19th century, sweeping aside both daguerreotype and paper negative within a decade.

1851–57 In September 1851 Louis-Désiré Blanquart-Evrard opens his Imprimerie Photographique at Loos-les-Lille, an establishment of some forty workers, mainly countrywomen, designed specifically to offer '*artists and amateurs the production, in unlimited numbers, of positive prints from glass or paper negatives*'. Between 1851 and 1855, when the factory ceases production, Blanquart-Evrard prints or publishes at least twenty albums and large archaeological/travel works with more than one hundred plates, an estimated total print output of one hundred thousand. Among the Imprimerie's publications are three classic Middle Eastern works, detailed below. The Lille Imprimerie is followed only a month later by a rival establishment in Paris, the Imprimerie run by H. de Fontney until 1857.

1853 *Two of Giuseppe Verdi's most popular operas are premiered.* Il Trovatore *opens to great success in Rome, while* La Traviata *flops at La Fenice, Venice.*

1852 Gide and Baudry of Paris publish Maxime du Camp's *Egypt, Nubia, Palestine and Syria*, illustrated with 125 salt prints made at the Lille Imprimerie. Isabelle Jammes has called this, '*the first book published under normal commercial conditions and illustrated with photographs of real value whose pictures have remained in a perfect state of preservation*'.

1853–56 *The Crimean War: fought between the allied forces of Britain, France and (in part) the Ottoman Empire against Imperial Russia. Casualties: 400,000 killed, wounded or died of disease.*

1854 Two more important products of the Lille Imprimerie are published: John B. Greene's *The Nile* and Auguste Salzmann's *Jerusalem*.

Picture credits

The publisher has made every effort to trace the photographers and copyright holders, and we apologize in advance for any unintentional omission, and would be pleased to insert the appropriate acknowledgment in any subsequent edition. Thanks for their particular helpfulness are due to Nick Galvin of Magnum Photos, London, Miki Okabe, The Japan Foundation, Tokyo, and Yoko Sawada, Osiris Company Ltd., Tokyo.

Cover: Massimo Vitali/Courtesy Arndt & Partner, Berlin; Title page: © Jeff Wall/ Courtesy Marian Goodman Gallery, New York; page 6 Getty Images; page 10 © Photo RMN – André Kertész; pages 14 and 15 (detail) Bayerischesnationalmuseum, Munich; page 17 Bibliothéque Nationale de France; pages 18 and 19 Science and Society Picture Library; page 20 and 22 above National Gallery of Canada; page 21 and 22 below © Rineke Dijkstra/Courtesy: Marian Goodman Gallery, New York; page 23 Digital Image © 2006, The Museum of Modern Art/Scala, Florence; pages 24 and 25 private collection, London; page 26 Getty Images; page 27 © Paul Seawright; page 28 V&A Images; page 30 Scottish National Photography Collection, Scottish National Portrait Gallery; page 31 Science and Society Picture Library; pages 32–33 Science and Society Picture Library; page 34 V&A Images; pages 35 (thumbnail) and 36–37 © Gregory Crewdson/Courtesy Jay Jopling/White Cube (London); pages 38–39 Kingston; pages 40 and 41 Science and Society Picture Library; page 43 The Metropolitan Museum of Art, Alfred Stieglitz Collection, 1933 (33.43.39) Photograph © 1998 The Metropolitan Museum of Art; page 44 and page 45 (details) Getty Images; page 46 Library of Congress; page 47 © Aperture Foundation Inc., Paul Strand Archive; page 49 Collection Center for Creative Photography © 1981 Arizona Board of Regents; page 50 Photographs by Jacques-Henri Lartigue © Ministère de la Culture – France/AAJHL; pages 54 and 56 MoMA/ Scala; page 58 V&A Images; page 60 and 61 (detail) © Estate of Hannah Höch/Courtesy Nationalgalerie, Staatliche Museen zu Berlin/NG 57/61/Foto: Jörg P. Anders/BPK; page 62 Rodchenko/MoMA/Scala/DACS; page 64 Lászlo Moholy-Nagy/ Julien Levy Collection, gift of Jean and Julien Levy, Art Institute of Chicago; page 65 © Man Ray Trust/ADAGP-DACS/Telimage – 2006; page 66 © Albert Renger-Patzsch/Archive Ann und Jürgen Wilde, Zuelpich/DACS London 2006; page 67 V&A Images; pages 68 and 69 August Sander; pages 70 and 71 © Bernd and Hilla Becher; page 73 The J Paul Getty Museum; pages 74–75 private collection; page 76 V&A Images; page 77 Library of Congress; page 79 Humphrey Spender/Bolton Metropolitan Borough Council; page 80 private collection; page 82 Brassaï; page 83 Imperial War Museum; pages 84 (thumbnail) and 85 (detail) CIP/Getty Images; pages 86 and 88 Library of Congress; page 90 *Life Magazine*/Getty Images; page 91 © Pierre Jahan/Courtesy Galerie Michèle Chomette, Paris; pages 94–95 and 96 (thumbnail) Robert

Capa/ Magnum; page 97 © Lee Miller Archives, England 2006. All rights reserved. www.leemiller.co.uk; pages 98–99 © Luc Delahaye; page 100 Henryk Ross/ Archive of Modern Conflict/Chris Boot; pages 102–3 SLUB Dresden/Deutsche Fotothek/Walter Hahn; page 105 Henri Cartier-Bresson/Magnum; page 106 © Estate of Robert Doisneau/Courtesy Hachette Photos; page 107 Helen Levitt; page 108 Philip Jones Griffiths/Magnum; page 110 Eddie Adams/AP/EMPICS; page 111 © Don McCullin/Courtesy N B Pictures, London; pages 112–13 Geert van Kesteren/Magnum; W. Eugene Smith/ Magnum; page 116 Leon Levinstein; page 117 © Joan Colom/Courtesy Kowasa Gallery; page 119 Johan van der Keuken; page 120 © Ed van der Elsken/Nederlands fotomuseum/Courtesy Annet Gelink Gallery; pages 122 and 124 private collection; pages 126 and 128 © William Klein/Courtesy Howard Greenberg Gallery, New York; page 130 The Metropolitan Museum of Art, Gilman Collection, Purchase, The Horace W. Goldsmith Foundation Gift, 2005 (2005.100.109) Copy Photograph © 1988 The Metropolitan Museum of Art; pages 132–33 The Nelson-Atkins Museum of Art, Kansas City, Missouri. Gift of Hallmark Cards Inc., P5.196.039.88; page 135 Anselm Adams/Corbis; page 136 © Roger Mayne; page 138 © Lee Friedlander/Courtesy Fraenkel Gallery, San Francisco; page 139 © Estate of Garry Winogrand/Courtesy Fraenkel Gallery, San Francisco; page 141 © Tony Ray-Jones/private collection; page 142 © Chris Killip; page 144 © Stephen Shore/Courtesy 303 Gallery, New York; Sprüth Margers Lee, London & Galerie Kamel Mennour, Paris; page 145 © Richard Misrach/Courtesy Fraenkel Gallery, San Francisco; pages 146–47 © Joel Meyrowitz/Courtesy Edwynn Houk Gallery, New York; page 148 © 2006 Eggleston Artistic Trust/Courtesy Cheim and Read, New York. Used with permission. All rights reserved; page 149 © Robert Adams/ Courtesy Fraenkel Gallery, San Francisco; pages 150 (thumbnail), 151 (detail) and 152–3 Massimo Vitali/Courtesy Arndt & Partner, Berlin; page 155 © Osamu Kanemura; page 156 © Sophie Ristelhueber/Courtesy Blancpain art contemporain, Geneva; page 157 © Shirana Shahbazi/Courtesy Galerie Bob van Orsouw, Zurich; pages 158–59 © Roni Horn/ Courtesy Hauser & Wirth, Zurich; page 160 © John Gossage/Courtesy private collection; page 162 Martin Parr/Magnum; pages 164 and 166 © Cindy Sherman/ Courtesy Metro Pictures; page 168 © Christian Boltanski/Courtesy Marian Goodman Gallery; page 170 Bibiothèque Nationale de France; page 172 © Aperture Foundation Inc., Paul Strand Archive; page 173 The Metropolitan Museum of Art, Gift of Arnold H. Crane, 1971 (1971.646.18) Copy Photograph © 1999 The Metropolitan Museum of Art, © Walker Evans Archive, The Metropolitan Museum of Art; page 175 (detail) and 176 The Metropolitan Museum of Art, Gift of George Davis, 1948 (48.188) Image © The Metropolitan Museum of Art; page 178 © Katharina Behrend/Nederlands fotomuseum, Rotterdam; page 179 © Lee Friedlander/Courtesy Fraenkel Gallery, San Francisco; page 181 © 1979 The Richard Avedon Foundation/Courtesy of

the foundation; page 182 Matthaei Collection of Commissioned Family Photographs by Diane Arbus © Marcella Hague Matthei; pages 184–85 © Seydou Keïta Estate C.A.A.C – The Pigozzi Collection, Geneva; page 186 The Jo Spence Memorial Archive; page 187 © Miyako Ishiuchi/Courtesy of the artist and The Third Gallery Aya; page 188 © Larry Sultan/Courtesy Janet Borden Gallery, New York; page 189 © Richard Billingham/Courtesy Anthony Reynolds Gallery; page 190 © Tina Barney/Courtesy Janet Borden Gallery, New York; page 192 © Hannah Starkey/Courtesy Maureen Paley; page 193 © Katy Grannan/Courtesy Fraenkel Gallery, San Francisco; pages 194–95 © Philip-Lorca diCorcia/ Courtesy Pace/MacGill Gallery, New York; pages 196 and 198 © Nan Goldin/Courtesy Matthew Marks Gallery, New York; page 200 © VG Bild-Kunst, Bonn/DACS, London 2006/Courtesy Monika Sprueth/ Philomene Magers and Matthew Marks Gallery, New York; page 202 © Jeff Wall/ Courtesy Marian Goodman Gallery, New York; page 204 The Metropolitan Museum of Art, Alfred Stieglitz Collection, 1933 (33.43.40) Copy photograph © The Metropolitan Museum of Art; pages 206–7 © Richard Prince/Courtesy Gladstone Gallery, New York; page 209 © Ed Ruscha/Courtesy Gagosian Gallery; page 210 © ADAGP, Paris and DACS, London 2006/Courtesy Galerie Perrotin, Paris; page 212 © Peter Fraser; page 213 © Boris Mikhailov/Courtesy Galerie Barbara Weiss, Berlin; pages 214–15 © Thomas Demand, VG Bild Kunst, Bonn/ DACS, London 2006/Courtesy Victoria Miro Gallery, London; page 216 © Nobuyoshi Araki/Courtesy Galerie Kamel Mennour, Paris, and Yoshiko Isshiki Office, Tokyo; page 218 © Joel Sternfeld/ Courtesy Luhring Augustine, New York; page 219 © Jem Southam; page 221 © Rinko Kawauchi/Courtesy Foil, Tokyo; page 222 © Dayanita Singh/Courtesy Frith Street Gallery, London; page 223 © Cuny Janssen/Courtesy Sabine Schmidt Galerie, Köln; page 224 © Paul Graham/Courtesy Anthony Reynolds Gallery, London; page 227 Donovan Wylie/Magnum; page 228 Carl de Keyzer/Magnum; pages 229 (thumbnail), 230–31 Martin Parr/Magnum; page 232 © Yinka Shonibare MBE/Courtesy of Stephen Friedman Gallery, London, and James Cohan Gallery, New York; page 234 Courtesy salon.com.

Acknowledgments

I would like to acknowledge the help of everyone who worked on this project: Jane O'Shea, my publisher, and Helen Lewis at Quadrille, Mary Davies, my editor, John Morgan, Michael Evidon and Sven Herzog, who were responsible for the book's elegant design, and finally Joanne King, Frédérique Dolivet and Claudia Condry, our picture researchers.